ON UNDERSTANDING ART MUSEUMS

 The American Assembly, *Columbia University*

ON UNDERSTANDING
ART MUSEUMS

Prentice-Hall, Inc., *Englewood Cliffs, N. J.*
A SPECTRUM BOOK

255563

Library of Congress Cataloging in Publication Data
MAIN ENTRY UNDER TITLE:

On understanding art museums.

(A Spectrum Book)
At head of title: the American Assembly, Columbia University.
Background papers prepared for the 46th American Assembly, Arden House, Nov. 1974.
 1. Art—Galleries and museums—Addresses, essays, lectures. I. American Assembly.
N410.058 069 74-34015
ISBN 0-13-936286-X
ISBN 0-13-936278-9 pbk.

10 9 8 7 6 5 4 3 2 1

PRENTICE-HALL INTERNATIONAL, INC. *(London)*
PRENTICE-HALL OF AUSTRALIA PTY., LTD. *(Sydney)*
PRENTICE-HALL OF CANADA, LTD. *(Toronto)*
PRENTICE-HALL OF INDIA PRIVATE LIMITED *(New Delhi)*
PRENTICE-HALL OF JAPAN, INC. *(Tokyo)*

Table of Contents

Preface

The Republic will be two hundred years old in 1976, but many of its strongest institutions are somewhat younger. Art museums, for example, came into being about twenty years after the birth of the nation but began to gather their great strength in the nineteenth century. Since then they have become recognized institutions for delight and education. They are thought of as "custodians of knowledge and culture, reporters of the contemporary artistic scene, and one educational force among many in our pluralistic society." Accepted and publicized though they may be, however, art museums have not generally been the objects of public examination, even though in 1971–72, according to one of our writers, forty-three million Americans visited art museums. Being in the public eye is one thing; being in the public mind, quite another. Knowing what is in a museum is important; so is knowing how it works and what its concerns are.

In the words of the participants of the Forty-sixth American Assembly (on *Art Museums in America*, Arden House, November 1974) a view of the inner workings, character, responsibilities, and priorities of museums is "justifiable and necessary," and "the time is overdue for considering future goals, present purposes and operations of art museums," especially in the face of uncertain financial outlook for many of our cultural institutions. Which is another reason why this book was written.

Clearly, something is stirring for American art museums. The pages which follow analyze it. Originally designed by Sherman E. Lee, Director of The Cleveland Museum of Art, as background for the Arden House meeting (the report of which may be had from The American Assembly), this volume is also intended for the public at large. For there is need for greater awareness; hence the title *On Understanding Art Museums*.

The American Assembly, a national nonpartisan, public affairs forum, does not take a stand on matters it presents for public discussion. This volume therefore represents no official position of the Assembly but rather the opinions of the individual authors. The Ford Foundation provided generous financial support for this program, but the Foundation is also neutral in its attitude toward these chapters.

Clifford C. Nelson
President
The American Assembly

Sherman E. Lee

Introduction

The purpose of this collection of essays is to provide a general but informed background on art museums for those concerned about them. In doing this we hope for both a planned exchange of ideas and a certain serendipity leading to a better understanding of the art museum, its aims, tasks, problems, and future. Certainly the time is a proper one for such a consideration. Not only has the art museum profession been asking more and more questions (see the essays by Taylor and Rich in particular) but public concern about these museums has been more than evident in extended news coverage of such problems as "deaccessioning," alleged illicit origins of acquisitions, the representative nature of governing boards, accountability to representatives of the public, and the large amounts of money involved in major purchases. Obviously somebody cares—but some caring may be misguided, for only certain aspects of the museum are highly visible. Still criticism and concern are justified, for museums do solicit the support of Maecenas but offer their justifications from Olympus.

What is not so evident to the reader of newsworthy items is the nature of museums and their manner of operation. Few outside the profession, even some trustees and good friends of museums, have a firm grasp of their often complex organization and activity, or of

SHERMAN E. LEE, *director of The Cleveland Museum of Art since 1958 and adjunct professor of art at Case Western Reserve University, is a widely-recognized authority on Oriental art and in 1947–1948 was in charge of the arts and monuments division of General MacArthur's headquarters in Tokyo. Dr. Lee is the author of numerous books and articles on Far Eastern art, is a Chevalier of the Legion of Honor and has been awarded the Swedish Order of the North Star. He is vice chairman of the National Council for the Humanities and a trustee of the J. D. R. III Fund.*

the consequences of their often insubstantial and quixotic means of support. The research and planning required to properly hang and label a painting is too often assumed to be minimal, if conceived of as existing at all. One hopes that this book will at least begin to answer some of the questions involved in performing this "simple" act of displaying an object. Why do it? Who does it? Who is responsible for the result? What are the meaningful ways to do it? How can we understand the result?

One begins with the assumption that the questions are worth asking, and answering—beyond the justification of art as merely "a good thing." While experience supports this conclusion it does not guarantee it. The first essay by this writer and Edward B. Henning attempts to provide both traditional and modern justification for the "collection, preservation, display, and elucidation" of works of art. The following essay by Joshua C. Taylor places the institution of the art museum in an historical matrix with particular emphasis on its place in the United States since World War II. It tells us what art museums are now and how they have become so—not only as organizations but as physical realities—their varied look in our modern landscape. The contents of the building, both permanent collections and temporary displays, take a part in this historical development, and the marked changes occurring in this century have a significant influence in how things look now and what problems need solving now. From private privilege to public responsibility may be an over-simplified summary phrase but it is not far off the mark.

Charles P. Parkhurst, in the third essay, considers those unsympathetic entities—nuts and bolts. But without some understanding of the practical working of the art museum, all of us, professional or layman, are without any guidelines for possible change. Simple material facts—humidity control for example—govern apparently free and grand architectural or display possibilities. The names and numbers of the expertise involved in even a medium-sized museum operation give certain unalterable perimeters for budget and space, among other considerations. While no essay on this subject can provide easy reading, careful study of this essay is essential before considering the following higher flights of fancy.

George Heard Hamilton considers what is probably the most pressing current question about art museums—their proper functions in education and scholarship. The historical development he

summarizes demonstrates the relatively modern motivations of educational activity in art museums while firmly recognizing the ancillary nature of the museums' educational activity in the distinction between the work of art as object and as document. With this core distinction it is inevitable that his developed argument arrives at a justification of the "ivory tower" as the major effective and meaningful function of the museum in society. In short, the museum has educational responsibilities, its collections can educate in themselves, but it is not primarily an educational institution. The tactics, as well as the strategy, of the recent educationist pressures he describes are current problems of considerable gravity.

Behind all the exposition of the first four essays lie the topics considered by Daniel Catton Rich. The implications of governance, power, and integrity are as important as they are hard to demonstrate. But the first two words name the ultimate questions that must be faced if integrity is to be achieved. Mr. Rich's exposition of the growing tensions and increasing problems surrounding management as museums entered a larger public arena reveals his long experience in depth during the crucial years of these developments. Some necessary alternatives to "uncontrolled growth" are certainly to be found in his conclusions; others have been proposed by the Forty-sixth American Assembly conference, on Art Museums, which provided the reason for the preparation of this background collection of essays.

Darby Bannard's paper may well be the most controversial of the seven. The relation of the living artist to institutions of art, particularly museums, is always a subject evoking as many sharp divisions as there are artists, or at least like-thinking groups, involved in widely varying styles and attitudes. Bannard's essay incorporates those concepts of quality and dedication which Henning described under the "Formalist" heading at the beginning of his part of the first essay. Needless to say social realists and conceptual artists, to name only two types, would probably not agree with Bannard's assumption of the discernibility of quality or of the basic "social" irrelevance of art; but his suggestion that artists unite to explore and solve their own problems is certainly a relevant proposal that would do much to redress the existing imbalance in the art museum's role as patron of, or collaborator with, the contemporary artist. And while some may wish the museum to go much farther than Bannard suggests for participation in the

avant-garde scene, still others think he goes too far and that the art of the hour belongs outside the museum and in the marketplace. Perhaps his strictures on the place of crafts in the contemporary world of art are shared by other painters—if not many craftsmen.

The last essay by Robert Coles may seem indirect to admirers of standard didactic and expository prose. To the contrary, I find it a most stimulating, moving, and educational effort. The case history method, which Dr. Coles and his profession have developed and elaborated so well, is not much used in the world of art museums—a loss to us, judging from the clear reverberations coming from his essay. No time or energy for art museums is one recurrent theme of the disadvantaged, a much clearer statement than a discourse on the use of leisure time. If one added to that cry, no money, as will be true if current museum tendencies to admission charges increase, then one would be forced to recognize that the disadvantaged were almost totally barred from the art in our museums. I was struck also by the effect of labels recording the transfer of ownership as a fact equal in importance to the name of the artist. While one sympathizes with the legitimate desire to recognize a donor, I at least, had no previous inkling of the impact provided by a seemingly harmless label. Here again the interrelationships of the various essays become clear—for Rich's essay is, in part, a discussion of other facets of the power and ownership problem.

Like many of his colleagues Coles proposes a wider use of satellite museums, a development also discussed in the essays of Parkhurst and Taylor, but called somewhat into question if one absorbs the financial and conservation sections of Parkhurst's paper.

But what comes through very clearly from Coles' case histories is the enormous scale of the social problems originating the pressures on art museums. These problems evidently are not solvable by the puny activities of art museums. They are, properly and humanely, urban, regional, national, and international in scope and require political and social action on a scale unknown to the museum. This is not in any way to suggest that they be ignored by art museums. Quite the contrary. But they should be approached in terms of the vocabulary available to art and the museum. The reproduction of Renoir's *Le Bal à Bougival* is an effective, if small, witness to art's place in social reform. But I take Coles' case histories to show that social reform can lead to visual understanding; and that the relevance of art in this context is sporadic but well worth nurturing on its own terms.

Sherman E. Lee
and Edward B. Henning

1

Works of Art, Ideas of Art, and Museums of Art

I

There are sufficient reasons to begin with the word *art:* it is the first word in the term *art museum,* while the second word is far more concrete and subject to definition. It would be a relatively easy task to develop or destroy a museum. To create *art,* or to destroy it, would be a vast project, for art is generally accepted as at least somewhat ineffable and is many more things to more people than that material thing called a museum. Art can certainly be imagined without the presence of a museum; the art museum can hardly be envisaged without art.

Before the first real art museum, the Louvre, created by the Revolution and by Napoleon as a visible manifestation of European empire in fine arts, there were numerous houses of art. The cave, the temple, the palace, the cathedral, and others played their part in housing works of art for various purposes. But the Louvre, and its now vast progeny, had new purposes, a self-conscious awareness of art as both a contemporary and an historic product, as well as the acceptance of responsibility for the public exposure of certain products as art. The Renaissance and Modern heritage of a

EDWARD B. HENNING *is Curator of Contemporary Art at The Cleveland Museum of Art and a professor of art history at Case Western Reserve University. A specialist in modern painting and sculpture, he is the author of* Paths of Abstract Art *and articles in American and foreign art journals.*

self-conscious awareness of the artist, his art, and his works of art, became a public reality at the beginning of the nineteenth century before the Industrial Revolution. If the idea of genius and high art is first properly associated in the West with the Renaissance, then the idea of the art museum was a somewhat belated product of the Enlightenment. Since then and until today, no one has seriously questioned a concept of the art museum in the definition adopted by the professional associations concerned with that peculiar institution:

> . . . a permanent, non-profit institution, essentially educational or aesthetic in purpose, with professional staff, which acquires objects, cares for them, interprets them, and exhibits them to the public on some regular schedule. (*Professional Practices*, Association of Art Museum Directors, N.Y., 1972)

Art

Art is the decisive word in the term *art museum,* but it is most elusive of definition, or in common acceptance of a definition. All dictionaries and almost all writers on art agree that one word must be included in any such definition—*skill.* From this seemingly obvious concept one can move to both limitation and expansion— skillfully made, visually perceived objects; or skill visually mani- fested in intellectual, emotional, or imaginative imagery; or ulti- mately, skill manifested in the beautiful. Unfortunately, we now find more words to define and to evaluate—the longer the definition, the more tangled and unclear is the resulting image.

What is to be done with remarkable and unusual imagery presented with little skill? Or, extraordinary skill—seemingly wizardry—in the presentation of banal or insignificant visual images? What of apparent lack of skill, skillfully presented? This is not a mere play on words for much of important later Chinese painting and many fine works of contemporary Western art rely on just this combination for their effectiveness and originality. (We will return to this latter devastating word later.) Historically and pragmatically we cannot go far wrong if we assume that art has, in a complex and often subtle way, something to do with skill, intellect, feeling, and imagination, in various combinations of these qualities, and that the visual products of such art can be recognized by numerous and stringent comparisons made by knowledgeable

observers, just as a manager recognizes a skillful quarterback or a talented shortstop.

Art and Quality

And here is where a major stumbling block is placed in the path of any art observer. The ultimate test of the athlete is his performance. There are many skillful and stylish players in all sports who consistently lose. There are no such ultimately definitive measures in the arts though numerous abortive attempts have been made to provide them. To say that there are no winners, that we can ultimately prove nothing, is to offer shifting boundaries in a strange but rewarding land, where relatively vague rules govern a fascinating game.

The nearest approach to a winning score is probably to be found in the area encompassed by originality—"such as has not been done or produced before" (*Oxford English Dictionary*). Each great work of art should have in it some thing of such power or wonder as to demand our attention and surrender to it. *But,* so do many derivatives—a foreshortened figure in a newspaper cartoon amazes the ignorant who know nothing of the six hundred and fifty years since Giotto. What is the difference? Why does it matter? Here questions of truth and history become evident. If the problem does not matter then neither do history or truth. Hence the essential, if supporting, role of the history of art. The ultimate question is: Do quality and originality matter? One cannot beg these issues. To argue that each work—good, bad, or indifferent—is *an* original may be semantic wisdom but also practical nonsense. We can *prove* from history that manners of representation, methods of making, grammars of ornament, do change and that the change occurs because at some point "such as has not been done or produced before" occurs and the fabric of a particular art at that time, and in that place, is inexorably changed and subsequent production is not understandable without taking that change into account. (See particularly H. Focillon, *The Life of Forms in Art*, New Haven and London, 1942, and G. Kubler, *The Shape of Time*, New Haven and London, 1962.)

It is equally true that no original creation is made without antecedents—art historians would have even less claim to attention than they do if that were not so. Change occurs more rarely and

more slowly in some cultures than in others; originality may be overprized and self-destructive in yet another context. But the concept of innovation and development (but not of progress) is inherent and demonstrable in the history of art. One can only deny it by an act of faith, a romantic position well exemplified by Tolstoy or William Morris and their epigones who dream of a peoples' art, where the act of communal participation destroys the concept of originality and quality.

The implications of "quality," once so easily, and often falsely, accepted, are now considerably resisted by a new *avant-garde*. Again the word is defined as embodying "capacity, ability or skill" (*Oxford English Dictionary*). One can safely hold that the character and appearance of an art museum depend upon the acceptance or rejection of this word by those responsible for the institution. One can have a museum of folk art, a gallery of painting, a museum of useful art, a *glyptothek* devoted to carving or sculpture, a museum of religious art, a museum of abstract art—the divisions by medium, style, content, place, and/or time of origin are numerous—but unless one deals with the implications of quality one is simply recording and preserving anything. And anything is a boundless mass impossible to imagine within any known human context. Perhaps such a situation prevailed in the days *before* man made tools, but by then the innovations of the better chippers were irreversible and we now have to deal with the results, however indirect, of such early originality.

Quality, Context, and History

Quality can be considered in this historical, developmental, and innovational sense, but it can have other implications in contexts within or even other than an historical one. Technically, Chinese bronzes of the Shang and Chou dynasties are demonstrably superior to bronzes cast in most other cultures until modern times. The anatomical knowledge of Renaissance artists is demonstrably superior to that revealed by any art of the previous thousand years. In these areas we are on reasonably secure ground. But consideration of aesthetic quality comes a cropper if one strays beyond a relatively limited context, certainly limited both geographically and chronologically, and perhaps typologically as well. Thus Rem-

brandt can be shown to be, and certainly perceived to be, superior to Bol, but not to his more geographically distant contemporaries Rubens or Poussin. As the modern age developed and wide ranging visual communication became commonplace, geographic boundaries were less important—one would not hesitate to decide among Degas, Frith, and Segantini, if one wished to pursue such a thankless task.

The Museum and the Art of Past and of Present

Considerations of *poor, good, better,* and *best* are, then, rooted in culture and history and hence what should be the natural affinity between the art museum and art history. If quality is a contextual problem (see below) then the contexts must be visible in the art museum. Arbitrary aesthetic permanent arrangements disregarding such contexts become, if sometimes beguiling, willful exercises in long-term futility. The historical-contextual position also deals a frightful blow to a museum's deep involvement with immediately contemporary art because the context for that lies everywhere *outside* the museum. (See H. Rosenberg, "The Old Age of Modernism," *The New Yorker*, August 15, 1974, pp. 66–74.) Gilson puts it clearly, almost brutally: "Museums provide homes for aged masterpieces." (E. Gilson, *Painting and Reality*, Washington, D.C., 1957, p. 229) Both Santayana and Proust understood this very well—not necessarily denigrating the art of contemporary society but understanding that it belonged in that society and that a museum (or the past) served quite different but essential needs. Santayana wrote, disparagingly, that the moderns

> . . . prefer to take that wisdom [Greek] for a phase of sentiment, of course outgrown, but still enabling them to reconstruct learnedly the image of a fascinating past. . . . This is a vitality lent by the living to the dead, not one drawn by the young and immature from a perennial fountain. (George Santayana, *Egotism in German Philosophy*, N.Y., 1940 [originally 1916] pp. 36–7)

The study of the past, the re-creation of its image is a "fascinating" task, but not to be confused with the unveiling of divine law and also note, it is to be the result of *our* activity and study.

Proust put it as an aphorism—that the public looked at contemporary artists such as Maurice Denis or Edouard Vuillard, but these creators looked at the past as revealed in the Louvre. The

experience of the past, not its re-creation must come from the direct evidence provided by the remains preserved and shown by museums. (M. Proust, "Journées de Lecture," in *Pastiches et Mélanges*, Paris, Gallimard, 1919, pp. 267–8) The contemporary artists, in a sense, make us see the past even if in a new light. The past is not to be "marketed" by, for example, sleazy slip covers on serious literary works, but is always there to be seen, always seen differently and usually afresh. Such renewed seeing, constant comparison, and reevaluation of the accumulated wealth of visual art provides a foundation for judgment, and the art museum is the prime instrument in this process. It provides the balancing weight to that of the here and now. Without it the overweening drive of the present, however valid or expedient, carries all before it—one remembers the "wave of the future" as a thing fortunately past—whatever is, or is presumed to be, is not necessarily right. Or, put in a satiric vein by Grigson:

> There is no sound so soft, so determined, so typical of our time, as the step of art-officials advancing in fear of ridicule to accept the ridiculous. (*The Contrary View*, London, 1974)

Kinds of Art and Needs of Society

The museum is never more democratic than when it insists on the presence of the plurality of the past. This presence attests to the concept of grades of skill, of levels of quality. If this is falsely deemed by the modern Tolstoyites as undemocratic, then the contrasting conformity can only be defined—and by recent historical example in Germany, Italy, Russia, and China—as totalitarian. The development of aesthetic potential, however uneven the result, is essential in a democratic society. Rightly enough, the beginning of such a vision of society, not only confined to aesthetic matters, is to be found in the Italian Renaissance, specifically in the writings of Machiavelli, where questions of toleration, diversity, empiricism, and compromise—essential to this particular discussion—have been traced by Isaiah Berlin to the Florentine skeptic.

> If we choose forms of life because we believe in them, because we take them for granted, or upon examination, find that we are morally unprepared to live in any other way (although others choose differently), if rationality and calculation can be applied *only to means or subordinate ends,* but never to ultimate ends:

then a picture emerges different from that constructed around the ancient principle that there is only one good for men. ("The Question of Machiavelli," *New York Review of Books*, Nov. 4, 1971, p. 31)

The devotion of the art museum to history, pluralism, context, and quality is, then, a better part of our modern heritage from the Renaissance and the Enlightenment.

The plurality of historic art can be seen as an extensive, seemingly endless, mosaic composed of individuals, schools, regions, periods, styles, subject matter, symbols, traditions, etc. Certain broad categories may be particularly meaningful for the art museum and its position in society today.

PUBLIC ART

Perhaps one reason Classical art has always looked well, belonged, in a museum is because it was created and seen as public art. The great friezes and pediments, the free standing sculptures on pedestals in the open air, the reminders of the physiognomies of rulers, generals, and philosophers—all were meant to be seen openly and continuously. They are now viewed by museum visitors, often in modern re-creations of the architecture associated with the ancient sculptures. The public and official arts of the Renaissance and later periods were re-creations or variations on the themes and modes established by the Classical world. The museum environment seems just for Polyclitus, Donatello, and Canova, and such public art may be easier of acceptance sometimes, even today, as belonging to all of us and not subject to private covetousness. Unfortunately questions of expense, of profit-taking capabilities, are raised today in many private and public sectors involved in building and construction, making the production of a just proportion of public art more and more difficult. As we shall see, unless art can be bought and sold, transferred in ownership, it becomes simply a non-reimbursable expense—hence its general unattractiveness in all but a small percentage of business operations.

RELIGIOUS ART

A second major kind of art, with almost endless variations, is religious in its motivation and was originally seen and used in a religious context. To the truly religious, the presence of such works

in a museum often seems at least strange, if not sacrilegious. Indeed, such works of painting and sculpture formed only a small part of the earliest art museum collections. They only gradually came to occupy the conspicuous position they now command in museums. In our strongly Protestant influenced American society there are still inhibitions about having too many works of Christian, especially of "Catholic" art. Iconoclasm is still not wholly dead, especially on accessions committees; and *Christ as the Man of Sorrows* is a bitter pill for some to swallow. Still, a growing consensus reveres religious art as shown in art museums and with good reason—for seldom have the means and purposes of art been so firmly welded to intellect and emotion as in the best of religious art, whether a Sienese icon or a Gupta Buddha image. The *meaning* of the work is inescapable. Some, I suppose, still talk only of the "significant form" of a *Pietà* as if it could be divorced from the poignant representation and the deep and layered ideational content, but not convincingly and certainly not effectively from the viewpoint of an intelligent, informed, and sympathetic beholder. Also the public, or at least semi-public, nature of religious art as well as its content tends to remove it from the realm of private desire for ownership. It belongs in a temple or church—or in their modern stepchild, the art museum.

"FINE" ART AND THE HIGH INTELLECTUAL TRADITION

The rise of a relatively large number of people to literacy and knowledge, to Ralph Turner's "high intellectual tradition," in the Renaissance and later times, produced yet another kind of art at home in the art museum—but with some almost imperceptible and uneasy vibrations. Much of Modern (*i.e.:* Renaissance and later) art was, of course, public art. But much of it was private—privately commissioned, privately owned, and privately seen. (This was also often true in Hellenistic and Roman times, models for these later periods.) Even more, much of it was secular in subject and in flavor. If one really cannot convincingly covet an altar piece one can very much desire to *own* a Chardin, a Ruysdael, or a Monet. Not only are they smaller, more accessible, less public—they were made to be owned privately. Their presence on museum walls, unless carefully contrived, seems almost an invasion of the work's privacy. How many curators have had to deal with a trustee's stand that such and

such is a "private collector's" thing? Yet these works also embody numerous layers of intellectual and affective meaning. They can hold their own with their grander, more official peers especially when they *are* hung in the art museum, for there they lose both their privacy and, in a pragmatic sense, their monetary value. They cease to be property and become works of art, publicly shared.

Modern times also provided a rationale for the separation of "fine" art from "applied" art—for the gallery of paintings and the court of sculptures rather than a museum of applied art. While the production of refined and enormously expensive decorative arts continued without rupture, their wholesale but isolated inclusion in a museum context really began with what became the Victoria and Albert Museum in 1852; but the reception of the "minor arts" into the general art museum as an integral part of an historical context waited until Wilhelm von Bode's creation of the developed Berlin museum complex in the early twentieth century. The integration of all the arts still seems culturally and historically correct, but it does add immeasurably to the private, proprietary, and thing-like character of the museum's contents. Still, if skill is a major component of art, then the useful and decorative arts have strong and justified claims for inclusion in the art museum.

FOLK ART

In contrast to public, religious, and private art with their overtones of preciousness and luxury, is folk art. Not always consummately skillful, produced for the everyday needs of the middle or lower levels of society, folk art fulfills the expectations of communal thinkers and/or radical social reformers—men such as Morris or Tolstoy, or allied medieval or primitive revival thinkers of today. Non-luxurious and commonly accessible, such art has a direct appeal. No one who has visited the Folk Art Museum (*Mingei-kan*) in Tokyo or the Shaker Rooms at Shelburne, can resist. One even imagines a fully satisfying world furnished with just such artifacts—but not for long. Direct juxtaposition in the art museum soon disabuses the beholder, or at least convinces him that quite different qualities are involved in "high" and "folk" art and that they belong in and should be exhibited in different contexts. Are questions of property value involved in this judgment? Perhaps not consciously; but we suspect their presence.

Art as Property and Money

We have skirted the question from time to time of art as property. This problem demands our attention particularly today, for it has become a major cause of tension in the structure of both art and art museums. We have mentioned Morris and Tolstoy, not to dismiss them, but to recognize the questions they raised as legitimate, if historically open to question. Fine art, commissioned by church or state, bought by aristocrat or bourgeois, always had measurable material value. The medieval artist was most often handsomely paid for his skill. Renaissance and later contracts for commissioned works are usually most specific, not only about materials used but monies due. The recorded history of purchase prices in the market, private or public, shows surprisingly high prices for major works by major artists. This has become increasingly true with the broadening of the market, the growing scarcity of noncontemporary works, and the vastly increased instant publicity common today. In contrast, folk art, and until recently the simpler useful arts, have never commanded much more than the utility value of the object. The desire for the simple communal life, for a nonmoney economy, for valueless art, is a part of an anti-fine art movement reaching bizarre "common sense" in the contemporary efforts by conceptual artists and their epigones to create works that by their very nature are immaterial and not things to be bought or sold.

How does this affect the art museum? Its collections can be considered as capital. Its acquisitions can be and often are considered as such by newspaper reporters, trustees, directors, curators, visitors, and the casual observer. *How much?* is asked before *What?* and *How good?* Cocktail conversation on art would (or should) be unrecognizable to the student, scholar, or concerned beholder of art. And this conversation is fired by the art magazines, auction houses, misguided collectors, and professionals anxious about public "images." Small wonder that many long for the simple joys of works of art defined as a needed useful thing made well.

The problem is more one of money than of art. For money is a subtle and complex instrument infinitely sensitive to an infinite number of influences. The nature of seller and buyer, the weather,

the time of day, the psychological state of both local and national society, the many small accidents of everyday life, as well as the object, its rarity, condition, quality, subject matter, size, weight, etc., all play their part in determining what amount of money is transferred from one person to another when the sale of a work of art is consummated. One would think, then, that the price of an object would be purely arbitrary and easily subject to manipulation.

And it is; but the prices and/or values of works of art have historically reflected the real importance and agreed quality of objects. Money does talk; works of art do have reasonably determinable values. No one has yet devised a more flexible and subtle means of reflecting value than money, and if the arrival of the millennium demands the obliteration of aristocratic or bourgeois or elitist fine art, then its appearance is far from assured. Works of art are definable property; but if we admit only this, and not that they are many other things unrelated to financial value or ownership, we do them a tremendous disservice. Indeed it is just the seemingly endless variety of meanings, qualities, and stimuli involved in and around a work of art that makes it possible for the art museum to do other than the purely aesthetic—though the latter is its essential responsibility. Like many other things—wilderness areas, unique specimens, abstract scientific formulae—they are without price at the very least when they are removed from the marketplace and become a part of the historical and public domain.

In short, if art museums must be aware of, and act in the market, the rationale involved should not become a part of the museum's credo. The "marketplace" is one of many means; it can effect ends but that effect should be kept to a minimum, for property, and its surrogate, money, have nothing to do with the historical and aesthetic values of the works worthy of being housed in an art museum. And the fundamental intention of the anti-art movement should be recognized for what it is, directed not against art, but property. If the evaluation of art is in fact largely inseparable from money and property, then the question is both unresolved and grave.

The implications of this discussion for art museums, their financing, and development are obvious and far reaching. Think only of the problem of federal tax deductions for gifts of art to

museums, as one example among many. They have been a stimulus for museum development for the public good; they are a subtle and largely unrecognized form of government subsidy to museums. To date this has been the acceptable method of subsidy, yet its difficulties have been numerous and some legislators view the method with disfavor. But the general public good served by the existence of art museums—*regardless of their programs*—is evidently not recognized as good enough to provide more direct substantial subsidies. Even the commendable support given through the National Endowments and other federal programs is awarded on a project basis only. Other ramifications involved in the concept of art as property include the problems of illicit export and import traffic, insurance, special exhibitions, attribution and authentication, and others. Perhaps the most encouraging thing to remember in this sad recital is, that our Declaration of Independence proclaims man's right to "life, liberty, and the pursuit of happiness" —not "property," as was originally proposed.

ART, MONEY, AND DOING GOOD

A recurring theme in any attack on, or attempt to divert funds from, art museums is that so much money frivolously expended could be more worthily spent elsewhere. The elsewhere is almost always a worthy philanthropic cause doing good in various direct, unmistakable, and humanitarian ways. Naturally, if money were not involved in the collection, care, exhibition, and elucidation of works of art there would be no problem—save for the criticisms of a few latter-day Puritans and Iconoclasts. But, since money is involved, the problem exists. Why spend for ineffable art when so many concrete needs of mankind go unmet? The utilitarians are particularly well represented at voting time in legislatures.

It should first be clearly admitted that such strictures have a strong appeal not easy to rebut without appearing to be the devil's advocate. Social needs *are* enormous. Direct physical aid in many areas *is* essential. Iris Murdoch admits all this in her humane but tough minded way as she defends the arts from such attacks:

> The desire to attack art, to neglect it or to harness it or to transform it out of recognition, is a natural and in a way, respectable reaction to this display [of art as conspicuous frivolity]. ("Salvation by Words," The Blashfield Address to the American Academy of Arts and Letters, May 17, 1972, partially reprinted in *The New York Review of Books*, June 15, 1972, p. 3)

She goes on, ". . . sociological utilitarianism . . . represents a certain deliberate and even high-minded Philistinism," a comment directly to the point but, we fear, not persuasive to the Philistines.

Art has its honorable place, not in competition with other and totally different disciplines or needs, but in its own right as a fundamental part of our traditions—whether Eastern, Western, or other. However, not only is its fiscal share begrudged, its very purposes are to be manipulated for what many consider the public good. We are familiar with this in nondemocratic environments, both East and West, and in enclaves in our own society. A cogent, and ironic, counterargument comes from yet another creative artist of our present, W. H. Auden:

> . . . all works of art are primarily, personal utterances addressed to others as persons . . . art does not count heads. . . . The world about us is full of gross evils and great misery by which any decent person is appalled; but it is a fatal delusion and a shocking over-estimation of the importance of the artist in the world to suppose that by making works of art we do anything to eradicate the one or alleviate the other. . . . The extrovert, intent upon improving the world, will always tend to pinch his neighbor—for his own good of course—until he cries for help. ("Nowness and Permanence," *The Listener*, March 17, 1966, pp. 377–8)

Still another variation of these subversions of the nature of art deserves attention since its perimeters include just and successful experiments involving the application of art to mental illness. Surely this amelioration of widespread malaise must provide a clear case for the social usefulness of art. But as Richard Wollheim points out in discussing art as therapy:

> What art is goes by default. . . . For within the actual domain of art-therapy, art comes to be defined through therapy rather than—as was the original premise—therapy realized through art. ("Neurosis and the Artist," *Times Literary Supplement*, March 1, 1974, pp. 203–4)

Like applied science, the social uses of art need no defense as long as these uses are not confused with the real thing. When they are, strong defensive measures are essential and, by their very nature, are liable to be unpopular. Matthew Arnold's classic defense of culture against utilitarianism in *Culture and Anarchy* is still germane and still a minority viewpoint. But inherent in this minority's concerns is the ancient and modern examination of ends and means, thought and action. These concerns are still crucial and not to be cast aside as mere matters of detail—or worse as unimportant.

William Blake, now often quoted in defense of modern versions of earlier types of mysticism, puts the point in unmistakable and uncompromising terms:

> He who would do good to another must do it in Minute Particulars: General Good is the plea of the scoundrel, hypocrite, & flatterer, For Art & Science cannot exist but in minutely organized Particulars. ("Jerusales: III" in G. Keynes (ed.) *Poetry and Prose of William Blake*, London, Nonesuch Press, 1932, p. 655)

Now modern systems of philosophic and aesthetic thought embody and attempt to explain the tensions and contradictions involved in art, one of its instruments—the museum, and its larger context—society. What are the most significant of these efforts?

<div align="right">S. E. L.</div>

II

Two Major Developments in Recent Art and Criticism

Two of the most significant developments in recent art, with explicit theoretical implications for art museums, are the so-called "Formalist" school of painting and criticism on the one hand and "Conceptualism" on the other. Formalism is manifested largely in "post-painterly abstraction" and in the critical writings of Clement Greenberg, Michael Fried, and others; while Conceptualist artists, such as Joseph Kossuth, Sol Lewitt, and Edward Ruscha, are highly diversified in their activities and prefer to define the intentions of their work themselves.

FORMALISM

Formalistic critical thought has played a large role in art, and writings about art, in the twentieth century. When Cézanne and the post-Impressionists focused on the morphology of painting, their art stimulated Formalist theories such as those of Roger Fry and Clive Bell. But serious concern with form in painting can be traced to Baudelaire's writings about Delacroix's art, and is even implicit in Roger de Piles' early eighteenth-century methodology for evaluating artists in terms of their skill in using color, line, composition, and expression.

Recent Formalist theory is largely indebted to Clement Greenberg. As Leo Steinberg has pointed out, Greenberg conceives the essence of modernist art to be criticism from inside the discipline of art itself. According to Greenberg:

> The task of self-criticism became to eliminate from the effects of each art any . . . effect that might conceivably be borrowed from . . . any other art. Thereby each art would be rendered "pure." [Modernist pictorial art thus emphasizes] the ineluctable flatness of the support [*i.e.,* the stretched canvas or panel]. Flatness alone was unique and exclusive to that art. (Leo Steinberg, *Other Criteria: Confrontations with Twentieth Century Art*, New York, 1972, p. 67. Steinberg quotes from Greenberg's essay "Modernist Painting" which first appeared in *Art and Literature*, Spring, 1965.)

Thus, the definition of the flatness of painting is right and good. To destroy the flat character of the surface by suggesting areas of deep space or extreme formal exaggeration is wrong and bad. If we applied this standard to the art of the past we would find that artists such as Botticelli, Poussin, Vermeer, Ingres, Cézanne, and Seurat should be considered good, while Signorelli, Michelangelo, Leonardo, Tintoretto, Caravaggio, Courbet, and Van Gogh must be considered bad.

Modernist Formalism also equates quality with this purist attitude. It applies certain rational criteria to works of art, making judgments on the basis that these criteria are self-evidently true. It thus acknowledges the operation of standards of aesthetic value and, by implication, the validity of the role of institutions where *good* art can be exhibited for the edification of the art public.

CONCEPTUALISM

Conceptualism, on the other hand, considers the artist as heir to the philosopher, analogous to the scientist. (Joseph Kossuth's essay "Art After Philosophy," *Studio International,* October, 1969; and reprinted in Ursula Meyer, *Conceptual Art,* New York, 1972) It is the business of the artist to investigate the nature of art by testing all assumptions about it. Art is considered in terms of idea, activity, and knowledge rather than aesthetic form and value. Conceptualism aims to extend the perimeters of art in the area of "knowledge" while opposing the notion of the aesthetic object.

Marcel Duchamp's "Ready-mades" challenged traditional aesthetic art. His intentions were misunderstood by most critics and he

later complained that he threw a *urinoir* into his critics' faces and they now admire its beauty. For Duchamp, art was what he said it was. Donald Judd echoes this by declaring, "If someone calls it art, it's art." In brief, Conceptualism is dedicated to the notion that it is the business of art to define itself by presenting new concepts about its nature.

Conceptualism is particularly dedicated to the following ideas: (1) art is not manifested in aesthetic art objects; (2) objects should not be created for the purpose of providing satisfactory aesthetic experience; (3) no object should depend on an art context (museums, galleries, books, etc.) to provide a relevant ambience; (4) artists should be unconcerned about an audience; (5) they should avoid traditional forms of art and invent new means of communication (often using verbal language to formulate ideas not concerned with aesthetic propositions); and (6) the sole purpose of art is to define itself.

The essential nature of Conceptualist art, therefore, is the process of self-definition. Art propositions, whether given any kind of material representation or not, are tautologies in that they express only themselves as they define art. Implicit in such a position is the notion that value refers to *ideas* about art, not to art objects. The value of Braque's *The Portuguese*, according to Conceptualism, would not be in its aesthetic form or expression, but in its role as an historical curiosity. The Conceptualist argument is that such a painting has precisely the same kind of value that the *Santa Maria* or Galileo's telescope might have. An art museum, therefore, is simply a record of art defining itself; it provides information, not aesthetic pleasure!

Conceptualism thus poses a challenge to the entire art complex of dealers, collectors, critics, and museums. The history of art becomes a history of art ideas, not of aesthetic masterpieces. Artists become their own critics defining the intentions of their own work and thus render interpretation and evaluation by others superfluous. Since the essential nature of art is the artist's concept, there are no more collectable objects for delectation, and the art dealer, collector, and museum (as a storehouse for aesthetic masterworks) no longer have a function. The role of the artist parallels that of the scientist, and his investigations must be supported by enlightened patronage rather than the sale of objects.

This ideal is based on the premise of a society in which people

other than artists are concerned about the nature and definition of art. What actually exists, however, is a pragmatic society which supports pure science only because its discoveries ultimately result in such practical objects as hydrogen bombs and refrigerators and that society will support the pure investigation of art only if it results in objects which can be used.

Formalism, Conceptualism, and the Idea of Aesthetic Value

Formalist art and criticism imply a new academic-like structure based on the notion of aesthetic value inherent in a single tradition in the arts. Conceptualism rejects the notion of aesthetic value and replaces it with intellectual activity dedicated to the investigation of the nature of art. Thus, Formalism is relatively absolute concerning aesthetic value while Conceptualism is absolutely relative. Conceptualism cannot deny that some people feel *good* when they experience certain things; but it insists that feeling good is purely subjective and that it makes no sense to ask whether one *should* feel good. Formalism implies that one should feel good when experiencing certain kinds of objects and that if one does not, it is because he is insufficiently informed or insensitive.

THREE ATTITUDES TOWARD AESTHETIC VALUE

Until now, we have been tentatively probing three major considerations about art: form, content, and value. We have suggested that Formalist art and criticism emphasize a certain kind of form in art and credits the objects which manifest it with aesthetic value. Conceptualism, on the contrary, is concerned with content (meaning, idea, conception) and denies aesthetic value except as a purely personal and socially irrelevant experience. Value, however, has traditionally been the central issue in art, just as it has in ethics. These two normative disciplines (Ethics and Aesthetics) ultimately ask the question: Is the work (or the act) good? And if it is, how can we know?

Although there are many variations and combinations of theories, there are but three basic positions underlying all critical expositions concerning value. These can be thought of as three poles around which cluster, more or less closely, critical attitudes. These poles are: 1) Absolutism (value is objective, universal, and is located

in the work of art); 2) Relativism (value is subjective and is located in the individual perceiver); 3) Contextualism (value is relative to biological and psychological satisfactions and can be located in the relationship between the work of art and the perceiver. (Stephen Pepper, *Aesthetic Quality and Principles of Art Appreciation*)

The first of these positions implies an idealistic philosophical attitude. Value has an *a priori* existence and is applied by cognoscenti to measure the aesthetic value quotient of works of art. If a work of art is *good*, it will always be so, no matter what anyone thinks. If humanity itself were to disappear, a good work of art would remain good. Formalist criticism comes as close to absolutism as a predominantly relativistic society will tolerate.

The second position contends, to the contrary, that value lies in the response of the perceiver. "Beauty is in the eye of the beholder" is the extreme relativist's cliché. If one person is moved by Rembrandt's *Jewish Bride*, but another prefers a Norman Rockwell illustration, there is nothing more to be said. Conceptualism prefers to avoid all discussion of value on the basis that values have neither an empirical existence nor are they tautological. Furthermore, the business of art is to objectively investigate and define the nature of art in the spirit of a pre-atomic science that asked no moral questions. It is an ironical paradox that just as science begins to accept the responsibility for moral (*i.e.*, value) judgments, some artists are surrendering that role in the name of the scientific spirit.

The third "pole" is a moderate form of relativism which contends that we are justified in holding certain values to be temporarily stable within given contexts: the broadest and most inclusive being the biological similarities of all human beings. There is a discernible pattern of basic hungers, desires, satisfactions, likes, and dislikes which are common to the nature of all normal human beings. Pleasure is preferred to pain, interesting to boring experience, etc. A more limited context is that of the culture which provides the birthplace for a work of art. This context may be large or small, it may contain many values or few. Cultural values may temporarily condition and modify biological values. One may learn to take pleasure in painful experiences associated with sex, for example, and some people may enjoy boring experiences (*e.g.*, Andy Warhol's film *Sleep*). Cultural values constantly change. Some lose their ability to stimulate enjoyments and satisfactions and are discarded; others are invented or discovered, find an appreciative audience,

and are adopted by society. During the past century, for example, Western culture has adopted values from many exotic cultures such as those from Asia, Africa, Pre-Columbian America, Oceania, etc., thus enormously enlarging its own context of values. Contextualism does not dispute that everyone has a right to like what he likes. However, it contends that art history is a record of man's aesthetic values and that art museums manifest both the changes that have occurred and the relative contextual stability of aesthetic value. With almost no exceptions, the works of art that are highly prized and are relevant to a contemporary audience were also prized and relevant at the time they were created.

Bases of Attitudes toward Aesthetic Value

Absolutism as a system of aesthetic value has traditionally been associated with absolutistic political, social, and religious institutions. Extreme relativism accompanied the decline of such highly structured systems, the development of democracy, *laissez-faire* economics, and romantic individualism. Moreover, the decline in the prestige of traditional institutions accompanied by new knowledge about exotic cultures and previously little known and poorly understood periods of Western history (*e.g.,* the "Dark Ages") led to a new interest in their cultural values. With the establishment of museums specializing in the arts and artifacts of alien cultures and the advent of the general art museum, it became important that works of art be understood, insofar as possible, in terms of the values which obtained within the culture that produced them. Aesthetic contextualism is, therefore, inextricably bound up with the general art museum.

Formalism, Conceptualism, and the Art Museum

There is a well known story about Renoir which is recounted by the art dealer Ambroise Vollard in his book about the artist. Renoir once asked his friend, the statesman Leon Gambetta, for a job as curator of a provincial art museum. Gambetta, who was liberal and sympathetic to his friend's desperate circumstances, nevertheless answered:

> My dear Renoir, you talk as if you had been born yesterday. Ask for a job as professor of Chinese or as inspector of cemeteries—something at least that has

nothing to do with your profession—and I will help you; but if we nominated a
painter as curator of a museum, we would simply be laughed at.

Etienne Gilson who repeats the story in his book, *Painting and*
Reality, adds ". . . rightly so. In a gallery of modern art directed by
Delacroix, there would not have been two Ingres; in a gallery
directed by Ingres, there would not have been a single Delacroix."
Today, Gambetta would have to extend his prohibition to include
many critics and art historians as well as artists. In a museum
directed by Greenberg, for example, there would surely be no
Oldenbergs, no Rauschenbergs, and probably no Picassos after the
twenties.

In a museum directed by Joseph Kossuth or Robert Morris, on
the other hand, there might be no "works of art" at all. The
galleries would probably be used to carry out experiments intended
to define art. Some of these artists protest the sterilizing influence on
themselves of the exhibition of masterpieces from the past, echoing
the complaints of the Futurists and Dadaists of some 60 years ago.
Yet, as Gilson points out, ". . . there is no law compelling anybody
ever to enter an art gallery."

The Formalist position regarding art and criticism is logical and
its relations to past traditions are clear. One may disagree with the
extreme purism of this position but at least one knows the "game"
and the "ground rules." An art museum devoted to formalistic art
would not be a logical absurdity.

Conceptualism, however, aims to change the "game." The inner
logic of Conceptualism leads to the inevitable conclusion that the
very idea of an art museum must be contested, for it is precisely the
business of art museums to preserve works of art held to be
aesthetically valuable; an idea which Conceptualism disdains. Yet
to preserve these works is to preserve man's visions of himself and
his world; in short, to preserve his values. An assemblage of
masterpieces of art thus reveals a more significant history of man
than any record of battles, treaties, or leaders' litanies.

The Creative Act

While the relationships between the artist and society can be
demonstrated to have had a determining influence on art styles, the
creative act itself remains largely personal and subjective. The

creative pictorial artist invents forms, in his own métier, which define significant subjective experience. This is a theory of creativity that can perhaps be best illustrated by the problem of meaning in music. Roger Sessions, for example, declared:

> Emotion is specific, individual and conscious; music goes deeper than this, to the energies which animate our psychic life, and out of these creates a pattern which has an existence, laws, and human significance of its own. It reproduces for us the most intimate essence, the tempo and the energy, of our spiritual being; our tranquillity and our restlessness, our animation and our discouragement, our vitality and our weakness—all, in fact, of the fine shades of dynamic variation of our inner life. It reproduces these far more directly and more specifically than is possible through any other medium of human communication. (Roger Sessions, "The Composer and His Message," in *Intent of the Artist*, edited by Augusto Centeno. Quoted by Brewster Ghiselin in *The Creative Process*, N.Y., 1952, p. 46.)

The creative process as described by Sessions is not limited to music, however, or even to the arts; Albert Einstein described a similar process. To a question put to him by the French mathematician, Jacques Haddamard, Einstein answered:

> The words or the language, as they are written or spoken, do not seem to play any role in my mechanism of thought. The psychical entities which seem to serve as elements in thought are certain signs and more or less clear images which can be "voluntarily" reproduced and combined.
>
> There is, of course, a certain connection between those elements and relevant logical concepts. It is also clear that the desire to arrive finally at logically connected concepts is the emotional basis of this rather vague play with the above mentioned elements. But taken from a psychological viewpoint, this combinatory play seems to be the essential feature in productive thought—before there is any connection with logical construction in words or other kinds of signs which can be communicated to others. The above mentioned elements are, in my case, of visual and some of muscular type. Conventional words or other signs have to be sought for laboriously only in a secondary stage, when the mentioned associative play is sufficiently established and can be reproduced at will. (Albert Einstein, "Letter to Jacques Haddamard," in *The Psychology of Invention in the Mathematical Field*)

Thus, the theory of creativity as proposed here does not deal with simple emotions; it encompasses the full range of subjective experience, including concepts, feelings, moods, emotions, and experiences that are amorphous until they are appropriately formulated. It includes creative science as well as philosophy and the arts; it can accommodate Mondrian and Rothko as well as Kirchner and de Kooning. It is based on the notion that creative

artists invent images referring to their subjective experiences of the world; that these are adopted by other human beings and condition the ways in which they, in turn, experience the world. Anthropological evidence indicates that primitive man regarded primeval nature as alien and filled with dangers. Later, painters and poets conceived the idea of romantic nature and this idea, in turn, has become an integral part of human experience. The Alps, or the American wilderness, to take just two examples, were until recently, alien and unexplored territory. When they became subject matter for writers and painters they acquired a romantic character cherished in Western culture. Even the experience of romantic love, unknown to many societies, is largely the invention of the troubadours of Provence during the eleventh, twelfth, and thirteenth centuries who transformed rude and lusty pagan tales, such as the adventures of a legendary chieftain called Arthur and his henchmen, into chivalrous tales of love and adventure. Thus, creative artists have contributed largely to the ways in which we view the world and the values that we experience. The visible, material articulation of many of those values is to be found precisely in art museums.

The Theoretical Bases of Conceptualism

What then is the theoretical basis of Conceptualism which disdains physical objects mainly concerned with aesthetic form and value? Conceptualist art is indebted to Logical Positivism, Linguistic Analytic philosophy, and to the theories of Ludwig Wittgenstein who influenced both movements. Since Wittgenstein's philosophical career is divided into two distinct parts, it might be well to summarize them. They shed light on the notions of Conceptualism, but perhaps it can be demonstrated that they can also accommodate the ideas of aesthetic value, form, and the theory of creativity summarized above. It is interesting, perhaps significant, that the linguistic philosophers most often referred to by the Conceptualists are Wittgenstein, the Logical Positivists, and the members of the Oxford School. American linguistic philosophers such as Noam Chomsky and Leonard Bloomfield are largely ignored, although American linguistic philosophy is surely the most advanced in the world today. Perhaps this is why there has been "no feed-back on

and are adopted by society. During the past century, for example, Western culture has adopted values from many exotic cultures such as those from Asia, Africa, Pre-Columbian America, Oceania, etc., thus enormously enlarging its own context of values. Contextualism does not dispute that everyone has a right to like what he likes. However, it contends that art history is a record of man's aesthetic values and that art museums manifest both the changes that have occurred and the relative contextual stability of aesthetic value. With almost no exceptions, the works of art that are highly prized and are relevant to a contemporary audience were also prized and relevant at the time they were created.

Bases of Attitudes toward Aesthetic Value

Absolutism as a system of aesthetic value has traditionally been associated with absolutistic political, social, and religious institutions. Extreme relativism accompanied the decline of such highly structured systems, the development of democracy, *laissez-faire* economics, and romantic individualism. Moreover, the decline in the prestige of traditional institutions accompanied by new knowledge about exotic cultures and previously little known and poorly understood periods of Western history (*e.g.,* the "Dark Ages") led to a new interest in their cultural values. With the establishment of museums specializing in the arts and artifacts of alien cultures and the advent of the general art museum, it became important that works of art be understood, insofar as possible, in terms of the values which obtained within the culture that produced them. Aesthetic contextualism is, therefore, inextricably bound up with the general art museum.

Formalism, Conceptualism, and the Art Museum

There is a well known story about Renoir which is recounted by the art dealer Ambroise Vollard in his book about the artist. Renoir once asked his friend, the statesman Leon Gambetta, for a job as curator of a provincial art museum. Gambetta, who was liberal and sympathetic to his friend's desperate circumstances, nevertheless answered:

My dear Renoir, you talk as if you had been born yesterday. Ask for a job as professor of Chinese or as inspector of cemeteries—something at least that has

nothing to do with your profession—and I will help you; but if we nominated a
painter as curator of a museum, we would simply be laughed at.

Etienne Gilson who repeats the story in his book, *Painting and
Reality*, adds ". . . rightly so. In a gallery of modern art directed by
Delacroix, there would not have been two Ingres; in a gallery
directed by Ingres, there would not have been a single Delacroix."
Today, Gambetta would have to extend his prohibition to include
many critics and art historians as well as artists. In a museum
directed by Greenberg, for example, there would surely be no
Oldenbergs, no Rauschenbergs, and probably no Picassos after the
twenties.

In a museum directed by Joseph Kossuth or Robert Morris, on
the other hand, there might be no "works of art" at all. The
galleries would probably be used to carry out experiments intended
to define art. Some of these artists protest the sterilizing influence on
themselves of the exhibition of masterpieces from the past, echoing
the complaints of the Futurists and Dadaists of some 60 years ago.
Yet, as Gilson points out, ". . . there is no law compelling anybody
ever to enter an art gallery."

The Formalist position regarding art and criticism is logical and
its relations to past traditions are clear. One may disagree with the
extreme purism of this position but at least one knows the "game"
and the "ground rules." An art museum devoted to formalistic art
would not be a logical absurdity.

Conceptualism, however, aims to change the "game." The inner
logic of Conceptualism leads to the inevitable conclusion that the
very idea of an art museum must be contested, for it is precisely the
business of art museums to preserve works of art held to be
aesthetically valuable; an idea which Conceptualism disdains. Yet
to preserve these works is to preserve man's visions of himself and
his world; in short, to preserve his values. An assemblage of
masterpieces of art thus reveals a more significant history of man
than any record of battles, treaties, or leaders' litanies.

The Creative Act

While the relationships between the artist and society can be
demonstrated to have had a determining influence on art styles, the
creative act itself remains largely personal and subjective. The

the Art-Language group from the linguistic philosophers they emulate" (L. Lippard, *Six Years: The Dematerialization of the Art Object*, p. 263).

LUDWIG WITTGENSTEIN: "TRACTATUS LOGICO-PHILOSOPHICUS"

Wittgenstein's first important philosophical work, *Tractatus Logico-Philosophicus*, published in 1922, influenced the Vienna Circle of Logical Positivists (Moritz Schlick, Rudolph Carnap, Otto Neurath, A. J. Ayer, others). In the *Tractatus*, Wittgenstein argues that language pictures facts by combining words (names of *things*) in propositions which have the same logical form as reality. Because of this correspondence, he held, the limits of language coincide exactly with the limits of the world. According to this view, there is only one language since what we call "languages" are all made up of words which name *things* and other kinds of words which refer to the *relations* of things. And since language establishes the limits of what can be said or thought, it must also establish the limits of *what can be said* to exist. Therefore, logical propositions, like mathematical propositions, are tautologies. Wittgenstein insisted that it is absurd to speculate about the universe as a whole; however, he acknowledged that there is something beyond "facts" (whatever language can logically refer to) which is associated with "feeling" and which can be revealed but not put into words. This he referred to as "mystical." It is foolish, he contended, to try to say anything about the "mystical" since it is, by definition, that which cannot be said. Words can picture things and processes but they cannot be employed to deal with values which have no objective existence in the world. Logical Positivism elaborated on the *Tractatus* by admitting only the logically, mathematically or empirically *verifiable*, and by denying the "mystical" altogether.

LUDWIG WITTGENSTEIN: "PHILOSOPHICAL INVESTIGATIONS"

Wittgenstein later came to question the major premises of the *Tractatus* and then to revise them after an Italian colleague made a gesture with his hand, used by Neapolitans to express contempt, and asked what its logical structure was.

Following this revelation, Wittgenstein reversed his earlier beliefs. The logical structure of verbal propositions cannot picture a logical structure of facts if such a structure does not exist. And if

propositions do not refer to a logical structure of facts, what happens to the notion of language as a picture of reality? Briefly, Wittgenstein's answer was that language is like a tool with a variety of uses. A word is not simply a name, the meaning of which is the object to which it refers; instead its meaning is *how* it is used in the language. He also came to accept the Logical Positivists' notion of a plurality of languages. He used the simile of "language games" and suggested that they express a people's way of life.

According to this later view, Wittgenstein held that languages have no one thing in common and, therefore, language *cannot* be defined. There is, however, a "complicated network of similarities overlapping and crisscrossing: sometimes similarities of detail." They have what he called certain "family resemblances." In the same way, games have no single common element, yet they also form a "family." According to the *Tractatus*, a proposition could be shown to be correct or incorrect, while in Wittgenstein's later view, it can only be understood or not understood. Thus, the solution to a problem is to be sought through insight into the function of propositions and by understanding the language game which is its context.

"Inner Events"—Finally, Wittgenstein defined a certain class of words as referring to "inner" events or sensations. These are different in kind from the experiences we have of the sensory world—the world of trees and tables and dogs. Some of these words refer to sensations such as pain, pleasure, a burning sensation, etc. They cannot be demonstrated empirically, yet they cannot be doubted. If someone says he has a stabbing pain in his chest, it would clearly be absurd to suggest that he check and be sure it is not a tickling sensation instead. Such assertions do not refer to empirical facts, they are *a part of the behavior relevant to the "inner" event itself*. A statement about pain, therefore, is simply a substitute for the primitive cry of pain.

Linguistic Analysis and Value

Wittgenstein's later work was strongly influential on the development of Linguistic Analysis at Oxford and Cambridge. J. O. Urmson, an Oxford philosopher, wrote a paper titled "On Grading" in 1950, which has significance for the question of evaluating

works of art. Urmson suggested that grading is one sort of activity, describing is another, and expressing one's feelings yet another. Grading is based on objective criteria and, therefore, "more important and impressive than mere indications of likes and dislikes." (Justus Hartnack, *Wittgenstein and Modern Philosophy* [translated by Maurice Cranston]) One can understand the logic of a statement such as: "This is a good apple, and it has a certain amount of nutritional value, but I don't like apples." However to say, "This is a good rose" is simply an expression of one's feelings and has no other significance. The Conceptualists adopted this position and, in consequence, have given up considerations of aesthetic value. Instead, they have developed "idea games," and various methods for dealing with material facts in ways which are intended to more fully define art. According to this view, there is no valid basis for the proposition: "Rembrandt is a better artist than Norman Rockwell." The only valid statement that can be made is, "I like Rembrandt better than I like Rockwell."

Content in Works of Pictorial Art

Using Wittgenstein's own simile of "language games," it appears obvious that human beings have invented the "game" of pictorial art which has its own formal means of expression and communication. Even the most formal work provides insight into the artist's inner sensations. The theoretical key to this view can be located in Wittgenstein's notion of "inner" or "private" events. According to this view, as discussed above, expressions such as, "I have a pain" are part of the pain behavior itself. Therefore, if the formal elements of art and their interrelations are considered as the structure of a visual means of expression which can convey content—based on the common associations of these elements and on the notion of empathy (Thomas Munro, *The Arts and Their Interrelations* and Wilhelm Worringer, *Empathy*)—then the form of a work of art is also part of the behavior of the artist's inner sensation itself. Thus, a pictorial work of art *reveals* subjective experience by articulating it in a pre-verbal form. If it cannot be articulated in logical sentences, it can be felt, expressed, and communicated by the artist in his own "visual language." The informed and sensitive perceiver, of course, does not *feel* the same sensation as the artist

(just as the physician does not *feel* the same pain as his patient), rather, through *information* provided by the form of the work of art, he gains insight to it.

Such "inner" experiences, sensations, or events are precisely what Wittgenstein referred to in his notion of the "mystical" as an area of experience which can be felt but which is ineffable. Creative people in every field have referred to the subtle yet acute dynamics of our inner life. They have recognized the *relatively* limited power of words to express the infinitely varied and nuanced shades of such subjective experience. And they have described the creative process as the struggle to find—or invent—the means to most poignantly express such feelings or events thereby providing knowledge about them.

Thus, creativity involves the articulation, in an appropriate form, of "inner" feelings, experiences, or events. Further, communication of content and value includes the complement of creative activity: sensitive and informed perception. Neither content nor aesthetic value, are located entirely in the inner experiences of the artist, in the work of art, or in the experience of the perceiver. The work of art, as the appropriate visual form of the artist's inner experience, provides insight to the import of that experience for the perceiver. Aesthetic value is located in the relationship between the work of art and the perceiver.

The Art Museum and Contextualism

The art museum provides an appropriate environment for experiencing works of art. It can organize aesthetic objects in ways which will provide the possibility for an audience to experience the values that man has invented to give shape, form, and meaning to his life. Above all, it *can* be what a Japanese art lover is said to have called a museum that he built: ". . . a Pavilion of the Pure Pleasure of Art." (E. Gilson, *op. cit.*, p. 233)

Summary

Formalist thought concerning the arts apparently accepts the idea of aesthetic value as inherent in a particular stylistic tradition.

But art museums demonstrate precisely that value cuts across all traditions in the arts.

Conceptualism has tried to turn our attention from the questions of form and value to those of ideas in art and the idea of art. Yet, art museums also provide incontestable evidence that works of art from all cultures can provide aesthetic satisfactions for perceivers sensitive to pictorial form, as well as provide insight to the nature of the artist's "subjective experience."

In the past, the mechanics of patronage and the art market assured a period of time sufficient to acquire a perspective allowing one to see a work of art within a relevant context and to develop an opinion about its relative quality. Today, the art market operates in such a way that, more often than not, it is difficult to distinguish important and serious art in the show-and-sell business atmosphere surrounding it. When an art museum engages in speculation with highly innovative art works which it does not yet comprehend or appreciate, it becomes part of the mechanics of the art market, influencing it as well as being influenced by it. (Ironically, this is precisely the case with Conceptualism, despite the fact that the artists deliberately set out to do things which could *not* become part of the art market and *not* be collected by museums.)

The general art museum is a physical manifestation of philosophical contextualism insofar as aesthetic value is concerned. And more than ever, it is morally incumbent upon the museum to make certain that it has a period of time sufficient to gain perspective on new forms of art. What history once imposed (time to reflect and compare) curators must now achieve by an act of will.

Above all, critics and curators should not conceive their role as that of a judge making pronouncements about works of art by measuring them against an *a priori* set of standards. Instead, they should simply respond to works of art from a base of wide experience and then ask themselves *why* they respond in such a way (not *should* they respond in such a way). Finally, art criticism and education must not conceive their roles to consist in explaining works of art. Instead, their function should be to prepare human beings to sympathetically receive the signals of visual form ultimately enabling them to "read" the work for themselves.

 E. B. H.

III

The Community of Art and Science

The positions, problems, and conflicts we have indicated as part of the situation of art and art museums today are only too transparently familiar to philosophers and historians of modern thought. In addition to the perennial arguments about ends and means, thought and action, idealism and pragmatism, the modern historian can readily summon up, among others, the conflicts of liberal reform and political conservatism, of intellectual and know-nothing—or of science and technology.

To the true scientist our concern comes as no new thing. The connections and congruencies between the creative acts of science and art have already been proposed. The necessity for defense of this creativity and for its preservation as history has become increasingly apparent in both the scientific and artistic communities. Utilitarian, mystical and pseudohumanist derogation of science and rationality has increased to the point of broad public interest and discussion—not coincidentally since 1945. Fundamentally, the debate is still a part of the ancient conflict expressed in the figures of Apollo and Dionysus. What is relatively new is the apparent recognition by devotees of both science and art that their aims and processes are headed by the same rubric and that what they defend is indeed a tradition in which their stakes are equal.

To read some of the essays in the Summer, 1974, issue of *Daedalus* is to recognize the congruency of art and science in the most meaningful contexts—their concern for creativity, the individual, and freedom of inquiry. And the sciences reach out to embrace art—not on the crude technological grounds of common applied techniques—but on the firmer foundation of motivation and ends. Thus Edward Shils'—"The human race did not take up science lightly a half a millennium ago. It had been preparing for at least two millennia. It was making no mistake, any more than it was when it took up religion or art." ("Faith, Utility and Legitimacy of Science," *ibid.*, p. 14)

This is not to confuse some fundamental differences in the *results* of the two—each being both an art and a science. It should be a commonplace that if the achievements of science as "truth" are

cumulative, the history of the acts of scientific creativity is not. Equally the history of art is not cumulative in the quality or meaningfulness of the images created by artists, but it is cumulative in terms of the information and techniques available to creativity. How else could we have had Malraux's "Museum Without Walls"?

What is essential to science and art is integrity, a word imbedded with other essentials—truth, freedom, independence, quality, originality, criticism, and many more. Without this being embodied in the artist, his work and the institutions designed to preserve and transmit these achievements, the human capacity for civility will almost surely wither. As many of the scientists and their historians now see, the contest is for civilization itself and the winning requires a concerted effort by a community of intellectuals.

> . . . the analysis of creativity in all its forms is beyond the competence of any one accepted discipline. It requires a consortium of the talents: psychologists, biologists, philosophers, computer scientists, artists, and poets would all expect to have their say. That "creativity" is beyond analysis is a romantic illusion we must now outgrow. (P. B. Medawar, *Induction and Intuition*, Philadelphia, 1969, p. 46 [quoted in G. Holton, "On Being Caught Between Dionysians and Apollonians," *ibid.*, p. 77])

Even more than science art, especially historic art, and more especially its container the museum, is placed in an ambiguous position in the midst of the struggle. The work of art is an essential part of many non-artistic studies and activities. It is a document of history; it can be a religious image; it may be important for the history of technology; it can have immense anthropological importance; it can support the study of literature. Great scholars like Burckhardt, Riegl, Panofsky, and Gombrich have immeasurably deepened and broadened human knowledge in general by the study of individual works of art or of accumulations of them. The art museum houses invaluable grist for many mills and so is by necessity pulled in many directions. But it would ill serve its various uses if it became, like applied science, only useful. The art museum may well be one of the many contexts of art but it is defined as context by the art it holds. Should it lose that and the integrity it must have to preserve its core, it may well become an abandoned quarry rather than a marble mausoleum.

S. E. L.

Joshua C. Taylor

2

The Art Museum
in the United States

From the beginning, art museums in the United States have come into being in response to somewhat different motives and with differently stated goals than many traditional art museums abroad. Originally there were no princely collections, grandly housed, to be filtered gradually into the public domain as in Europe. Collections tended to grow to fill the mission of the conscientiously established museum. Rather than the creation of a single munificent patron, the first museums were formed by associations organized to promote learning and to provide a cultural base in a society largely cut off from established European institutions. The late eighteenth century was a time for the creation of learned societies in the arts and sciences, in Europe as well as in the Americas, but the United States was in a far better situation for keeping abreast of scientific learning than it was in art. With the flora and fauna of a new continent to be investigated, the pursuit of natural philosophy was an important undertaking with significance also for European colleagues.

But there was no comparable environment in art to be explored. Although this was also the period in which serious studies in the history of art began in Europe and collections were being looked at

JOSHUA C. TAYLOR, *Director of the National Collection of Fine Arts, Smithsonian Institution, has since 1949 been Professor of Art and Humanities at the University of Chicago. Author of numerous books and articles on art and art education, including* William Page *and* Learning to Look, *Dr. Taylor has also served as director of a number of art associations and is a Benjamin Franklin Fellow of The Royal Society of Art.*

with a new analytical eye, there was little the American amateur could do in the field but read books and tour Europe. Some connoisseurs, such as Thomas Jefferson, attempted to implant traditional aesthetic imagery through architecture, and in the early years of the Republic a referencial style was adopted to give the substance of tradition to a new and untried state. Such sculpture as existed also self-consciously made reference to styles and imagery of the past. But in painting especially the visual continuity with the past, unlike the verbal continuity sustained in literature, was even for the educated public a tenuous matter.

Responding to the popular theory that great art was based on antique sculpture, advantage was taken of Napoleon's gathering of masterpieces in Paris to bring excellent collections of casts from the antique to the United States (in New York 1803, in Philadelphia 1807). But the shock with which their nudity was met by the public indicates how far apart the European and American environments were.

However, Benjamin Latrobe in 1807 emphasized in his oration at the dedication of the Pennsylvania Academy building that art was an indispensable element in a democracy, and similar thoughts were reiterated by speakers on every possible occasion for many years to come. Art provided a healthful recreation for the growing democratic leisure, and marked as well the cultural character of the time for posterity. Because of its art, Athens, not Sparta, said Latrobe, survives as a precious treasure of all times. There was thus a double aim in the concern for art. The first was to create art that would bring lustre to the nation, springing from the free atmosphere of the new political state. And of equal importance was the necessity of providing a repertory of great works of art to elevate the public taste. The art academy which served to aid artists and point them in the right direction and the public display of works of art were from the beginning united, and it is significant that when serious museums were organized much later in the century they usually were associated with an art school. This duality of purpose, to provide education through the eyes or creative activity for the hands, is important to remember, because in somewhat different guise it still presents itself as a problem to the American art museum. Built into the structure from the beginning also was the question of whether such an institution owed its primary obligation to the viewing public or to the local creating artist.

Exhibitions of Art

The earliest displays of art in the United States showed a generous attitude toward the material: they included works by local artists, prints and paintings purchased abroad by self-conscious amateurs, and designs of a practical nature. Art and ingenuity were rarely distinguished from one another. Occasionally whole private collections were shown, but in spite of many well-intentioned efforts no permanent exhibition facility for art was successful with the public. Although at times for temporary exhibitions an effort was made to create an elegant setting, art had no permanent temple until after the middle of the nineteenth century. Nor was there much art installed in public places. Except for portraits of statesmen and politicians, public buildings exhibited little that would create a sense of the artistic, and churches were, for the most part, aesthetically austere. So the chance to be surrounded by works of art was afforded only by annual exhibitions of art associations or sales—as in the Art Union galleries. In the United States, throughout much of the nineteenth century, art had no visual environment of its own.

The concept of museums stirred early in the American consciousness but the muse was more regularly history than art. "Athenaeum" was the preferred term, applying to the pursuit of knowledge in all fields, and knowledge meant information, knowing about. Collecting was, in a sense, the physical manifestation of knowledge: to own was to know. Art was not left out. The Boston Athenaeum, founded in 1807, early began to collect and to show art, and the Wadsworth Athenaeum opened its galleries built to display art in 1844. Amongst the cases of patent models in the elegant galleries of the Patent Office in Washington, begun in 1836, paintings and sculpture belonging to the National Institute were displayed along with whale bones and Indian relics, and when James Renwick designed the original Smithsonian building in 1847, space was designated as an art gallery—although it was never used solely for that.

The Museum of Art

It would make for simpler history to suggest that the art museum came about as a natural outgrowth of this general, unified interest in collecting—the "athenaeum" approach to knowledge—but such is not strictly the case. The concept of an art museum, as such, in a way ran counter to the idea of a collection representing universal knowledge. Although works of art continued to take their place as examples of culture or of historical facts and faces, art was beginning to take on connotations not consistent with the detached viewing afforded by a science museum. In the separation that followed, largely in the 1870s, the art of some cultures remained with the history and science museum, while the art of others that best served the Western tradition of art became a part of the new entity, the art museum. Works from early Mediterranean cultures counted as art; works from other areas including pre-conquest America and, initially, Japan, were ethnic artifacts. The division was critical for American museums, and its persistence has been a source of some critical embarrassment in recent years.

When the art museum finally appeared in the United States, it was only in small part related to the long existent tradition of miscellaneous collecting. It sprang instead from a new consciousness of artistic values, from the thesis that accepted works of art are not simply collectible curiosities or cultural artifacts, but have a moral and aesthetic existence of their own. Although this concept of art had long become a public cliché, it had prompted little action outside a limited circle of artists and patrons. In the 1870s, when several major museums of art were formed (the Metropolitan in New York, 1870; the Museum of Fine Arts, Boston, 1870; Philadelphia Museum of Art, 1876; Art Institute of Chicago, 1879), the fine arts were deliberately separated from manufacturing, the quantitative collecting of objects, and the pursuit of cultural history in general. Art now was accepted as having its own history and as demanding its own special range of sensibilities. It required therefore its own place, a physical representation of its intellectual habitat, so that it could maintain its stature in the mercantile world. Crowning the façade of the building James Renwick built for W. W. Corcoran's gallery in Washington (begun in 1859, and

opened in 1869) was the motto "Dedicated to Art." The word "art" was now unambiguous. It was no longer to be confused with other pursuits; art was no more a cultural curiosity, but the means for a special, life-enhancing experience.

The art museum as a separate phenomenon was the product of a gradually developed attitude toward art, reflected also in other institutions. One such manifestation was instruction in art for other than the artist. Although from the beginning of the nineteenth century drawing was looked upon by some as an essential part of elementary education, instruction had little to do with works of art. The education of the coordinated hand and eye was a means of disciplining the mind. Only after mid-century did a study of art begin to work its way into university education as a respectable field, taking first the form of a kind of Ruskinian appreciation and eventually a somewhat systematic historical structure. The contemporary artist was not ignored, but the primary study was of art from the past. Histories of art had begun to appear early in the century—Lanzi, Kugler, Ruhmor and now the ideas of Ruskin and Taine, in their very different ways, opened up further prospects of scholarly immersion in past art. One could talk of styles and developments and of national differences in artistic expression. But for these to be appreciated a new sensibility had to be developed, and a missionary goal for winning new citizens for the world of art swept intellectual circles in the late 1860s and 70s. Although a moral purpose tacitly underlay the campaign for art, it was not stated in the bold didactic terms of Latrobe. Art was in itself rewarding and some would eventually maintain that it was its own sole reward. The art museum when it finally took form was not to be a compendium of all knowledge but be in itself a world apart. As Rome had been a haven earlier in the century for artists and amateurs, the art museum was to be a special precinct in which artistic values took precedence over any other.

MUSEUM BUILDINGS

In creating this artistic precinct, the tendency was to construct a building that itself embodied Ruskin's quality of memory, one of the most appealing "lamps" in his *Seven Lamps of Architecture*. Not only must the building speak of the moral nature of its own society, through its materials and workmanship, it must also summon

cultural support from the past. For the most part, art galleries (and libraries) found their voice in a Venetian Gothic style, quite in contrast to earlier buildings of cultural purpose which drew their dignity and importance from a Greco-Roman reference. The change is worth noting. In its allotting of styles to ideologies, the art world had come to associate rationality with the classical style and emotion with the Gothic; philosophy was personified by an elder Greek; art—or at least Christian art—was depicted as a winsome female shown in the manner of Raphael or early Titian. Art was not argument but persuasion, and the new-old architecture of Ruskinian Gothic seemed just right. Renwick's art gallery in the Smithsonian building of 1847 was designed as a Gothic chapel; Peter B. Wight, a confirmed Ruskinian, designed a Venetian palace for the National Academy in New York, 1865; and the first Boston museum building by Sturgis and Brigham, opened 1876, was in the Gothic manner.

Corcoran's original gallery in Washington was a notable exception: it was designed in 1859 in what became known as the "new Louvre" style. As in most such buildings, the major exhibition gallery was on the second floor, reached by a grand flight of stairs. This permitted the gallery to be lit by a skylight, and also created an impressive ceremonial approach to the works of art. For many years the grand stairway, totally useless for exhibition purposes, was an indispensable feature of museum design as if the ceremony of going to look at the works was as important as seeing the works themselves. Around the frieze of Corcoran's grand gallery where most of the paintings were hung appeared the names of famous artists past and present, and the sculptured likenesses of a chosen few were placed in niches on the outside. This custom was repeated as a feature of art museums for many years and provides a useful index of how the museum organizers saw their time in relation to the past. In a sense, this was one of the major functions of the museum: to prove the unity of great creative minds throughout time and to provide an elevated colloquy between the past and the present. If museums were conservative it is not surprising; that is what they were created to be.

THE COLLECTOR

To pretend that art museums sprang up simply as a response to a

public desire for a special place for art would be to overlook a major factor. Two kinds of people, newly arrived on the scene, were needed. The first was the enlightened private collector. The collecting of works of art in the United States had expanded tremendously through the first three-quarters of the nineteenth century. Not only were there many more collectors as the century progressed, but the quality of collections was also vastly improved. Major collectors no longer fit the earlier stereotype of the gullible American who bought anything that looked old as a masterpiece. Systematic scholarship in art had brought about a major change in both buying and selling. The admonitions of Morelli on connoisseurship, holding that the general assignment of authorship to "old masters" must be replaced by a meticulous system of attribution, did not long go unheeded. Following a system that had long existed in Europe, collectors began to depend on advice from newly trained experts in artistic matters, sometimes a dealer, often an artist of historical bent, and more and more frequently a scholar who devoted his full time to the study of art. The enlightened collector and the expert in art worked together to build a collection that met a standard beyond just personal taste. These men and the collections they built were the foundation of the major art museums in America.

However, the growth of art museums was not limited to a few affluent institutions. The same kind of zeal that brought the organizers of the Metropolitan Museum together animated groups throughout the country. The classical pattern underlying the creation of art museums in the United States begins with a group of devoted enthusiasts, not with a collection. An art association, often a mixture of artists and amateurs, has usually been the first step. Many times art classes and temporary exhibitions of borrowed works and works of local artists were offered. The rationale of the associations has almost always been couched in educational terms, with a wide public seen as the association's audience. From the 1870s through the 1890s art associations were formed throughout the country, with particular activity in the Middle West. For example, as the result of a temporary exhibition held in 1883 a group organized in Detroit in 1885 to found a museum. By 1888 the museum was opened to the public. In 1919 the museum, now the Detroit Institute of Arts, became a joint effort of the city and the founding society. The Cincinnati Art Museum was founded in 1881

by a private organization. The Art Association of Indianapolis was founded in 1883. The Portland (Oregon) Art Association was founded in 1892 and opened a school and galleries to found the Portland Art Museum.

In some instances major collectors were members of the initial boards and committed parts or the whole of their collections to the institution. Just as often the associations wooed collectors to strengthen the fabric they had begun. But certainly the establishment of associations and museums stimulated collecting and often helped in maintaining quality. Whether instrumental in founding the institution or not, the private collector, with his advisors and dealers, was a major force in shaping the nature of most museums. As a donor and member of the board, his attitude toward collecting and general taste in art had a major impact on acquisitions and museum activity. The professionally trained museum director came only slowly into the picture.

This historical situation has continuing importance. While in Europe, at least on the continent, the museum director has traditionally been a professional scholar judged by his peers and often appointed by the state, in America he has served usually as an instrument of a local organizing committee or board.

THE NEW MUSEUM

In 1876, the Centennial Exhibition in Philadelphia included a separate building for art, designed by Schwartzman specifically for the purpose. The rather flamboyant form of its academically Renaissance architecture might be called a kind of celebration style; it ushered in a new pomposity in contrast to the studied dimness of the Gothic mode. Art was to be celebrated, and with it the people who collected it. For the next fifty years art museums would resemble noble palaces, usually in a kind of seventeenth century classical style with a heavy French accent. This was the character of the Chicago Art Institute building of 1893, the new Corcoran Gallery of 1896, the Metropolitan Museum, opened to the public in 1902, and the new Bostom Museum, the product of extraordinary study and planning, opened in 1909. Doubtless the architecture of the Columbian Exposition of 1893, largely the product of French academic instruction, had its effect.

The usual plan was a large central foyer with an elaborate open

stairway to the second floor, suitable for elegant public receptions. The galleries were arranged symmetrically on either side of the axis, and rarely was there modification of the plan to accommodate the exhibition of special material. Paintings were hung according to tradition from "the line" to the cornice, with the elaborate frame of each painting desperately trying to shield it from the paintings hung a few inches from its sides. Lighting was by skylight supplemented by a suspended horizontal pipe for gas or, later, a trough for electric lights. First floor galleries often had high windows or none at all to allow adequate wall space, but more usually windows were included to go with the external architecture rather than to provide proper gallery spaces. Since it was assumed that all collections would be shown, little space was provided for systematic storage and the concept of "the museum basement" was introduced by default. Nor was there adaptable space for temporary exhibitions or their preparation. The same gallery space, or at least the same in kind, was used for both permanent and temporary displays.

The building contributed a properly imposing setting for art, "like the Shrine of the Muses whence it takes its name, sacred to the nurture of the imagination" (as the old handbook of the Boston Museum of Fine Arts said), providing art in general its social status. But the actual works of art had often to fend for themselves.

To list the museums built following this monumental plan between the 1890s and the 1920s would be to include almost every major museum in the United States up to that time. The exceptions were for the most part museums that began as private collections— for example, the Gardner Museum (designed in 1896, opened in 1925) or the Frick Collection (built 1913–14, remodeled 1932–35), or were established in pre-existing buildings, such as the original Museum of Modern Art (1929) and the Whitney Museum (1930) in New York. In general, by the early part of the twentieth century there was a well established museum archetype that reflected the elevated concept of art, no matter how small the structure or superficial the reference. It spelled permanence, selectivity, and discreet withdrawal from surrounding urban activity.

As collection grew in size and diversity and as greater historical knowledge informed collecting and the study of art, some changes in presentation were deemed necessary. Possibly the ideas of Hippolyte Taine, so popular late in the nineteenth century, were in

part responsible for the efforts to surround works with an historical environment suggestive of their time and place of origin. Mrs. Isabella Gardner, believing an historical ambiance was necessary for the proper experiencing of transplanted paintings and sculpture, filled her Fenway Court building with gleanings from Europe, sometimes recreating a whole room and sometimes only suggesting the decorative clutter of a hereditary palace. For the historically minded, contemporary trappings made individual works more accessible to those who had never seen the historical places. If one could not very well see the paintings themselves in the historical gloom, he at least had the experience of visiting the past where art, it often must have seemed, exclusively existed.

The shift from a generally aesthetic to an historical environment was not universal, but the effect was significant. For one thing it encouraged the collecting of the decorative arts or what more austere judges called the minor arts. There were two tendencies: one was to suggest simply an "historical" environment—that is, galleries filled rather casually with choice remnants of the past; the other to reconstruct total rooms, usually purchased in their entirety. The most thorough example of this attitude is possibly the Philadelphia Museum of Art, opened in 1928, which was planned to show paintings, sculptures, and decorative arts in contemporary groupings, as often as possible in period rooms. But few museums were content in the period between the wars to regard themselves as complete without at least one period room. As means for widening the context of taste for untraveled people and for preserving works of fine craftsmanship, such reconstructed environments surely have served a useful purpose. As galleries for exhibiting works of art, however, they leave much to be desired since one can rarely get close to anything and never sit down to absorb the atmosphere that is to transport one in time. The visitor is placed in the rather false position of pretending to live in a century not his own in order to see the art, a procedure that runs counter to the opposite principle for showing masterworks: that art knows no epoch but transcends time.

Through the 1920s and 1930s the two views existed side by side, creating occasionally a certain amount of aesthetic and ideological chaos within a museum. The contrast was especially marked in monumental museums which were hardly equipped to accept foreign interiors in their midsts. But by this time the history of art had so detached itself from any other reality that what should have

seemed shocking contrasts usually went unnoticed. The museum had become, indeed, a world unto itself.

It would be tempting to say that art museums in the 1920s were turning back toward general historical museums, but this is not quite true. On one level they were responding to the interests of their sponsoring collectors; on another they were being persuaded by popular theories of historical determinism in art; and on yet another they were accepting the judgment, current through the past generation, that the decorative arts were as worthy of serious consideration as art as were painting and sculpture.

The historical environment as a means for giving formal rationale to expanding collections was only one solution. The concept that each work of art deserved to be seen for itself had no less drastic an effect on museum practice. At the same time that some galleries were being turned into period rooms, others were being starkly simplified. Only those paintings judged to be the very best were shown, and each was presented at eye level with ample space around. The change was gradual, but by the end of the 1920s any museum that still persisted in floor to ceiling hanging was considered backward and unfriendly toward art. It was in the 1920s also that a process of refining collections began, and those objects no longer acceptable as masterpieces were sold off or otherwise disposed of. The term "museum quality" became common, and well it might because over the preceding thirty years the quality of works coming into American public collections, usually through the hands of private collectors, was extraordinary. Not every museum could acquire acknowledged masterpieces—although no one part of the country had the exclusive privilege—but most acted as if they could. Humbler works, usually by American artists, began to disappear from the walls to make way for token samplings of great art. A kind of standard repertory began to develop that would tend eventually to make each secondary museum much like every other.

THE NATIONAL GALLERY OF ART

As a climax to museum activity over the preceding fifty years, in 1937 Andrew Mellon gave his collection and money for a museum in Washington that was to be called the National Gallery of Art. Unlike its predecessor by that name it was to be at each point superlative: in collection, in building, in management. Russell

Pope's building, opened in 1941, was a kind of apotheosis of the American museum image as it had existed since the 1870s. Refined in detail and massive in size, it had its convocation center—this time a rotunda instead of a staircase—vast corridors and lofty galleries. Such a building would confirm as a masterpiece anything shown in its elegant spaces. All galleries on the *piano nobile* were lit by skylights, and garden courts provided relief from too large-scale architecture. When it came to designing the galleries for the original collection, a nice compromise was made between the conflicting theories of period rooms and spacious isolation. Through materials, proportions, and general architectural features, galleries, without ceasing to be galleries, took on a suggestive coloring of the historical and geographical place. Characteristically, no special provisions were made for adapting galleries for temporary exhibitions, nor were any special features included for educational purpose, other than an auditorium. In comparison to earlier museum structures, a relatively larger space was allowed for staff and administrative activity. While the receiving and processing of works was carefully planned, it is noteworthy that at this point a fully equipped conservation laboratory was not considered essential.

THE MUSEUM OF MODERN ART

It is instructive to compare the organization and fabric of the National Gallery with that of a very different museum, erected at the same time, the Museum of Modern Art in New York, opened in 1939. Although conscientiously designed as a museum building, it contradicts in almost every feature established American art museum traditions. In the first place, it is wedged between the crowded buildings on a busy street with no special approach. In fact, the interior is quite visible from the street. There is no grand foyer and all floors are treated with equal emphasis—there is no architectural hierarchy of gallery spaces. Furthermore, it is impossible to predict the plan of the building; galleries differ in size and lead one into another providing a sequence of looking experiences concentrated on the works of art rather than a series of spaces in which works of art are shown. Decorative arts and all aspects of contemporary design were displayed, but as objects in their own right, not to create a period atmosphere. Provision was made from the beginning for changing the size and shape of galleries as the

occasion required. Ceilings were relatively low and artificial light was used almost exclusively.

This manner had been used earlier for temporary exhibitions, but this was the first time in a permanent museum structure. To be sure, the Museum of Modern Art, founded in 1929, was a distinct institution, devoted as it was only to the contemporary. Although it had by 1939 amassed an impressive collection it was meant to be flexible, to be always up to date. From the beginning its goal was largely didactic, in the established American tradition, but its missionary purpose was to expose a wide audience to the farthest reaches of contemporary art, to explain the present to itself, rather than to make a modern audience feel easy with the past. It depended chiefly on temporary thematic exhibitions and skillfully prepared publications which used traditional art historical techniques to justify a theory of continuous change. In consequence, its staff was highly productive and concerned at all points with its relationship to the public. Although the building was, in 1939, a controversial symbol of modernity, the museum was characterized more by activity than by place. It created a new image of what a museum is, and would have a strong impact on postwar America.

The Postwar Art Museum

In the years since World War II, the expanded interest in the visual arts as evident in higher education, publication, and quite spectacularly in the art market, has been reflected as well in the extraordinary growth in number, size, and activity of art museums. Statistics are always vague in the field because definitions change and each of the several surveys of museums has a different way of assembling figures, yet some general points are evident. Walter Pach in his *The Art Museum in America* (1948) listed 106 art museums as worthy of note. Had he included more university museums, serious art centers and out-of-the-way museums he could have added another 100 (although some he did list would not today be counted as museums). The figure should probably be around 200. In a recent survey commissioned by the National Endowment for the Arts, about 340 art museums were listed, not counting those combining art and history (the line distinguishing art from history museums becomes very fine in the area of American art and in

some ethnic areas). A modest estimate would be that in the twenty-five or so years between the two surveys, the number of entities functioning as museums of art increased by at least 70 percent. If one were to include all university museums and art centers, the increase would easily be 100 percent.

But this kind of statistic in no way represents the extent of the expansion of museum activity in art. It is a rare prewar institution which has not increased its facilities, enlarged its programs and taken a totally new look at its relationship to the art community and the community at large. Some of this growth can be judged from the enormous increase in museum income and expenditures, although because of the change in buying power and the complexity of museum accounting, figures here too have to be used with caution. The Belmont Report of 1968 lists sample increases among established museums within the ten year span of 1956/57 to 1966/67 alone ranging from 60 percent to about 150 percent (in one instance about 800 percent). It has been estimated, however, that the increase of cost in the five succeeding years for nine out of ten museums was about 39 percent. Financial pressures, colliding with expansive tendencies, have forced a keen examination of museum programs. Although art museums account for only 14 percent of general museum attendance (something over 43,000,000 out of over 308,000,000 in fiscal 1971/72), they seem, unfortunately, to require more money than history museums and even many comparable science museums. Furthermore, in comparison with history and science museums, many more art museums are sponsored wholly by private organizations, a fact understandable from their history and significant in considering their manner of operation.

If one were to isolate a single element that has most characterized art museum operation since World War II, it would probably be the efforts made by small and large alike at public involvement. This has taken many forms, from the enlargement of departments of education to a greater concern for appealing installations. It has included, moreover, the founding of many participatory activities both outside and inside museums.

A second concern in the postwar period has been conservation, both the restoration of individual works and, more important, the care of the collection as a whole. Each of these new emphases has

had a profound effect on the size and structure of museum staffs and on the building itself.

THE MUSEUM BUILDING

There is hardly an art museum building in America that did not undergo major physical change after 1945. Earlier museums, built for the most part between 1890 and 1935, were usually designed for a relatively static situation. Only the few largest museums had staffs of any complexity and the demands for administrative space were small. In the 1930s, with a great increase in temporary exhibitions and the management demands of increasing collections, space that had been designed for the display of permanent collections had to be adapted for new uses. Galleries were made into offices, libraries, and storage areas, and temporary exhibitions were fitted in wherever possible, often displacing portions of the permanent collection. In the late 1940s the situation became more critical when even smaller museums, which had been run largely by a director and helpers, began to departmentalize. Space had to be provided for growing special collections, such as prints and drawings, and for the added curatorial staff. Provision had also to be made for more public services. If a larger public was to be drawn to the museum—and attendance had begun to increase significantly—lounges, checkrooms, etc., had to be provided. The growth of the museum sales shop is a good example of the effect of new public interest.

The Sales Shop—Except for actively producing museums like the Museum of Modern Art in New York, publications available at the museum were few, usually limited to catalogues for exhibitions, a guide to the collection, and an assortment of postcards, all accommodated at a small stand near the entrance. Beginning in the 1950s, many museums began to stock publications of other museums, as well as trade books. With the growth of the paperback industry to include titles on the arts, the selection grew enormously. By the late 1960s many museum shops were looked upon as the chief source of books on art in the community. Early in the 1960s many shops began to offer gift items more or less related to the museum—jewelry, ceramics, and sculpture reproductions of objects from various museums throughout the world. Wholesalers began to

supply materials especially acquired for museum sales. The character of the items available varied enormously. The museum shop—it could no longer be a simple counter—became one of the most frequented spots in the museum, and its income was soon looked upon as a dependable contribution to the budget. The Christmas season brought crowds looking for cards and gifts. Where, in the traditional museum building was such a facility to be housed? The grand ceremonial lobby of many museums began to take on an air of commerce, and even gallery space often had to give way.

Although art museums in America had always professed an educational goal and many had always maintained a tie with the public schools, increased school population and more ambitious programs began to demand more space, not just for an increased staff but for the wants of large groups of children without disrupting the museum operation. Space had to be found, and again it was usually at the expense of the permanent collection.

Renovation for Public Services—It is not surprising, then, that among the first additions and modifications, beginning in the 1950s, should have been areas for public services of all kinds from restaurants, coatrooms, and auditoriums to separate children's areas, as well as for quarters of the increasing staff. As in Chicago, Detroit, and at the National Gallery in Washington, three examples that span the period, extensions have freed the original structure to return to uses more suited to its initial design, and to provide at the same time for changed museum functions. The metamorphoses followed in the Art Institute of Chicago, whose chief building was opened in 1893, are instructive. The first step, in the mid-1950s, was to eliminate a large two-story area devoted to architectural and sculptural casts. Once a mainstay of many museums, casts were considered by the 1950s to be a space-eating embarrassment. In its place more gallery space was created including a flexible area for temporary exhibitions. A wing was then added (1956) to house offices, receiving and shipping areas, and a conservation laboratory. This freed considerable gallery space, including additional area for the print and drawing department. Beginning in 1961 blocks of galleries were air conditioned. A second wing was then added (1961) which provided a large, high gallery for twentieth century art and a spacious area, neutral in character, that could be refashioned to suit the demands of temporary exhibitions. In the process of change, an area was

opened up for children including a gallery, a library, an auditorium, and an eating area (1964). The restaurant was enlarged, a public lounge was created, and a small lecture room built. The museum store, meanwhile, went through two phases of enlargement, the major checking facilities were expanded, and the library was forced into more compact quarters to provide still more temporary gallery space. In 1974 the print and drawing area was again enlarged and equipped with a climate conditioned storage area and its own conservation laboratory. Further construction was underway in 1974 in the area of the museum school, which would also free additional gallery space.

Although Chicago's aligning of priorities was typical, not all museums could proceed so consistently. Full scale renovation of most museums was slow in coming. In its *Report on Museum Facilities* of 1966, the American Association of Museums stated that the physical plight of American museums was desperate. While money for acquisitions and special exhibitions could be obtained, money for basic renovation of old structures was difficult to come by. Only in the late 1960s and early 1970s, partially with federal help through the National Endowment for the Arts, did it seem that real headway was being made.

New Building Design—The extent of new concepts can possibly be traced best in new buildings created between 1946 and 1974. The older image of the monumental museum with its solemnly displayed permanent collections and ritualistic spaces was by no means forgotten, but it now had to face up to its rival, the museum devoted to public activity and changing display. This concept produced a quite different kind of basic architecture.

Doubtless the most spectacular—and controversial—example was Frank Lloyd Wright's Guggenheim Museum, designed in 1943 and opened in 1959. Here the museum is conceived of as a continuous path along which works of art are to be seen. Unlike the labyrinth common to many temporary shows, the path exists in a comprehensible total space. Although the spectator continually moves he is never lost and can see where he has been and where he is going. The entire area has a single, unifying character that is never lost sight of. So complete, however, was Wright's concern for the passing viewer that he gave little thought to the various demands made by individual works of art, either for their physical

handling or for their need of a special ambiance. All exhibitions had, perforce, to be at home in the same unified atmosphere. Furthermore, so completely was it a spectator museum that inadequate provision was made for storage or handling.

A not dissimilar concept of viewing underlay Gorden Bunshaft's design for the Hirshhorn Museum in Washington, opened in 1974, but the differences tell much of the changes in attitude in the intervening years concerning basic museum necessities. Although the outside curving walls provide a sense of continuous gallery, they are punctuated by dividers and movable partitions. Moreover, the hanging area is separated from the central core, distinguishing the continuous circular passageway looking into the central space from the galleries where one might be surrounded by works of a particular kind. Although the central space is lit by daylight, the painting area has a flexible artificial lighting system.

In a sense the Hirshhorn Museum makes a compromise between a continuous flow plan and a discrete gallery plan. Except for some pieces of sculpture, all works are shown either above or below the ground floor level, and there is no monumental relationship between the floors—a great stairs or a two-story lobby. Emphasis is placed on the gallery areas. On the top floor are offices, a library, and an extensive storage area where works not on display can be studied by scholars. Below ground level are a gallery for temporary exhibitions, an auditorium, coatrooms, restrooms, and the museum shop. On this level also, quite out of public sight, are an extensive receiving dock, registrar offices, conservation laboratory, and large shop and work areas. In accordance with modern practice, more space is allotted for administration, storage, care of the collection, and exhibition preparation than for public display (not counting the sculpture garden, to be sure), and none of these activities impinges on gallery space.

Of course, both the Guggenheim and the Hirshhorn are museums of modern art. For the most part what they display is roughly contemporary with the building it is in. In a sense they are just as much symbolic creations as were the museums in the form of French Renaissance palaces from the turn of the century. That is, they stand for an attitude toward art—in this case its modernity— and ally themselves with distinguishable cultural values. They set the stage for seeing art in a particular way. It would be interesting

to see Italian Renaissance paintings exhibited in the Guggenheim; they would doubtless all seem totally new objects.

Who Makes Decisions?—Although art museum structures after the war took into account in one way or another the new public and professional requirements, they were by no means created primarily from the standpoint of practical use. They had to stand for art. One problem arose in reconciling symbol to use that was never solved: who makes the decisions about what the museum is to be? From the 1930s on, the number of professionally trained art museum directors grew rapidly. A surprising percentage came from the museum program at Harvard. By 1945 there was a large professional group that maintained close contact with one another. A recognition of common professional needs among the expanding number of museum personnel stimulated the American Association of Museums, founded in 1906, to become more active in establishing standards and in representing the profession. A museum accreditation program was begun in 1970 to deal with the ever growing number of museums (it was estimated in 1970 that about 330 new museums—not only art museums—had been founded each year over the preceding five years). The Association of Art Museum Directors was formed in 1916, and grew rapidly in size and activity through the 1960s.

Surveys and reports in the 1960s also made professional museum personnel more conscious of possibilities and needs. But the development of the museum professional with his sympathetic colleagues and his special area of learning produced some problems in the traditional museum structure. In many instances tension developed between the museum staff and its board of trustees. Nowhere is this relationship more severely tested than in a building program.

Since trustees usually raise the money for a building, it is natural that they should wish to choose the architect and determine, at least to a degree, the appearance of the building. In other words, the image of what the museum is has traditionally rested with the board. Where the trustees were content to work in close association with the professional staff to determine what would be in every sense most useful, there has been little problem. But the art museum is a prestige building, a sparkling cultural jewel in the mundane crown of the commercial landscape, and the importance of the

symbolic function of the building can sometimes overwhelm a consideration of its more practical uses. Nor is the special meaning of the building lost on architects; no other type of edifice, including the church, seems to have provoked in these years such creative fantasy as art museums.

Potentially, then, the design of the modern museum has depended on a three-way relationship—board of trustees, professional staff, architect—and the balance can be delicate, especially since each element tends to have a fixed notion about what a museum should be. One museum from the early 1960s makes a magnificent impression with fountains, entrance plaza, and sculpture but has a strangely organized interior because cuts were made for economic reasons without consulting the professional staff. Another building of luxurious design was pushed to completion by a museum board at the expense of the collection and museum activity. The director then had the unhappy task of trying to fit exhibitions into a space that he found physically and aesthetically insufficient.

The Building as Monument—As an architectural monument a museum building can, of course, make an artistic contribution in its own right. The question must be asked, however, whether its impact as architecture will enhance or negate the effect of the works of art to be shown in it. The charge of preempting the artistic expression of the museum was first leveled at Wright's Guggenheim Museum building, but it has recurred often in criticizing museums built in the 1960s and 1970s. Although the postwar architect has been freed from the necessity of historical reference, he may be bound by equally restraining notions. For example, space seen as a dynamic structure, a concept dear to schools of architecture in the 1950s, is not always a useful principle in museum design where, except in a sculpture gallery, the works on the walls, not the space flowing past, should be the source of the artistic experience. There can be a contest for expression between the artists of the works and the architect.

Another problem with the museum as an architectural monument has been the unresponsiveness of the space, physically or aesthetically, to temporary exhibitions not in sympathy with the building's imposing character. It is conceivable that a conscientious museum director might feel compelled to select exhibitions on the basis of what will look well in his galleries.

There have been, to be sure, notable examples of collaboration between skilled architects and museum staffs and boards. In these happy situations, it has become evident that there is no single solution to museum design. Also proved is the fact that a positive museum image need not of necessity be sustained at the expense of the internal operation of the museum itself.

CONSERVATION

In the survey conducted under the auspices of the National Endowment for the Arts in 1972, 33 percent of the museum directors listed conservation facilities as the service most needed. This was in addition to those institutions which already had such facilities, most of which were thought inadequate.

The care and safeguarding of collections, hardly a recognizable separate activity before the war, came in for new scrutiny from the 1940s on. Although scientific procedures in conservation had been developing well before, it was only in the later 1940s that serious attention was paid to analyzing the physical conditions of the individual works and the way they were shown and stored. The development of climate control systems with proper filtering devices now offered possibilities for protecting collections, but the cost of such systems in old buildings with great open foyers and stairways and inadequate electrical wiring was in most cases prohibitive. Ironically many great old collections have remained unprotected in their old buildings, while new buildings for even small collections have been able to provide a stable humidity-temperature relationship throughout their museum and to minimize dirt and pollution. Some older museums began in the 1950s to air condition sections at a time. Because of the insistence of lenders, by the late 1960s most areas for temporary exhibitions were air conditioned even when permanent collections were not. Once considered a luxury, a sophisticated climate control and filtering system became in the short span of some fifteen years an essential aspect of maintenance.

In the late 1940s, most museums sent paintings to be restored to the few private conservators with a reliable reputation. Some museums unfortunately still used local amateurs or depended on an artist member of the staff. By the early 1950s, however, partially in response to the pioneering work of the Fogg Museum, some museums began to take a more comprehensive look at the condition

of their collections. Although the public was chiefly fascinated by the sensational discoveries by conservators of hidden images or revealing signatures, staffs of larger institutions began to concern themselves with more fundamental matters of conservation that could be handled well only by a laboratory in the museum itself. It is worth noting that the term *restorer,* still common in the 1950s, was supplanted by the word *conservator,* attesting to a recognition that restoring the appearance of a work of art to its supposed original condition was only a part of a larger task. By the end of the 1960s it was considered essential for a serious museum either to have its own conservation facility or have access to a respected laboratory. The problem has been to provide a sufficient number of adequately trained conservators, as well as to find space and financial support for the laboratories. One solution has been the setting up of regional centers for conservation serving several supporting museums, a program encouraged by the National Endowment for the Arts. To provide a forum for professional conservators and museum personnel, the International Institute for the Conservation of Historic and Artistic Works was incorporated in London in 1950. The conservators in the United States formed an American chapter, now organized as the American Institute for the Conservation of Historic and Artistic Works.

In larger art museums by 1970 the conservator had become an essential member of the staff, counseling on the handling and display of works, their packing and shipping, and conditions of storage, as well as seeing to the rehabilitation and cleaning of works both old and new.

COLLECTIONS

Museum collections after 1945 gradually took on a somewhat different direction. While notable private collections acquired earlier were given to major public museums in recent years, the direct acquisition of recognized early masterpieces proceeded at a much slower pace. Alarmed at the number of major works that had already left their countries and were being drained off in the postwar period, several European governments created protective systems whereby legal export became more difficult. Quite aside from that, the number of first-rate works by well-known early artists available to the market had sharply diminished since that gilt-edge

age of American collecting at the beginning of the century. As some few private collectors proved, one could still build an impressive collection, but by the mid-1960s market prices for recognized works had begun an extraordinary spiral that removed the possibility of purchase from museums not heavily endowed with purchase funds. As a result, collections began to expand in less conventional directions.

For one thing, less well-known exponents of the schools that made up the standard art historical repertory were found to be more interesting than previously expected. Scholarship supported these interests, since art historical studies had become more diversified. Epochs that had been less popular came in for new emphasis. Early medieval and Byzantine studies, well rooted before the war, flourished afterwards. Mannerist and Baroque painting and sculpture found a new audience. Far Eastern art, once the concern chiefly of a few major museums, became a necessary part of smaller collections as well. Beginning in the later 1940s and 1950s, an impressive number of young scholars entered the field, more rigorously trained from the standpoint of language and culture than many of their predecessors. Although only a limited number of museums as yet have specialized curators of Far Eastern art, the impact of the new studies can be seen in the nature of collections and the knowledge with which they are displayed.

Non-Western Art—Although Far Eastern art had been collected by museums in America for a long while—quite systematically from the 1880s, other areas were relatively new, at least to the art museum. One area has been the large field vaguely labeled "primitive" art. Although it was well known that African and Oceanic art had been regarded with enthusiasm by early twentieth century artists, before the 1940s it found little place in art museums. The large collections were to be found in ethnological departments of science museums—and still are. Particularly beginning in the 1950s, however, African and Oceanic works began to be collected as individual works of art. So expansive did the market become that artisans in many countries worked hard to keep up with the demand, creating their own works, copies, and useful forgeries. Even though many science museums, recognizing the new attraction of their ethnological collections, began to display their extraordinary material with new sensitivity and appeal, art muse-

ums felt the need to have their own representative displays, quite aside from the occasional temporary exhibition. The Museum of Primitive Art in New York opened in 1954, the Museum of African Art in Washington, D.C. was founded in 1964, and throughout the same period art museums from coast to coast began to include primitive art in their permanent presentations.

Art and the Cultural Artifact—This rivalry, in a way, between the ethnological museum and the art museum poses a nice question, which also exists in relationship to archeological collections. At what point does an object become a work of art instead of only a cultural artifact? Obviously the answer does not rest wholly with the object since practically the same object may exist in art and ethnological collections. Doubtless it depends more on the context of viewing: whether the object is seen in such a way that it makes a direct aesthetic statement, or whether it is seen as part of an externally judged cultural content. Archaeologists and anthropologists have accused art museums of wrenching works from their contexts and interfering with the orderly studies of science. Art museum personnel doubt that the others recognize the human value as works of art that these objects possess.

The differences in point of view between those who collect objects as works of art and the scientist concerned with the study of social contexts came to the fore in the late 1960s and early 1970s when the protests of many countries, most forcefully from the Near East and Latin America, that their national cultural heritage was being wantonly plundered by foreign collectors found a sympathetic hearing in the international cultural community. The pre-conquest art of Latin America had begun to attract the art collector's eye in the late 1920s and 1930s when Mexican artists were themselves discovering the charms for the modern eye of works from their local past. Much earlier, of course, some works had entered ethnological collections. It was only after the war, however, that the works became widely popular with collectors in the United States. Many collectors of modern art became equally passionate about pre-conquest works from Mexico, Central America, and Peru. Some very large and significant collections were amassed before the market was threatened by political and ethical restrictions. The impetus was not ethnology or archaeology but art, and art museums throughout the country have eagerly sought such works as part of

their collections. At some point a more unified goal in scholarship will have to resolve the tensions created by these disparate approaches to the same objects.

Somewhat related is the concern for the art of the American Indian. From the middle of the nineteenth century systematic collections were assembled by the Smithsonian Institution, the Peabody Museum at Harvard and other institutions concerned with ethnology and anthropology. In the 1920s a new interest was shown in the art of the Indians of the Southwest, but it was not until after the war that art museums began to see the material as a part of their sphere of concern. In 1949 the Portland (Oregon) Art Museum installed a large permanent collection of Northwest Coast Indian art. Other museums began to include works from local Indian cultures and in the early 1970s major exhibitions were held at the Whitney Museum, the Walker Art Center, the National Gallery, and elsewhere. The repertory of art museums was expanding significantly.

"Western Art"—Through the 1950s and 1960s another area was being added by art museums in the West. Although the works of Remington, Russell, and other depictors of the West of the late nineteenth and early twentieth century, as well as those by earlier artists such as Catlin, King, and Stanley, had been looked at as having more historical than artistic interest, as exponents of what now became known as "Western Art" they became eventually a part of the art museum sphere. The Gilcrease Institute of American History and Art in Tulsa, Oklahoma, founded in 1942, notably combined art and history, but art museums, such as the Joslyn Museum in Omaha, began to include Western collections. In 1961 the Amon Carter Museum of Western Art was founded, devoted wholly to the field. The distinction between an art museum collection and that of a history museum—as well as that of a science museum—became somewhat blurred. The principles upon which art museums were self-consciously founded in the 1870s had obviously been modified.

Two other areas further expanded and complicated the area of collection in the postwar period: a new concern for early American art and the association of museums with contemporary art.

American Art—The history of the collecting of American art is marked by many shifts in conception and evaluation. The "old

master" complex that underlay the founding of large museums and major private collections in the late nineteenth century was not helpful in general for American art. Although some collectors such as Corcoran, Freer, and Gellatly in their very different ways insisted on mixing modern American painting with art of other times and places, and some specialized wholly in contemporary American painting, at the turn of the century earlier nineteenth century works were not highly prized and as a field for serious collecting hardly counted at all. A distinction must be made between the acquisition of contemporary works, usually as the result of periodic exhibitions, and the deliberate effort to acquire works from the past. Some few names stood out from the early period—West, Copley, Stuart, and Sully—but the new art museum, as distinct from the historical society, showed little interest in much more. Probably the first phase of a new interest came with an historical concern for American decorative arts and interiors which began as early as the 1870s but reached widespread popularity only in the 1920s. Paintings provided useful staffage for period settings, although since the interest hardly extended past 1830, the main body of nineteenth century American painting and sculpture remained untouched even in this context. Periodic exhibitions in the 1930s helped stimulate interest, and the large exhibition mounted by the Metropolitan Museum in 1939 was doubtless of great importance. The organization of the American Wing of the Metropolitan Museum (1924), the establishment of the Whitney Museum of American Art (1930), and the Addison Gallery of American Art at Andover (1930), each in quite different ways, marked a change of attitude. Although some museums were quietly getting rid of parts of their holdings, others began to acquire; the Detroit Institute of Arts, for one, carefully assembled a broadly representative collection beginning in the late 1930s.

In the later 1940s activity increased with exhibitions more detailed in nature than ever before, and much more exacting scholarship was underway both in museums and universities— although there were few university departments of art history interested in the field. Active collecting of American art by museums began in earnest in the late 1950s, and museums with collections dating back to the earlier nineteenth century began to reassess their holdings. In the ten years prior to 1974 the prices brought on the market by American paintings rose spectacularly.

The works of nineteenth century artists for many years forgotten, sold in the early seventies for high prices.

Beginning in the late sixties, not only forgotten American painters but also less well known nineteenth century European painters acquired new respect. The concept of the forgotten master, so contrary to the earlier masterpiece preoccupation, became a current theme. Even heretofore despised works denigrated as academic were reevaluated and found desirable for display.

As a result of these various tendencies to bring to the art museum materials not so readily separable from the fabric of culture as the ordained masterpiece, the whole complexion of the museum changed. Museum directors would protest that they continued to acquire works on the basis of artistic quality; nevertheless it became evident that the definition of quality had been much expanded.

Contemporary Art—Since many American museums have roots in temporary exhibitions of locally produced art, the inclusion of contemporary works in their collections is not surprising. In this respect, museums throughout the country should not be judged on the basis of those few that exist in cities with more than one art facility. The community art museum is normally looked to for all activity concerning art. But another sort of recognition of modern art was manifest in the collecting habits of museums, especially in the 1950s and 1960s. The nontraditional aspects of twentieth century art were, from the 1930s on, regularly justified in historical and developmental terms (one might say that this began with the Armory Show of 1913). The popularization of this approach through admirable, analytical exhibitions, with their convincing publications, mounted by the Museum of Modern Art through the 1940s, created a repertory of twentieth century art no less fixed in the public mind than that of earlier art.

To these "modern old masters" desired by museums were added later on the postwar American painters who made their mark on both the domestic and international scene. It was a kind of instant history, and quickly a sampling of their works was to be found in most museums. But the acclaim of postwar American painting, and eventually sculpture, had other effects. As a kind of cultural pump-priming it stimulated many museums to collect actively in contemporary art both within and beyond their local areas. Within the restrictive Renaissance frame of older museums, space and

appropriate environment had to be contrived for large, demanding works conceived of on a totally different scale from those for which the museums were created. On the other hand, it is precisely the exhibition of this kind of work that the designers of new museums and annexes often have in mind. In its own way, this emphasis on the new imposes a limit which is equally restrictive on exhibition practice since the ambiance may be unfriendly to other kinds of works.

The question inevitably posed by the extraordinary range of artistic languages, each clamoring to be heard in its own terms, assembled in even a relatively small art museum of the 1970s, is—what kind of structure could possibly do justice to them all? The diversity acceptable under the unifying concept of art is now so great that a fresh look at just what an art museum is and can do is badly needed.

Public Involvement

American museums have always considered public involvement a major element of their mission, but the word *involvement,* a favorite as applied to all manner of activity, particularly in the 1960s, has taken on many new meanings. Not only has the kind of involvement been much discussed, but also the extent and nature of the public to be involved.

The Temporary Exhibition—One means of drawing people to the galleries has always been the temporary exhibition. This was once largely a matter of showing works by local artists or private collections, but as the interests of museums and their associated scholars became more specialized, temporary exhibitions took on new character. Often organized around a theme—which might be an epoch, a national survey, a particular style, or the works of a single artist—such exhibitions have probably had the greatest impact on what the public knows and how it thinks about art than any other museum activity. So accustomed has the public become to special exhibitions that museum attendance tends to rise or fall on the basis of whether or not there is an exhibition to be seen that is not from the museum's own holdings. Since World War II the number of special exhibitions by museums, many of which circulate to other institutions, has increased steadily in spite of concern for

the security of works of art and the hazards and costs of shipment. Of the programs for which support was offered by the National Endowment for the Arts between 1971 and 1974, special exhibition was by far the most popular. Through it art becomes news and, in the museum's appeal for broader public support, being newsworthy gradually became a necessary ingredient in its program. In many ways, the art museum over the last two decades has entered the realm of show business.

Exhibition Design—If there have been detectable trends in the character of exhibitions, they are probably to be found in their size and elaborateness. A willingness to spend large sums of money on temporary exhibitions and the increased capabilities of museums for the handling of large numbers of objects has made comprehensive exhibitions possible. The subjects have ranged from Egyptian art to recent monumental sculpture. But it is not just the assembly of objects that has counted; the necessity of special presentation has grown to be almost as much of a concern as the material shown. Developing through the years in which "presentation" became the basis of a complex industry serving consumer products, museum presentation also became the subject of much expertise. Exhibition specialists were developed who concentrated on the technique and psychology of display. An extraordinary number of companies came into being which announced their ability to make any material interesting to an audience through their particular understanding of people.

Older companies had offered cases, hanging devices, and lighting equipment. The newer companies could also handle such technical matters but made a point of selling psychology and design. When the designers worked closely with the curators and acquired a sympathy for the material, the results of this expert collaboration elicited enthusiasm and won a more intensive response to the works displayed. But there were complaints in the late 1960s and later of over-installed exhibitions—exhibitions in which the installation had overwhelmed the works, its novel and dazzling methods running counter, in some cases, to the demands of the art. The development of standard exhibition equipment began to give a look of sameness to more modest temporary displays, no matter where they were encountered.

The extraordinary advance in sound and visual equipment made

its impact on both temporary and permanent exhibitions: various means of projection were used to supplement the exhibition, and sound narration and music were made available. In the 1950s, some museums began to experiment with individual narration systems that allowed the visitor to see an exhibition (or the permanent collection) with audible commentary without disturbing others.

Possibly the greatest technical change to have an effect on the design of exhibitions, as well as on the presentation of permanent collections, was lighting. Selective lighting making use of individual, adjustable spotlights tended to replace, or at least supplement, general lighting or daylight. Much study had been given to the effect of light intensity and quality on works of art, and in most instances (unless the daylight system was as sophisticated as that of the Kimball Museum of Fort Worth) incandescent illumination was found easier to control. The skylights that characterized most museums before the war, culminating in the National Gallery of Art, rarely appear in postwar museums. For the *staging* of special exhibitions—and the word is quite appropriate for some—an area free from daylight that could be illuminated in accordance with the exhibition was finally preferred; and the temptation to create unsuitably dramatic effects was not always avoided.

All these innovations—the use of professional exhibition designers, audio-visual supplements, and flexible lighting facilities—have one manifest purpose: to involve the attention of the viewer and intensify the experience of the works of art in the particular assemblage. Sometimes the didactic urge has been so great that the visitor has had little chance to see the exhibition in other than the way planned for him. At best, the careful planning of galleries to invite the public to participate more fully in the experience of the works has doubtless been a factor in increased attendance at art museums.

Related Activities—In addition to planning exhibitions with a sharp eye to public response, it became customary to schedule a series of events relating to exhibitions—lectures, demonstrations, films, symposia—to make of the museum a center for actively relating to the arts. Possibly the growth of the concept of art centers had its impact on the art museum. Following an idea that had been much discussed earlier in the century but rarely acted upon effectively, communities and universities after the war began to plan complexes

to accommodate music, theatre, and the visual arts. University complexes usually included studios as well. The plan was so appealing that some institutions found they could get support for such art centers more easily than for a single facility. The implication of such a center—apart from its philosophical under-pinning holding all arts as different manifestations of a similar impulse—is that one looks at works of art in much the same spirit as one goes to the theatre or concert and, in fact, that the various experiences enhance one another. Be that as it may, many more museums began to hold concerts, dance, and theatre performances, and one of the needs stated by a large percentage of museum directors in 1973 was for more auditorium space. Certainly the notion that art involves activity had become pervasive by the 1970s, and the visual arts borrowed much from the performing arts (quite aside from the "art as performance" tendencies of the late sixties and seventies) in striving for a new persuasiveness.

A Larger Public—Chiefly during the 1960s museums considered a variety of means for reaching a public beyond their walls. One effort, like the Virginia Museum's *Art Mobile* or Michigan's *Art Train*, was to create a mobile gallery that could reach areas without other access to galleries or museums. Another was to establish subsidiary galleries in outlying areas or in parts of the city not likely to be reached by the museum itself. Many studies assessed the effectiveness of these programs, and the National Endowment for the Arts paid special attention to such "out reach" programs.

Not properly a part of museums but often aided by them are the neighborhood art centers of many cities. Sometimes centering on ethnic identities, they offer great possibilities for making art a meaningful factor in lives it might not otherwise touch. As an active element in the potential museum public, the operation of these centers has merited the serious consideration of art museums.

Children—Probably the greatest concern for the public has been manifest in programs for children. Many museums have long been associated in some way with local schools, but there was in the 1960s much discussion about what this association should mean. Art instruction in the schools, always precarious, changed both in theory and practice over the preceding twenty years, as had museums. Museums could not expect children to be prepared to find the galleries meaningful to them, given the nature of much art

education, and had to undertake a larger share in active education. They began to accord their departments of education more importance, granting more staff and space for their activity. Provision was also made in larger museums for such practical matters as eating facilities and coatrooms. A major problem, occasionally exacerbated rather than helped by separate facilities, was the relationship between the curatorial staff and the activity of the increasingly aggressive education department. With the orientation of museums more and more toward the public, the relationship between the educational and curatorial operations became a problem demanding attention.

THE MUSEUM AND THE ART STUDENT

The association between the museum and the student of art has in the postwar years undergone major changes, inevitably reflecting the direction of art and art instruction. Many museums began in association with schools of art; traditionally it was deemed very nearly impossible to have a school without a museum collection, and one justification of a museum was its contribution to the education of the artist. As molders of taste, museums had collections of the sculptural casts so necessary for art instruction.

Through the 1950s instruction in art changed radically, making the association of school and museum seem almost an anomaly. Reverting to a theory of art current earlier in the century, the student artist wished to feel free of the past, a rebel against established taste. Even technical methods had little or nothing to do with earlier art. Although faculties were not quick to adapt themselves to the new viewpoints, they eventually capitulated, and art instruction was revised to encourage experiment and individual judgment rather than the acquisition of traditional crafts.

On the museum's side, cast collections were destroyed or moved out of sight, and galleries were organized with no thought to the erstwhile copyists. Only the museum's new interest in contemporary art maintained a bond of communication although, ironically, this was not at all originally the museum's contribution.

The matter of art school and museum becomes serious, however, not so much on a philosophical as on a practical level. When financial and physical resources were strained, where were priorities to be given? Faced with such a question, one is likely to wonder

whether art schools belong any more in museums. When museums were originally founded, universities offered little in the way of training in art, and there were few independent art schools. Now in most universities the faculty devoted to teaching the practice of art is much larger than that concerned with the history and theory of art. Some universities maintain large professional art schools and many independent schools exist. In which environment is the art school more justified? Again the art museum—this time not through its own expansion—is brought into a potentially conflicting or at least overlapping relationship with other institutions.

Conclusion

Over the years the art museum has been transformed. From a genteel storehouse of culturally uplifting artifacts it became a rare, refined world of its own, only to be invaded by a demanding public that was unsympathetic to the idea of art as a world apart. Like a careful lady who wishes to remain dignified enough to be accepted by the elegant and financial pillars of society, yet speak a language understandable in the city streets, the art museum has had some difficulty adjusting its image. The aloof building guarding the treasures of the past has been threatened with becoming a kind of recreation center in which art is only the catalytic element. Once a palace run by a single caretaker and a group of helpers, the museum has been transformed into a technical and administrative complex requiring the services of many specialists. Moreover, American museums, begun as modest purveyors of art to the local populace, have now become the repositories of collections so rich that no phase of art can be studied with competence without consulting them. They hold responsibility to a world-wide constituency.

As art museums have developed and expanded their activities, so have other institutions, and the museum's role is not so clear as once it was. Once supported almost wholly by small local groups of patrons, it now campaigns for members amongst the public at large and has begun to depend on federal sources to support a part of its expanded program. More and more the museum belongs to a wide public, which accords with the thoughts of those cultural founding fathers like Latrobe, who saw art as an essential element of a

democracy. But are there limits to what it can best accomplish? The administrative demands have now become so great that some museums look for administrators, rather than scholars of art to run their institutions. Does this organizational expansion, this effort to be many different things to many people, threaten the substantive quality that museums were founded to uphold?

Although the art museum has quietly been evolving over many years, the changes taking place since the late 1950s have been so basic as to interrupt any sense of orderly progression. Accepted as a protector of the past, the museum has nevertheless had to justify itself anew as an institution for the present.

Charles Parkhurst

3

Art Museums:
Kinds, Organization, Procedures,
and Financing

About Art Museums in General

All museums, whether dedicated to art, history or science, are contained in one of the "spheres" which surround man in environmental writing—the biosphere, the technosphere, and the recently identified aesthetosphere. Although not considered a necessary part of life by all people, museums preserve and present to them tangible objects for elucidation and delight. Indeed, so deep is the penetration of museums into our lives that one can scarcely find an advanced discipline or field of study which is not to some extent, or totally, based on the natural, aesthetic, or historical objects and collections preserved in museums. Art museums collect and preserve those things of intrinsic aesthetic value. The American Association of Museums' definition of a museum quoted by Sherman Lee on page 6 has been generally acceptable to museums and to other organizations including the Congress of the United States.

Before becoming Assistant Director of The National Gallery of Art, CHARLES PARKHURST *was Director of The Baltimore Museum of Art and before that a professor of art history at Princeton and head of the department of art and museum at Oberlin. A member of many art boards and commissions, he is a past president of both the College Art Association and the American Association of Museums and co-founder of the Intermuseum Conservation Association. He has written art books and catalogues and many articles on the art and museum worlds.*

FURTHER DEFINITION

A museum must be organized as a duly constituted body with stated responsibilities and authorities (charter, by-laws, tables of organization, policy directives, operating manuals); be expected to continue in perpetuity as a tax-exempt public benefit; and be knowledgeable in the use and exhibition of its holdings for elucidation and enjoyment. It must have at least one paid employee who commands a body of special knowledge, has the ability to reach museological decisions and to supervise museum operations in a manner consonant with the experience of his peers, and who works sufficient hours to meet adequately the demands of administration, record keeping, and care of the collections. These collections will be, in an art museum, inanimate objects of intrinsic artistic value constituting a partial visual record of man's past art activity, his history, tendencies of mind, and aesthetic preferences. The manner in which they are displayed should be evidence of the subject, art, rather than a tool for communicating what we know of that subject, and should forward and reflect the museum's stated purposes.

Finally, to care for its collections properly a museum must keep adequate records pertaining to the provenance, identification, and location of its objects; must maintain current professional standards with regard to security and environment to minimize damage and deterioration, and must restore these objects to, or conserve them in, a visual state which distracts the viewer as little as possible from the original intent of the artist.

Such a museum is controlled by a governing body and administered by a professional staff, both committed to carrying out the institution's responsibilities for the benefit of the public.

Certain implications in our definitions, restrictive in nature, might be discussed at length, particularly the nonprofit phrase which implies a public trust. Although it is possible to imagine a profit-making museum ideally devoted to its materials as though it were a public trust, its realization is unlikely.

A museum should be governed by generally accepted good museum practices, written or unwritten policy, tacitly accepted or wrought by its governing board and should be organized to implement these through operational procedures established and

overseen by a director. He is chosen by the board, and under him is a pyramidal hierarchy of other officers and staff, selected by the director to operate the museum for its broad purposes, generally stated as collecting, preserving, presenting, and elucidating. In what follows we shall see what it takes, structurally, procedurally, and financially to do this, and for whom. The reader should be aware of the deep stream of power which flows through a museum, the characterization of which would constitute an answer to the question "who controls the museum?" but would differ from museum to museum.

Money can sometimes "buy" a museum's compliance with the wishes of one patron, whether an individual or a duly established agency or group; and misuse of purse-string power has led to deterioration of standards, controls, and public trust. A self-interested group may also come into control of a museum when a vacuum of indifference on the part of duly constituted trustees prevails. When this happens (and it has) a most serious breach of public trust has also occurred.

Kinds and Classifications of Museums

There is no entirely satisfactory list of art museums, but *The Official Museum Directory, 1973*, published for the American Association of Museums, is the most up-to-date and thorough. Around 800 art museums are listed there, in the following categories: Art Associations, Councils and Commissions, Foundations, and Institutes; Art Association Galleries; Arts and Crafts Museums; China, Glass and Silver Museums; Civic Art and Cultural Centers; Decorative Arts Museums; Folk Art Museums; and Textile Museums. This listing, good as it is for other purposes, is not entirely satisfactory and perhaps depends too much on the names of museums for their classifications. Another listing is that of the membership of the Association of Art Museum Directors, which includes most museums with budgets of over $250,000. There are about 110 such members.

A FEW EXAMPLES

Plain old art museums may be of many types, such as those that specialize in a period or a culture, like the Museum of Modern Art,

the Whitney Museum of American Art, or the Freer Gallery in Washington, known chiefly for art of the Near and Far East. General art museums, like the Metropolitan Museum of Art, the Boston Museum of Fine Arts, and the Chicago Art Institute have broader, less precise parameters. Other general art museums have become identified with specialities, such as the Seattle Art Museum, the Cleveland Museum of Art and the Nelson Gallery-Atkins Museum in Kansas City, famous for their Oriental holdings in addition to substantial collections of Western art. Other special kinds of museums house arts and crafts, or American decorative arts—china, glass, silver, antique furniture—such as the Du Pont supported Winterthur Museum in Delaware or the Bayou Bend Collection of the Museum of Fine Arts, Houston.

Folk art museums are open-air or indoor, or a combination as at the New York Historical Association in Cooperstown or at Old Sturbridge Village.

What we may term "teaching museums" prevail at colleges and universities in the sense that their collections tend to form like satellites around an art department's past and present course offerings, as at Berkeley, Harvard, Smith, the Universities of Nebraska, Michigan and elsewhere. School museums sometimes possess, in addition, windfall collections, given them by grateful alumni or stout friends such as the Salton collection of bronzes at Bowdoin and the Jarves and Griggs collections of Italian Renaissance painting at Yale.

Other schools, Princeton for example, have conducted archaeological digs which produced valuable art collections which are especially informative historically as well. Archaeological collections are akin to those in anthropological museums containing works of indigenous cultures, from North America or elsewhere, as for example the Museum of the American Indian (Heye Foundation), the Anchorage Historical and Fine Arts Museum, and the Dickson Mounds Museum, Illinois, although most of these do not classify themselves as art museums.

We may also include here several corporate or company art museums, the most notable and one of the oldest being the Corning Glass Center (since 1951), and one of the best of the most recent ones, the Campbell Museum of Fine China, Glass and Silver related to the history of soups.

Finally, some veritable art museums are included which are

satellites or subsidiaries or branches of general museums, but with separate governing bodies sufficiently self-directed, and with some budgetary autonomy. A case in point is the National Collection of Fine Arts, a subsidiary of the Smithsonian Institution.

There are many fringe subjects covered by specialized museums not included in our considerations: typography, medieval manuscript illumination, theatre design, maps, lapidary arts, and architectural monuments containing art to a greater or lesser degree, history or science museums with art or anthropological collections, sports museums with paintings illustrating sports, musical instrument museums, gardens, or techno-historical museums of crafts. Also not included are library museums which display from time to time their collections of fine books and bindings, manuscripts, and drawings, despite the greatness and fame of their art holdings, as the Morgan Library, the Library of Congress, and the Huntington Library, Art Gallery and Botanical Gardens.

Not included here as well are historic sites and historic house museums, nor general museums containing art along with natural specimens and technological displays, nor film and photography museums (*e.g.*, the International Museum of Photography at George Eastman House, Rochester).

CATEGORIES OF SIZE AND RELATED MATTERS

A museum may be measured by the size of its operating budget, that is, of all expenditures except those for major capital improvements or acquisitions for collections. Figures are not easily obtained but a recent survey in depth of a sample of 177 art museums out of 340 included in that survey indicated the following budget-size distribution:

Budget:	$	12,000	to	$	49,999	—	42 museums
		50,000	to		99,999	—	31 museums
		100,000	to		499,999	—	52 museums
		500,000	to		999,999	—	38 museums
		1,000,000	and over			—	14 museums

The results of this survey of 1,821 museums of all descriptions in art, history, and science, 728 of which were interviewed in depth, conducted for the National Endowment for the Arts, have been published in part by the Endowment as *Museums USA: Highlights* (1973). The total operating expenditures of all 1,821 museums in

the fiscal year 1971–1972 were $478,912,000. Museums with budgets under $50,000 represented 44 percent of the total operating budgets for all museums. Museums with budgets of $500,000 and over represent only 5 percent of all museums but account for 69 percent of the total operating expenditures.

Another interesting finding of this survey is that over two-thirds (69 percent) of art museums are governed by private, nonprofit organizations, while 21 percent exist under educational institutions. Only 10 percent of art museums are fully operated by government agencies—city, state, or federal.

DISTINGUISHING MUSEUMS BY APPEARANCE AND OTHER MEANS

Like human bodies, art museums come in all shapes, some suitable, some unsuitable—even "impossible." They could be classified on architectural grounds as classical temples (Toledo, Baltimore), as contemporary in design (Museum of Modern Art, Walker Art Center), or as "recycled" buildings intended for other uses such as the Akron Art Institute (which originally was housed in a part of the city library and later was given the entire building for their use), the Long Beach Museum of Art (originally the brick and lava stone mansion of E. Millbank Anderson), the North Carolina Museum of Art (built about seventy years ago by prison labor to house the Department of Highways), and the National Collection of Fine Arts (in the historic U.S. Patent Office Building). Many college and university museums are housed in classroom buildings and some state art museums are in capitol buildings. Museums often outgrow such adapted quarters or expand by accretion of wings, and may even dress themselves with a new, contemporary-looking façade. "Temples" may have contemporary additions (Buffalo, Houston and Cleveland).

The design problems inherent in contemporary additions to a building in an older style are formidable. An entirely new museum may risk incompetent or uninformed planning or an irresistible ego-trip on the part of its architect. The range of possibilities has been played on fully, but it is fair to say most museums built to be museums are designs of notable distinction (Albright-Knox Gallery, the Herbert F. Johnson Museum of Art at Cornell University, the National Gallery of Art, and the Munson-Williams-Proctor Institute at Utica, for examples in diverse styles).

BY SIZE OF AUDIENCE

A few museums, perhaps six or seven, are able to count over a million visitors a year; most draw over 25,000, and very few less than that. The total art museum annual visitation has been estimated at 43,024,000 for the year 1971–1972, according to the National Endowment for the Arts; the large-budget museums draw more visitors, of course, and 5 percent of the nation's largest museums account for 34 percent of the total attendance.

BY SIZE OF COLLECTIONS

All museum collections are growing by acquisition, through purchase, gift or bequest. It would make some sense to measure a museum also by the number of works of art it has on view; but this leads one into practically unanswerable questions of how much of low aesthetic value can be shown as art, even if it may be of technical or historical interest. An object may be in storage because it repeats what is already on view; or for a lack of space; or because it is unsafe and destructive to exhibit for a long period of time, as in the case of works of art on paper, which are very delicate and subject to fading and serious deterioration of their substance; or because it is a textile, in which case, among other problems, it has to be "rested" to reduce deformation consequent on stretching and sagging, even when properly mounted.

ADDITIONS TO THE ART MUSEUM UNIVERSE

Since about 1970 there have developed new kinds of museums serving new ethnic and other needs or demands, usually related to existing institutions as satellites or through alliances, as "basement" museums, or affiliated through educational systems, producing enough benefits through these alliances to enable them to survive.

Staff and Functional Organization

A museum is an intricate organization. Trustees, administrators, curators, staff, visitors, members and public officials all have an interest in the institution. It is easy to underestimate (or exaggerate) the influence of anyone there. Good governance depends on a reasonable allocation of responsibilities among all those groups in order to make the structure of authority credible. It is

impossible that all should decide everything or be consulted on every issue. In principle, the museum exists to make its collections and its related programs available to the greatest number of people. This objective is most likely to be achieved where there is a division of responsibility, a sharing of information, and a readiness to subject authority to the requirements of a well-defined system of accountability.

The preceding succinct credo was hammered out over two years by a committee of the Association of Art Museum Directors and included in its excellent booklet *Professional Practices in Art Museums* (1971), the text of which is woven in and out of the fabric of this chapter. We shall examine how the responsibility for objectives they cite is shared, and by whom.

There are three broad categories of museum staff: *First,* a group of individuals with very generalized skills—secretaries, clerks, accountants, janitors, sales persons, and artisans, who are easily transferable to almost any type of organization. *Second,* a group with para-professional or technical skills not peculiar to a museum, also transferable to other types of organizations where needed, as library cataloguers, engineers, editors, chemists, and others. There is a regular movement in and out of the museum world to and from industry and colleges and universities in these categories. *Third,* the specialists who can only work in an art museum, maybe even limited to certain types of museums—the curators and conservators.

Staff members normally are hired and fired by a director to whom they are ultimately responsible, although some boards retain the right to approve the appointment of key staff members. The schematized table of responsibilities which must be met in an hypothetical large art museum, given below, may be fully expanded (the Metropolitan Museum of Art has about 800 full-time employees) or contracted (to one person) depending on the size and character of the museum; but in general it is necessary to have persons with business, financial, legal, and curatorial expertise under or available to the director. What follows is written with reference to the chart, which, it must be stressed, is a *schema* giving mostly functions and a few top positions; it is not a "flow chart" of operations.

Personnel hiring policies of all museums may correspond more or less to the demography of their effective audience range, but it may be said that museums endorse and abide by established fair employment and equal opportunity practices. Nonetheless, there

are few blacks in directoral or high administrative and curatorial positions. The American Association of Museums adopted for the profession in 1973 a strong policy opposed to discrimination.

CURATORIAL

The core of the museum staff consists of its curators and conservators, often under a chief curator, whose activities center on the museum's reason for being, its collections, their conservation and restoration, and accompanying presentation, research, advanced study, and publication, and for support services including photography, editing, installation, exhibition design, registration, packing, handling, and storage.

Some other closely related functions in curatorial support areas, professional in character, are shown in our chart under "Assistant Director," but often they are the responsibility of the chief curator or of a curator of education. These are principally educational in character either for general public educational service, art schools, school tours and extension services, art information services or directly in support of the main curatorial thrust of the museum— library, research archives, photography, and publishing activity.

Museums differ so greatly in collections, functions, size, and budgets, that it is both impossible and undesirable to devise uniform job descriptions. Nonetheless, certain key personnel in the curatorial area have basic functions.

Curators—are the scholarly and research-matter experts. They study, identify, and arrange the collection, suggest acquisitions, originate exhibition ideas and carry them out, do research, write catalogues or other publications, represent the museum in the scholarly world, and are also responsible for seeing that collections in their keeping are protected, preserved, and conserved, and that proper records are kept, in most cases working with a conservator, a registrar—or others. There is in large museums a hierarchy of senior curators, associates, and assistants corresponding fairly closely with professional grades in colleges and universities. There may also be a research supervisor with associates and assistants not burdened with the more public duties of administrative curators.

Conservators—are trained in art, physics, chemistry, and other appropriate fields. They are both the scientists who analyze

museum objects to prevent deterioration and the restorers who mitigate distracting or unsightly evidence of deterioration. They see that objects are structurally secure, pest-free, kept in an ambience of proper temperature and humidity, and protected from pollution and harmful light. Conservation is so complex and expensive that most museums cannot make it a staff function and they depend on outside experts, or regionally pooled resources (the Intermuseum Laboratory at Oberlin, for example, founded in 1952). Members of the curatorial staff must learn to recognize conservation needs and know where to send the objects for proper treatment.

Curator of Education—often so titled, is an important link with the public, providing the formal and informal teaching programs of the museum. In addition to the interpretation of works of art in words, his responsibilities may include actual classroom instruction, short courses in the museum's subject matter, in-service instruction for paid docents and volunteer guides, workshops for teachers, formal lecture series, film programs, forums, seminars, and symposia and the organization of museum clubs, special tours, trips, radio and television programs, circulating exhibits for schools, and many other activities. He may also be the head of research and its support activities.

The Registrar—has charge of accessioning and cataloging objects and maintaining proper records for them. These duties frequently include responsibility for packing, unpacking, moving and storing of objects, and providing for their transportation and insurance. Some large museums are experimenting with computerization of museum records so that computer technicians may eventually work in many registrars' offices. He may also be charged with handling the customs problems involved in art imports or exports.

Exhibit Designer—(sometimes called an Installationist) is a specialist trained in design, with a thorough knowledge of art history and exhibition techniques. He is charged with translating curatorial or educational ideas into meaningful and attractive displays whether they be permanent, temporary, or for circulating to other museums. He is sometimes assisted by a staff of artists, draughtsmen, audio-visual and lighting specialists and other technicians.

Editor—is concerned with the printed, graphic or typographic image of the museum and responsible for all printed materials

Fig. 1. Table of Functions for an Hypothetical Art Museum

PRESIDENT

CHAIR PERSONS

AUXILIARY ORGANIZATIONS

BOARD OF TRUSTEES

CHAIR PERSONS

TRUSTEE COMMITTEES

DIRECTOR

ASSISTANTS

SPECIAL EVENTS

CAPITAL IMPROVEMENTS

COMMUNITY RELATIONS

ASSISTANT DIRECTOR

GENERAL ADMINISTRATION ORGANIZATION & PROCEDURES

ASSISTANTS

PUBLIC RELATIONS

LONG RANGE PLANNING & DEVELOPMENT

DIRECTION POLICY

Organizational chart — OPERATIONS

BUSINESS ADMINISTRATION	CHIEF CURATOR	CURATOR OF EDUCATION	TREASURER	LEGAL COUNSEL
SECURITY	CURATORIAL DEPTS. AS NECESSARY	LIBRARY	BUDGETS	LEGAL MATTERS
BUILDINGS & GROUNDS	CONSERVATION	PHOTOGRAPHIC ARCHIVES	ACCOUNTING	LEGAL RECORDS
PERSONNEL & EMPLOYEE RELATIONSHIPS	ADVANCED STUDY & RESEARCH	EDUCATIONAL SERVICES	RECEIPTS DISBURSEMENTS & DEPOSITS	TRUSTEE AGENDA & MINUTES
CONTRACTS	EXHIBITIONS	EXTENSION SERVICES	INVESTMENTS	GIFTS & BEQUESTS
PROCUREMENT EQUIPMENT & SUPPLIES	REGISTRATION	EDITORIAL & PUBLISHING	INSURANCE	LEGISLATIVE MATTERS
ARTISANS & WORKSHOPS	ART RECORDS	SCHOOL SERVICES	FINANCIAL REPORTS	IMPORT REGULATIONS
PUBLIC SERVICES	ART LENDING SERVICES	ART INFORMATION SERVICES	INTERNAL AUDITS INVENTORIES	REPRODUCTION RIGHTS
COMMUNICATIONS	PACKING HANDLING STORAGE	PHOTOGRAPHY		
DATA RETRIEVAL SYSTEMS				

issued by the museum. He prepares for publication and sees through production, books, catalogs, guides, periodicals, pamphlets, leaflets, labels, and ephemera, including signs and posters.

ADMINISTRATOR

The business office, under an Administrator, is charged with supervising the functional aspects that provide for security, all aspects of plant operation and maintenance, personnel matters, procurement and contracts, communications, public services— cafés, shops, first aid, parking, and the like. If the museum uses a modern computerized data-retrieval system for its business records and accounting, art information and records or other purposes, he may also be responsible for the hardware. Security for the collections often warrants a special staff position in charge.

The Security Supervisor—often called a Captain of the Guard, or Head Guard, has grave responsibilities. Museum security recently has become so important that many museums have a separate department with its head reporting to the director or another senior officer, to administer the guards and to be responsible for their training, for fire protection, electronic surveillance, procedures for emergencies, and with powers to make certain decisions on weekends when other staff members are not normally on duty.

Treasurer—is responsible for all money matters as outlined on the table, and at a later point we shall go into his duties in detail. Although the board is responsible for the museum's finances and must approve their handling, the board usually assigns to the director certain money matters in which he is assisted by the finance officer. In some museums he is on the directors' personal staff, and not an operational "line officer" as shown on the accompanying chart. He may also be charged with handling insurance on works of art, and liability insurance to protect the museum.

COUNSEL

The legal counsellor of a museum may likewise be on the director's immediate staff, although he also is shown on our chart as in the operational "line." Counsel is usually the last function added to staff as a museum grows, and most directors depend on outside

paid (on retainer), or voluntary legal counsel, sometimes a trustee. The legal issues that arise in the course of conducting the affairs of a museum may include handling litigation, negotiating with government agencies and labor unions, scrutinizing deeds and bequests of works of art, exhibition agreements, reproduction rights, and tax or legislative matters, including regulations governing imports of works of art and copyrights. Besides serving as general counsel, he may also act as secretary to the board and keeper of their records. In general it is his duty to identify and anticipate legal problems and to work with the director in dealing with them.

OTHER STAFF

Interns and summer aides may be a temporary part of the staff, the former selected from among post-graduate or in-training applicants from various relevant fields. The latter may also be bright, but deprived high school students earning summer money but also enjoying exposure to a profession they never knew existed and to which they might aspire later.

In addition, it is very common practice to utilize volunteers to assist or supplement the staff, sometimes with professional or para-professional skills, in areas where resources do not afford paid staff. These areas most commonly are administrative and programmatic, rarely curatorial. Such volunteers are an indispensible part of most American museums, and are regarded variously with delight and dismay, but usually the former. Their financial significance will be touched on later.

Thus a "complete" museum will have at least four major divisions of responsibility under its director, in addition to those areas covered by his personal or office staff and supporting the heads of these four divisions perhaps ten to fifteen subdivisions and, under them, thirty to fifty departments. Small museums may combine them all in one professional staff member supported only by a janitor who doubles as a guard.

The Director

A museum can be made or broken by its director or its governing board. A board can, by wise choice of a director, and by

its confidence in him, enhance the museum's future.

As pointed out by the Association of Art Museum Directors in its previously mentioned booklet:

> The administration of an art museum demands not only the acumen and procedural awareness needed in the administration of any corporation, but also taste, knowledge, and experience of a highly specialized nature. . . . The director also plays an active role in the creation of policy, in that it is his professional responsibility to originate suggestions for the board's consideration when conditions change and new needs arise.

The director, the sole person on the staff answerable to the board, is responsible for carrying out the existing policy of the museum and making it manifest through his general administration, the growth, preservation, and study of the collections and the development of exhibition and other programs to make them more meaningful to the public. He must also see to it that appropriate policies, organization, procedures, and supervision are provided for the staff at all levels. It is he who must supply stimulus to his staff, in order to assure the achievement of their maximum potential, and create working conditions which will enable each staff member to perform to the best of his ability, with freedom from unreasonable demands.

The director bears heaviest responsibility for the character of community attitudes toward his museum, the attitudes of possible benefactors, the general professional quality of the museum, and its public face as seen in the building and its grounds, its installations, its publications, and other elements of appearance. In a big museum, to the degree that he can assign responsibility to well-selected subordinates whose procedures he can trust and to whom he can provide guidance in principle, he will be successful.

There will be many committee and other working contacts between board and staff, with the cognizance of the director, but the code of ceremonial forms and courtesies accepted in official dealings, as well as common sense, require that the director be the sole intermediary for official communication between the board and the staff, and the principal contact point for outside agencies, other museums, donors, and patrons, although the board may be the ultimate arbiter in some of these matters.

Important as are the director's observance of ceremony and his concern for "appearance elements," is his system of quality controls

which will truly distinguish his museum. His skill at establishing standards and assuring that they prevail in day-to-day staff work are crucial here. A staff instilled with his standards and which desires to join with its director to achieve them is the greatest asset at his command. With such a staff, unexceptionably high performance will obtain throughout. This applies to acquisitions of works of art, conservation and restoration, handling and display, research and publication, security, administrative and financial practices, public utterances and events, legal and contractual habits, housekeeping for good appearance—in short, to the entire museum operation.

He is subject to judgment both from within and without, and his skill at developing operating policy, or in encouraging the proper development of it by others, can mean his museum will hum like a beautiful machine or wheeze like a cranky relic, or not move at all.

The director must afford encouragement and fruitful guidance to ancillary groups, advisory committees, men's and women's committees, junior boards, organizations of patrons, friends, members and volunteers, and see that they are happy and working in a productive and constructive manner in support of the museum's objectives, and interlocking effectively at the correct staff level. He should also provide for appropriate liaison with government agencies, foundations, and other organizations. His skill in liaison activities in all these areas will encourage cash to flow and patronage to take root; and this, coupled with a keen eye for quality in art, can make his museum a paragon. But he must be prudent, cautious, and discreet in exercising his personal aesthetic preferences, not to willfully substitute them for unbiased critical judgment or to exceed the parameters for collecting established by board policy; and he should be circumspect if he has reason to press against unwritten acquisition *caveats* or traditions of the community he serves.

One of the most demanding aspects of directorship has been referred to by an eminent and witty art museum patroness and trustee as "The care and feeding of donors," further clarified by the admonition currently being passed around: "Never forget that every art collector has a will of his own." It is generally conceded in the profession that the encouragement of giving by patrons can be rewarding, trying at times, usually precarious, sometimes unexpected and, occasionally, disappointing. The director—or a staff

member—can inadvertently cause established rapport to evaporate and connections to break. Heavy social schedules may be part of the relationship, but the ultimate desire of the patron to aid the museum, and of the director to clinch that aid, constitute both motives and boundaries for the relationship. Exhibitions demand special attention from the director. The philosophy of exhibitions is to provide the audience of the museum with experiences in art not otherwise available to them.

One final responsibility of the director is to maintain official communications with other art museums and with related organizations, societies, and associations, such as the American Association of Museums, Association of Art Museum Directors, various councils and committees, the Museum Computer Network, or with *ad hoc* confederations of museums for common purposes, such as those formed to produce an exhibition. He should further see to it that key members of his staff may make contact in their associations with their peers in the interests of training or retraining, and refreshment, thereby improving the quality of his museum's own operations.

There has been since about 1966 a more or less ongoing self-examination shared by all museums, chiefly in two Aspen Conferences (1966 and 1974) and in *The Belmont Report* (1969), in which all directors participate according to their desire to attack problems, to accommodate change, to recognize the pluralistic and polychromatic museum universe in which they circulate, to relate to nonmuseum cultural organizations, and to give meaning to their own existence.

In short, we may visualize the director's position at the apex of a Thomistic structure consisting of a terrestrial staff pyramid, afford-

ing a point of contact with the inverted pyramid of empyrean authority, with its various levels of trustees and angels, up to the supreme policy level. The identification and description of the

latter is an essential point in understanding who controls the museum. This image leads us into the question of how a museum is financed.

Museum Funding

A recent survey of art museums and four other types, made for the National Endowment for the Arts, classified all museum income as: 63 percent from the private sector and 37 percent from the public sector.

THE PRIVATE SECTOR

Private support (21 percent): from individuals, foundations, corporations, memberships, and allocations from colleges and universities. Individuals provided almost one-half of the private support.

Operating revenues (29 percent): from admissions, shop sales, and other miscellaneous revenues (restaurants, parking lots, etc.). Admissions generated about one-third of revenues.

Nonoperating revenues (13 percent): chiefly income on investments.

It is anticipated by many that the federal government will be a more important source of funds in the future, but without derogation of the importance of individual donations so long as the tax laws and their interpretation are favorable.

THE PUBLIC SECTOR

Municipal or county governments (18 percent); state governments (7 percent); federal government (12 percent).

Sixty-three percent of all public support went to government operated museums, 34 percent to private non-profit museums and 3 percent to educational institution museums (although indirect support is clearly greater than that).

The same survey showed, with reference to operating expenditures (excluding major capital improvements or acquisitions for collections) that 59 percent of all operating expenditures was for personnel.

86 *Charles Parkhurst*

WHERE DO DOLLARS GO?

The largest expense areas are those shown to be on the one hand operations and their support (custodial, security, services, 27 percent), and on the other hand, administration (28 percent) although this declines steadily as the budget size increases. The percentages of expenditures in four other areas are: curatorial and exhibitions (20 percent), education (15 percent), and research (10 percent). Costs of acquisitions and related expenses are not included, nor are any publication costs (often paid out of a revolving fund), and some extraordinary costs paid for out of donated funds for exhibitions and the like.

FEDERAL SOURCES

From the federal government may come grants, or appropriations, or matching funds from the U. S. Treasury, for approved projects under the laws in effect, the most important being those establishing the National Endowments for the Arts and Humanities on a project or program basis only. Other agencies also serve as channels to a lesser extent, including HEW, HUD, AEC, NSF, and the Smithsonian Institution.

Indemnification—in lieu of insurance, works of art owned by foreign governments could be covered by the federal government which then might indemnify foreign nations lending works of art borrowed for exhibition in the United States. This would afford considerable relief to strained funds in this particular area for larger museums, but would not be likely to touch many small museums.

Tax Benefits—long a boon to American museums, have increased since museums have been recognized as educational institutions entitled to full educational and charitable deductability, despite some setbacks in the Tax Reform Act of 1969. There, the provision allowing a donor to make a donation and take a deduction but retain life interest in the object in question was thrown out. Moreover, artists are now virtually excluded from tax benefits by gifts of their own works.

The preservation of deductions for gifts of appreciated tangible personal properties in 1969 has enabled museums to continue acquiring objects of artistic merit. Without this tax encouragement,

many donors would not have been motivated to release these objects from private ownership to museums, where they are available for the public good.

However, and also as a result of the Tax Reform Act of 1969, about 24 art museums suffer a serious handicap because they are classified as private operating foundations even though they operate as public charities like any other art museum. As a result, before they can even start operating they must pay a whopping 4 percent excise tax off the top of their endowment income. Furthermore, it becomes difficult for them to secure funding from other foundations which are permitted by law to fund only public charities. Examples here are the Currier Gallery of Art in Manchester, the Kimball Art Museum, the Clark Art Institute, the Corning Museum of Glass, the Frick Collection, and the Winterthur Museum.

It is striking that in countries where beneficial tax provisions do not exist, museums receive little, if any, private support through donations and bequests. Belgium provides a notable example.

State Arts and Humanities Councils and Commissions—all of which receive direct funds according to their qualifications from the National Foundation for the Arts and Humanities have also trickled slight federal funds to museums. Public and privately funded museums have different problems in establishing eligibility for federal grants—if a museum qualifies as a public tax-free institution under the Internal Revenue Service's classifications there is no problem; but if it is held to be a private foundation, the new foundation taxation laws may result in an additional financial burden, although later rulings may correct this.

STATE FUNDS

Other kinds of government aid come from state governments, usually in *ad hoc* support of projects which have been presented directly to state agencies by museums. Considerable funds have flowed into museums in states where the governor himself has an interest in their well-being, notably New York. As we have seen, the states also make grants through state arts councils, sometimes in the form of matching funds for federal monies; and of course, the state and local governments provide tax relief to museums.

MUNICIPAL GOVERNMENTS

A 1966 survey suggested through sampling that one-half to two-thirds of all museums in this country depend to some extent on local governments for financial support. The grants from local governments must often be supplemented by money from other public or private sources if their various purposes are to be adequately realized. Local governments frequently help by affording some services such as auditing and accounting, payroll supervision, central purchasing and building repair. Sometimes bond issues are floated for large particular needs, as, for example, when the Walters Art Gallery in Baltimore needed to double its space after many long years of sardine-like existence in its first building. The attitude of mayors, city council presidents, or comptrollers of cities is of extreme importance in determining whether the museum must scrape along on very meager funds or have a reasonable existence as an adequately supported agency of the city. The late Governor Theodore R. McKeldin of Maryland and one-time Mayor of Baltimore, like many Baltimore mayors, established a reputation in that city for appreciation of the value of the museum. He said, "I can envisage a city with a fine sewer system, excellent police, and good fire-protection; but it could not truly be a city if it did not have a theater, an orchestra and a museum." Certain other cities may be cited for strong support from leading officials.

DONATIONS BY INDIVIDUALS

Money from individuals may come through gift or bequest, by voluntary giving or as the result of solicitation, as in a capital fund drive or through continuing grass-roots money raising through membership and participation in museum programs and services.

Funds given or bequeathed to a museum may be restricted or unrestricted as to use; they may be restricted to specified purposes or as to expenditures from income only, or expenditure of principal at a certain rate. Funds are often given without restriction, but accompanied by a prefatory statement, which puts the burden of compliance on the museum, usually as effective as a restricted gift in achieving the goals of the donor. It must be said that restrictions are, from the point of view of the museum, both undesirable and cumbersome, but museums cannot always be choosy and a stiff-

voluntary), auditorium receipts (from cinema or theater and other events), subscriptions to magazines and periodicals published by the museum, and membership receipts for several thousand participants who are willing to put ten dollars or more on the barrelhead in return for special privileges. The privileges and services offered in return by the museum not infrequently become "lead-loss" items for the museum (in shops and cafes, for example), but they do provide some cash, and are considered worthwhile because of the service they provide, the standards they set, and because they attract an audience to the museum. Thus such deficits may be regarded as a public relations expense. Gate receipts from special exhibitions often yield a burst of dollars for the till when these exhibitions have great popular appeal, as has been the case for exhibitions of paintings by Van Gogh, watercolors by Andrew Wyeth, medieval art from Europe, or works from exotic lands like Russia, China, Egypt, and Peru, especially when there is an added topical interest of the day. The cash flow may be further augmented by fund-raising efforts—auctions, balls, and *ad hoc* money drives, or from the sale of photographs and rights of reproduction of works of art to publishers.

ENDOWMENT INVESTMENTS

These suggest a quandary for endowed institutions as capital needs grow, and satisfying those needs presents problems which museums must solve. Some, perhaps only a few, can meet their needs largely from endowments (Toledo, Kansas City, and Cleveland, for example). Museum endowments may provide some operating expenses not obtainable from other sources, but they are mainly used for acquisition of works of art, publications and exhibitions, and, in certain instances, selected salaries, particularly in areas where government cannot or will not give support for needed functions (unfortunately, staff salaries for curators and conservators, essential workers in an art museum, are the least understood by city, state, and federal budget personnel and are often the first to be excised from museum budget requests). In other cases, museums feel that government financing in some sensitive areas might lead to interference, and may therefore employ donated funds for acquisition, publication or exhibition expenses.

Investments may vary a great deal in annual yields, which may

necked director or board chairman who turns down a restricted but otherwise beneficial gift offer may learn that he has substituted his personal prejudices for institutional morality and shunted a most desirable donation to another beneficiary.

CORPORATIONS

Generous corporations also support museums in various ways; such support is sporadic, uncertain, and usually *ad hoc*. The Business Committee for the Arts has encouraged giving, and they report a considerable increase in corporation giving to museums in recent years. Some museums attempt to run a corporate membership program, sending membership cards and allowing privileges to employees of a corporation in return for blanket dues payment. The money realized in this is almost negligible and supervision of such a program is an expensive chore. Some corporations prefer to make outright contributions instead of taking membership.

It should be observed that gifts of works of art from corporations or individuals drawn out over a period of time for tax purposes, are a value in kind which improve the capital assets of museums by getting works of art on its walls. Without such giving, the National Gallery of Art, the Metropolitan Museum of Art, The Cleveland Museum of Art, and many others would not be the great museums they are now.

FOUNDATIONS

Foundations have also played a part in this kind of giving and are regular supporters of museums, some exceptionally so where continuing donations have sustained programs in several museum areas, notably conservation, archives, catalogues of collections, and research (for example, the Andrew W. Mellon Foundation, the Ford Foundation, and the Samuel H. Kress Foundation, which has placed nearly 3,000 works of art in 76 museums over the United States).

OPERATING RECEIPTS

Many museums depend much on receipts from various activities for a cash flow to keep them operating. Such receipts may come from a variety of sources, among them gate receipts (mandatory or

be high or low, depending on the investment policy of the museum. Investments may be made in stocks, in bonds, in Treasury bills, in business operations, real estate, and other unrelated business activities (which can be taxable), or by skimming off capital gains at an agreed percentage.

Even without increasing services, inflation is now generating sharply-rising costs while cost-control procedures are less than perfect and capital drives, important as they are, seem more difficult than ever to mount successfully.

Restrictions on endowment investments can make another problem. Most directors review each specific deed of gift to understand its restrictions prior to recommending acceptance by the board, and the board members themselves may disapprove or refuse on the grounds of restrictions which they cannot abide by, for whatever reason.

Management of endowment funds may be internal or external. There seems to be not much preference one way or the other; a sampling suggests that internal management may be only slightly less common than outside investment management. In at least one museum in recent years, the director has himself been the investment manager, but investments are usually governed by trustee sanctions. Some museums ride "piggy-back" on larger investment programs in which their trustees are also involved, for example of universities and hospitals. The director or treasurer of a museum may be given discretionary investment authority to some degree, as for example short-term investments of excess cash, on a reporting basis to the board of trustees.

OBSERVATIONS ON MIXED FUNDING

There are many consequences of such a variety of funding possibilities, not the least among them the responsibility for a split budget. Most public museums have two operating budgets—one for donated funds, another for public funds. Restricted nonoperating funds are held and reported in the areas of accountability to trustees and donors. Keeping track of restrictions of gifts of money or art is complicated, grows with the museum, and requires constant surveillance and staff instruction. Care must be exercised by a museum, too, not to engage in or become associated too closely with unrelated business activities so as not to jeopardize tax-free status.

Museums suffer from nonrecognition of their capital needs (including building improvements, acquisitions, increased security, reinstallation, and demands by the museum audience for better facilities) and other needs occasioned by depreciation, obsolescence or inflation—a blindness affecting legislator, public, and profession alike. Millions are needed if art museums are to survive, and serve. Their financial problems were recognized in the First Aspen Conference on "Museums in 1980" and in *The Belmont Report* (1969), but these still remain undocumented as to specifics. Facts, and interpretations of them, are needed or museums may discover, perhaps too late, that they have been gradually liquidating.

One of the chief obstacles in the road to fact finding is the irreconcilability of museum accounting systems, one to the other. There is no standard or uniform accounting system. Some systems are clear and patently related to operating needs and structures; others are obscure, involved, and practically unserviceable. The American Association of Museums is undertaking to set some standards for accounting and reporting which will provide better controls and enable comparisons; but they can only offer suggestions and models, and these are not yet in sight.

About half of American museums show an annual budgetary surplus. This is misleading and gives a false sense of security, for it does not reflect their solvency but rather that the law (or the board) requires the director to stop spending before he overspends. The skill of his financial officer at piloting to a landing on the $00.00 mark—more like a parachute jump, has saved many a director. But, like a retreating amoeba, a museum usually remains whole only at the expense of a contraction of the periphery of its acquisitions, conservation, presentation, and programmatic undertakings, to the detriment of the public, and of the discipline.

Thousands of volunteer workers in museums yield "income" of a special sort. The extent of this is undetermined, but two-thirds of the persons working in a museum are said to be volunteers. They are mostly part-time, however, and several large and medium-sized museums have estimated their dollar's worth. One large museum, for example, estimated that an average work load of four hours per week per volunteer was the equivalent of fifteen salaried positions a year.

The U. S. tax system, as one museum trustee put it, "has the greatest impact on museums of any economic factor, direct or

indirect," and although direct federal philanthropy has been scant, it is growing. Should the federal tax reductibles be reduced, or taxes increased on the private donors, there would be a reduction in charitable gifts to museums and this would become an indirect taxation of museums.

But for museums, Nancy Hanks, Chairman of the National Endowment for the Arts, has summed it all up: "Inadequate fund raising is important in failure."

Who Uses the Museum?

Because the third charge of a museum is the presentation of its art objects for the education and pleasure of its visitors, the general public is crucial in consideration of a museum's operation. Much of it is a casual audience, not a captive one, and must be handled differently from the audience of a teaching institution with its formal—and captive—classes.

Directors must be aware that dust, dirt, bacteria, and security problems attendant on public use are detrimental to the well-being of works of art. The director also must be aware that the attitudes of the public are important to the well-being of the museum and, in general, he applies the Navy slogan with regard to the public, "a taut ship is a happy ship," providing everything feasible in the way of facilities and instruction.

We know very little about the museum visitor. The Associated Councils of the Arts published in 1974, *Americans and the Arts* (including museums), as highlights of a full survey to be produced later. From it we learn that as of January, 1973, 48 percent of the adult U. S. public (over 16 years), or about 69.8 million out of a possible 145.5 million Americans, had gone to an art museum. Of the interviewed sample of "cultural attenders" (museums included) 10 percent were frequent attenders, 20 percent moderately frequent, 41 percent infrequent and 29 percent (projectable to about 43 million persons) were nonattenders.

Education and place of residence are among the most important determinants of cultural attendance, with an overlap to be noted between education, income, and age. So 68 percent of the eighth grade educated are nonattenders compared with 30 percent of the high school educated and 11 percent of the college educated.

Fifty percent of those with incomes under $5,000 were non-attenders. Thirty-seven percent of people in rural areas are classified as nonattenders, as are 30 percent of those in cities. The highest concentration of frequent attenders are in suburbs and cities. Geographically, the greatest concentrations of nonattenders are found in the South (51 percent); the greatest concentrations of frequent attenders are found in the West (17 percent), the Northwest (15 percent), the Northeast (12 percent), and the Mid-Atlantic states (14 percent).

Moreover, and generally, attendance does not vary by sex or race to the same degree that it does by other key socio-economic factors.

The survey showed also that "the public's attitudes toward museums are positive indeed." Reported also was that "any notions that the public sees museums as highbrow, elitist institutions were also dispelled by the survey." It should be noted that the survey covered history and science museums:

35% of the public prefer an historical museum,
27% prefer a science or natural history museum,
25% prefer an art museum.

However:

. . . people in towns and rural areas showed a greater interest in historical museums, whereas city and suburban residents leaned more heavily than others toward art museums.

The young (16 to 20 years) were more interested than others in art museums. The eighth grade and high school educated were more partial to historical museums, whereas the college educated expressed greater interest than others in art museums.

Men were evenly divided in their preferences between historical and science museums, with art museums trailing; women are more interested in historical and art museums, and are less so in science museums.

Although the public as a whole tended to favor historical museums, frequent museum goers (at least three times a year) expressed their strongest preference for art museums (37 percent).

OTHER OBSERVATIONS

One major audience problem arises out of work schedules of the visitors which cause them to bunch their visits on weekends. One large museum estimates that it could easily serve three to four times as many visitors if only they could spread their weekend visitations over seven days.

Museum audiences may be regarded as drawn from the "leisure class" described by Thorstein Veblen in 1899, for they certainly exemplify the conspicuous consumption of a service by the new mobile society of the United States. On the other hand, Professor Rolf Meyersohn has pointed out (*Saturday Review/World*, April 5, 1974) that the social class of the family no longer determines the leisure practices of its children, that the life cycles of Americans are changing, and that they are spending more time in learning and leisure. Meyersohn says, "The working years, with time for some leisure activities, are a preparation for retirement, which comes then as a grand finale of self-realization." He sees the class of young adults as responsible more than anything for the attention devoted to the New Leisure, and as young adults become older, and assume more responsibility, a new generation of adults appears, producing a continued youth line or a "serial community." It is this serial community which utilizes the museum like the incoming freshman class at a university.

After the general public the rest of a museum audience is made up of students, many of whom have studied or are studying art, professional museum persons, or art historians, school teachers, and school children herded in from nearby schools. On special occasions there are adult groups for various purposes, such as members' tours from other museums or minority groups to see a special exhibition.

There is a tendency in some museum quarters to view a museum more as a social instrument than as a museum-qua-museum. This may lead the trustees and the director, either voluntarily or under pressure, to order programs catering to deprived groups or ethnic and minority groups, shifting the emphasis away from traditional research, exhibition, publication, and programming to shows and events tailored particularly to the needs of these groups.

On the other hand, art museums once traditionally show-oriented, now seem more aware of the research aspect of their responsibilities and a number have developed a university nexus, in some instances combining the use of their two plants for research, scholarly production and serious teaching.

If there is one word which characterizes the relationship of a museum to all its visitors it is "underutilization." An increasing awareness of this may guide the trustees and the director of a museum toward new goals and new operating structures. The

people who want to go, and do go to museums, are also part of this problem, but less so than those who stay away.

Options

One great difficulty now facing the policy makers of a museum is to describe the parameters of their museum's interests. Where shall they put their limited dollars? The final operating pattern of a museum will reflect their choices, options, tendencies, and policies. Will they emphasize collecting, or is their collection static and will their emphasis be on conservation? Or will programs be emphasized? Programs are apt to be the most expensive, staff energy consuming, and a rich source for basic conflicts, such as that involved in scholars seeking to do proper research on the collections being siphoned off to administer programs for popular consumption. A staff can be worn out pursuing higher attendance figures and a steady flow of press releases about on-going events, and the museum can consume in programs substantial funds which might otherwise go into areas considered by many to be more basic— collecting and conserving. "Spurious enticements to the public debase a museum with razzle-dazzle," one foundation executive has observed.

There are many pitfalls in the path which emphasizes programs (and services, too) and the director must be wary of letting any one of the programmatic or service elements of his museum become disproportionately large and overwhelming, whether it be an activity, a school, a restaurant or a shop. "Focus on the audience or focus on the object," is too simple a choice, for it depends on how each is accomplished.

These are fundamental choices. A museum is inherently a combination of repository, theatre, classroom, research center, activity center, side show, and home for an art elite; while it cannot be all things to all men, it can provide something for everybody. The emphasis decided upon by the trustees and the director must be carefully thought out, have long-range stability, and the staff must be dedicated to pursuing the goals agreed upon. There is no reason why someone should not come to a museum to take a course in drawing or to see theatre, possibilities not unrelated to the practice of going to church to hear a concert.

In museums, it is difficult not to be on the side of what you take to be that of the angels. The truth of our profession is that a museum worker is as serious about his job as John the Baptist was about heaven. But, it has been observed, he carried the added responsibility which John never undertook, of knowing that he may be wrong. However, let no one write an epitaph for a museum like the one by the hypochondriac: "I *told* you I was sick." Museums need proper financing; but first they must examine and collate their data on what they need, where they are going to get it, and how they are going to use it. Perhaps a well-known English manufacturer's maxim may be applied to museum financing: that he knew well enough that half the money he spent on advertising his soaps and detergents was wasted, but he would be happy to know which half.

A museum is not a school, but has been called a "parallel educational system" doing what schools cannot do, making the confrontation of object and viewer possible and allowing an aesthetic experience to take place. And an educational experience occurs, too, as the viewer discovers the essential tendencies of the artist's mind manifest in the work of art. "The best educational technique," says one director, "is an exciting object beautifully installed." Under those circumstances "elucidation" is most likely.

All museums, except federally budgeted ones, do a national (even international) job on a local budget, chiefly because their publications and services are utilized by visitors who come from an area much wider than the local scene. Catalogs, photographs, and reproductions are out-reach factors. Where an extension service is in operation, the audience for that service in the classrooms and club rooms throughout the state or nation may be much larger than coming through the doors of the museum itself. The National Gallery of Art, for example, has an extension audience of over four million and a local audience of nearly two million.

To promote proper utilization the collections and exhibitions must be seen in relationship to the educational program, thus bringing the visitor into confrontation with the object, helping him to distinguish personal preference from critical judgment, to measure his capacity against that of the artist, and to learn how in another time and place, someone presented beautifully and without words his own point of view.

George Heard Hamilton

4

Education and Scholarship
in the American Museum

After some forty years spent principally as an art historian, but
also as curator and administrator in three museums, I am well
aware of museum education and have observed certain admirable
as well as distressing aspects of it. What follows, instead of a
definitive statement about museum education and the interrelated
question of the place of scholarship in a museum, are somewhat
disgruntled reflections on the necessity and place of education and
scholarship, with certain observations on the effects, good and bad,
which too much of one and too little of the other may have on the
function and structure of a museum. I have placed these remarks
within the context of the historical development of museums in
Western civilization, and although I shall support the argument,
where possible, by specific references, generalizations will be
unavoidable. May the reader recall Oscar Wilde's remark that "all
generalizations are false, including this one."

The reader is also advised that the following discussion is directed
solely to the problems of education in art museums, only tangen-
tially applicable to museums of history, natural history, and science.
In a science museum, for example, the laws governing planetary

GEORGE HEARD HAMILTON *is Director of the Sterling and Francine Clark Art
Institute, Williamstown, Massachusetts, and Professor of Art at Williams College. In
1971–72 he was Slade Professor of Art at Cambridge. Author of a number of
authoritative texts, including* The Art and Architecture of Russia, *he has sat on
many museum boards and advisory commissions and is a former president of the College
Art Association.*

revolutions, the genetic structure of cells, or the development of lower vertebrates may not be self-evident, which is to say visually intelligible, without the support of written texts. For the sake of the argument I shall assume that the development of artistic structures is much more, possibly almost wholly intelligible, with a minimum of peripheral documentation.

From this position I deduce a distinction between the kind of knowledge, usually historical, which is supplied by verbal sources and comprehended by the conscious, rational mind, and the kind of knowledge which grows from artistic experience, conveyed through the senses when confronting a work of art as a work of art. Such knowledge, irreducible to verbal formulae and not easily communicated by one individual to another, is largely nonrational; for the work of art may generate emotional responses from the preconscious and unconscious areas of psychic life.

With the late Sir Herbert Read, I ascribe to art not only its end products of pleasure, but also its function as the primary humanizing element in the development of human consciousness. "Without the creative arts there would have been no advance in myth or ritual, in language or meaning, in morality or metaphysics." (Read, *The Forms of Things Unknown, Essays toward an Aesthetic Philosophy*, 1920, 92; also the presentation of his position in *Icon and Idea: The Function of Art in the Development of Human Consciousness*, 1955.) From this point of view art not only precedes verbal rationalization, but is in itself a kind of knowledge, the apprehension of which, however, requires the suspension of verbal exchange just as, in theory at least, it needs no verbal exposition. Expository statements can at best illuminate only the causal conditions for the work's creation, its emergence at a particular historical moment whose specific intellectual, spiritual, political, and sociological character shaped its outward form and determined its inward content: Leonardo's *Mona Lisa* is not the same as Marcel Duchamp's.

Given the nonverbal substance of the work of art, the task of a museum educator in a society which puts a premium on knowledge verbally conceived and exchanged is not easy. Even the most up-to-date audio-visual devices designed for the explication of works of art are merely extensions of the word, cover-ups, as it were, for the fact that the irrational nature of the work of art will forever elude those who are condemned to talk about it. The audio-visual approach ". . . has added nothing to museum object presentation

except entertainment . . . Objects are the only exclusive media of museums." (J. Shannon, "The Icing is Good, But the Cake is Rotten," *Museum News*, January-February 1974)

The Museum in History

Because we are concerned with problems peculiar to the existence of the museum in the democratic societies of the twentieth century, we need only summarize the development of the museum as a cultural institution from its incidental emergence in ancient Greece to the proliferation of private collections or "cabinets" of natural and artificial curiosities in the Renaissance (for a general history of the development of museums from antiquity to the present, see Germain Bazin, *The Museum Age*, 1967).

The Latin word *museum* is derived from the Greek *mouseion*, meaning a sanctuary dedicated to the muses. Subsequently it was applied to what we might consider an academy for philosophical and scientific speculation. The most famous of these was the *mouseion* at Alexandria, founded by a bodyguard of Alexander the Great. There the scholars' meditations were supported by the great library which adjoined the academy (thus reinforcing the authority of the written word), although in the adjacent palace there seems to have been a collection of art objects, while in the *mouseion* itself there were productions of the performing arts—music, drama, dance— which were not thought inconsistent with scholarship and science.

Following the decline of the ancient world, the dispersal of the collections of Greek art formed by wealthy Romans and the destruction of the ancient libraries, the concept of the *mouseion* disappeared. What remained, however, was the impulse to collect rare, precious, exotic, or mysterious objects, or those hallowed by historical associations, whether works of art or natural specimens, gathered in cathedral sacristies or the treasure rooms of noble families. One of the greatest of such medieval "museums" of religious art was the Guelf Treasure owned by the ducal house of Brunswick-Lüneburg, dispersed only in 1930. The sacristies of many European churches still preserve the character of such ecclesiastical collections, just as the Green Vault in Dresden perpetuates the royal treasure rooms of the sixteenth and seventeenth centuries.

Whether such treasure rooms could be considered museums in the modern sense depends upon the degree to which they were accessible to the public. Certainly until the eighteenth century there was no conception of mass public such as flocked Blenheim Palace when it was finished (it had been built for the first Duke of Marlborough by the government, and the British public had an interest, financial as well as artistic, in such a considerable edifice). But evidence suggests that the serious scholar or educated amateur with the proper credentials could gain access to most collections.

The museums of science and art emerged from the collections of curiosities gathered in the sixteenth and seventeenth centuries by scholars and natural philosophers. The first of them, opened to the public in 1683, was and is the Ashmolean Museum at Oxford, designed to house Elias Ashmole's collection of antiquities and John Tradescant's collection of scientific and archaeological instruments. In 1753, the British Parliament acquired Sir Hans Sloane's library, including natural phenomena as well as manuscripts and books. It became the British Museum in 1758 when the libraries of Sir Robert Bruce and of Robert Harley, Earl of Oxford, were added. Meanwhile at the other end of Europe, Peter the Great had his *Kunstkamera* constructed in St. Petersburg to house the imperial library and collections of ethnographical artifacts.

Such combinations of works of art, books, and natural phenomena remained until into the twentieth century an accepted museological solution. The new building for the British Museum (completed 1852) still shelters behind its Ionic portico Great Britain's primary anthropological, archaeological, and literary collections, along with the Elgin marbles and magnificent Assyrian bas-reliefs. In our own country the first public museum was opened by the painter Charles Willson Peale in Philadelphia, in 1786. His beguiling self-portrait invites us to inspect his collection of natural wonders as well as his portraits of the Founding Fathers of the Republic.

Lest this association of what we now consider separate categories of art, science, and history, seems naive, we should recall that a collection of works of art given to our nation shared its quarters in Washington with the Museum of Natural History until 1968. In Pittsburgh the final separation of art from natural and technological objects occurred only in October 1974 when the Museum of Art, formerly the Department of Fine Arts of the Carnegie Institute, was

installed in a building of its own. Originally the heterogeneous materials had been brought together in the familiar belief of the Enlightenment that man could and should take all knowledge for his province, and that there was no fundamental intellectual distinction between organic or inorganic specimens of natural or man-made, scientific, literary or artistic products. The assigning of specialized spaces for specialized minds to work on specialized collections is a more recent development. The divorce of scientific thought from artistic feeling is symbolized in New York by the vast buildings of the Metropolitan Museum of Art and the American Museum of Natural History confronting each other across Central Park.

The Emergence of the Modern Public Museum

The first truly great public museum, revolutionary in concept and itself the result of a revolution was, and is, the Musée National du Louvre. On August 10, 1793, the first anniversary of the fall of the monarchy, the royal palace of the Louvre, in the heart of Paris, was opened as a public museum, exhibiting the expropriated royal collections. Closed for repairs in 1799, it reopened in 1804 as the Musée Napoléon with the spoils from the countries which the First Consul had conquered, among them numerous famous works of the highest quality. Until the collapse of the Empire in 1814, the Louvre was the greatest museum in the western world, rivaled only by the Hermitage in St. Petersburg where the imperial Russian collections, however, were not yet completely accessible to the public. In Paris, the world's treasures were there for all to see, and visitors came in numbers, from neighboring countries as well as France itself, to see what in essence was the first great public exhibition of European art on historical principles and on an international scale.

Summary

From this capsule account of the origin and definition of the public art museum as we know it today, certain attitudes may be inferred about its past and present function.

First of all, it is clear that the special character of visiting an art

museum was only slowly separated from other intellectual activities such as religious veneration, curiosity about natural phenomena, and about human history as exemplified by works of art—portraits of eminent or notorious personages, objects such as arms and armor, furniture, clothing, and utensils associated with them.

As the merely monstrous and fabulous was gradually eliminated from the collections of natural history, so the merely intricate and costly was eventually distinguished from objects possessing intrinsic artistic quality. Yet despite such discrimination, two persistent attitudes of the museum visitor are still with us: a fascination with technical virtuosity for its own sake, and the thrill of recognition when the spectator becomes more interested in identifying the subject of a work than exploring its form and content. These attitudes are probably inseparable from human psychology. Nor are they in themselves worthless, except to the degree that they deprive the spectator of what we now consider the more meaningful rewards derived from close attention to the total structure of a work of art.

Finally, this millennial history of museological development culminated when the fundamental functions of a museum—to collect, to conserve, and to present to the public—were spectacularly promulgated with the reopening of the Louvre in 1804.

The arrival at the Louvre of paintings which for centuries had never been removed from the churches and palaces for which they had been created caused serious problems of preservation. The greatest of the early directors of the Louvre, Baron Vivant-Denon, can be credited with having been among the first, if indeed not the first, museum director to establish proper conservation laboratories. In the presentation of the works, much thought was given to the repainting and rearrangement of the halls, so that the pictures, well-lighted, could be seen properly by the public.

To what end was the public provided with this exceptional artistic opportunity? Part of the answer, undeniably, was the national prestige acquired by the possession of the greatest art, but a more important part—that which motivates museum programs even today—was embodied in the Revolutionary legislation of the early 1790s, to the effect that the public was entitled to enjoy the advantages of free citizens in a democratic society, among them being access to the greatest works of art, heretofore the property of the Church, state, or private individuals. Such access, however, was

not solely for aesthetic pleasure, but for the inculcation of political and social virtue. Though Napoleon's imperial ambitions eroded the earlier republican artistic morality, there remained a strong belief that acquaintance with great art improves the morals as it does the taste of the individual and thus contributes to the general welfare of society. Is it not the fundamental moral imperative basic to the development of museums in the nineteenth and twentieth centuries, that they have an essentially educational function to perform in a modern democratic society?

The Foundation of National Museums after 1800

In one country after another the foundations for national collections of art in emulation of the Louvre were laid in rapid succession throughout the nineteenth century. The Prado in Madrid, after roughly three decades of construction, opened in 1806 for the Academy and Museum of Science, and assembled the royal collections of painting in 1819. In 1824 a National Gallery—primarily a collection of paintings—was founded in London. The collections of prints and drawings were maintained at the British Museum; the foundation of a national collection of sculpture and the decorative arts was developed at the Victoria and Albert (formerly the South Kensington) Museum.

In Berlin the Altes Museum, designed by Schinkel and opened in 1830, could be considered the Prussian national gallery, containing collections of Italian and Northern painting acquired by King Friedrich Wilhelm III. In Munich Leo von Klenze designed the Glyptothek (opened in 1830) to house King Ludwig I's collection of classical antiquities, and the Alte Pinakothek (opened 1836) for the collections of the Wittelsbach dynasty. Munich even had one of the first museums for contemporary art, the Neue Pinakothek, containing mainly works by Munich artists. In St. Petersburg the imperial collections were rearranged in new halls after a fire in 1837, and von Klenze designed the New Hermitage for Nicholas II. In Vienna the complementary museums of art and science, facing each other across a park, appeared as majestic as the Hofburg itself. The interior stairhall of the Kunsthistorisches Museum remains the most lavishly decorated of any museum in Europe. In the Low Countries the Rijksmuseum in Amsterdam (opened 1885) and in

Brussels the Musée des Beaux Arts were also as much repositories for the art of their own and other countries as witness of the national pride of people whose independence had but lately been won.

In Germany and Italy, political disunity hampered the concept of a national museum of the people as a whole. Usually, in the larger or more historic cities, ecclesiastical and princely collections could be arranged for public exhibition in disused churches, convents, palaces (The Brera in Milan, the Pitti in Florence), or even formal ducal office buildings (the Uffizi in Florence). Such museums have preserved to our time a degree of intimacy lacking in newly constructed museums.

Although palatial in design and decoration, the conventional majestic central staircase flanked on either side by galleries has often daunted even enthusiastic visitors. In our country, the essentials of the imperial plan, as we may call it, have been perpetuated in the twentieth century (the new buildings for the Metropolitan, the Boston Museum of Fine Arts, the Philadelphia Museum of Art, and the National Gallery of Art in Washington).

The reaction to the palatial concept began in 1939 with the Museum of Modern Art's first permanent structure, designed by Philip Goodwin and Edward Durrell Stone. To the first director of the Museum of Modern Art, Alfred H. Barr, Jr., is due the credit for having discovered informal and assymetrical arrangements which reveal instantly and to the eye sequences of form and feeling that no amount of labeling can expose. The most recently constructed American museums generally permit a freedom of installation for both permanent and temporary exhibitions to achieve arrangements which in themselves can be educational.

It is important to note that despite the implicit belief that the museum is primarily for the benefit of the whole people, educational activities in Europe remained at a minimum. As late as 1973, the Rijksmuseum in Amsterdam had no systematic education program for different age groups. The burden of providing some knowledge of the significance of the great Dutch art in the Rijksmuseum has been left to the schools and universities, and to community colleges which provide continuing education for adults and the working classes. Rather, it remained for the peoples of the English-speaking countries to realize that museums could be more than repositories limited to the protection and static presentation of

great works of art. In Great Britain and the United States—which had participated little or not at all in the development of the European tradition of painting and sculpture from the Middle Ages to modern times—the educational obligations of museums came to be embodied as essential principles in their charters.

In London the South Kensington Museum, created in 1857 on the basis of the collection of decorative arts remaining from the Crystal Palace Exposition of 1851, was intended to educate the artisan in the principles of good design, implementing Ruskin's and Morris's historical bias toward the study of the decorative art of the past for the improvement of the useful arts of the present. More complicated was the question of educational significance for the general public of a museum which embraced extensive collections of the fine arts. In the British and American museums special conditions inevitably affected the rapid growth of the collections and consequently their relevance to public instruction, as can be gathered from the charters of the two oldest important general art museums in this country, the Metropolitan Museum in New York and the Museum of Fine Arts in Boston. Both were founded in 1870 on the threshold of the stupendous economic development of the country in the later decades of the nineteenth century. Both soon moved from their modest quarters into buildings of overwhelming proportions, quadrupled in size, and have kept expanding ever since—not only to accommodate the collections, but to develop their public services, among them their departments of education.

Yet what was this lavish expenditure of money, time, and thought intended to do for the individual citizen? The Charter of the Metropolitan states that the museum was to be established and maintained for the purpose of "encouraging and developing the study of the fine arts, and the application of arts to manufacture and practical life; of advancing the general knowledge and kindred subjects, and, to that end, of furnishing popular instruction." Only a few years later, in 1876, the Philadelphia Museum received its charter as the Pennsylvania Museum and School of Industrial Art. Ruskin's moral fervor for the improvement of what has since been called industrial design is clear. In Boston, Perkin's modest hopes were that there might be established a museum where instruction for "artists and artisans . . . would be conducted through the study of casts and photographs." In February 1870, the Massachusetts Legislature created a corporation "for the purpose of erecting a

museum for the preservation and exhibition of works of art, of making, maintaining, and establishing collections of such works, and of affording instruction in the Fine Arts."

To collect, to preserve, and to present; to these fundamental museological functions was added the important fourth—education in the sense of affording instruction.

The difference between the New York and Boston charters is slight but interesting. In Boston the founders provided from the first systematic specialized instruction in the practice of art. The School of the Museum of Fine Arts is still one of the best art schools in the country. In New York, the emphasis was on general public education, with merely an academic recognition of the museum's obligation to the artisan and artist. Despite the charter's reference to "the application of the arts to manufacture," little seems to have been accomplished or even contemplated which would lead to such an alliance between art and industry. But then, in 1870 Cooper Union already existed to do just that. The Metropolitan's concern was rather scholarly, since the "popular instruction" offered at first in the form of lectures probably reached little more than the already well-educated upper class of urban society.

From 1870 on, no museum was founded in this country without formally recognizing its obligation toward public education. In 1950, for a much smaller museum of a remote village, the charter of what is now the Sterling and Francine Clark Art Institute spelled out the educational purpose of its founder in the clearest terms. In addition to the by now familiar statement of museum duties, the incorporators were enjoined

> to provide . . . facilities for study and research in one or more of the fine arts . . . [and] to engage in or assist educational activities, teaching and research in one or more of the fine arts or related fields . . . developing public knowledge of and interest in the fine arts and related subjects . . . to the end that all the activities of the corporation shall advance and assist the cause of art and learning for the general benefit and happiness of mankind.

Over a century and a half after the French Revolution, could the moral imperative for public education in the arts and the civic value of the art museum be more clearly expressed?

The Practical Implications of the Moral Imperative

It is one thing to secure a legal charter confirming education as a principal function of a museum; it is another to put the

educational function into practice. Considered as an end in itself, an extreme position has been taken by one prominent museum educator who states that the museum is "fundamentally an educational institution deriving its character from the needs and desires of the community which it serves" (Theodore Low, *The Educational Philosophy and Practice of Art Museums in the United States*, New York, 1948, 62; cited by M. Luca in *Museums, Imagination and Education*, UNESCO, 1973, 145–8). From this point of view the museum can easily become the servant of the community, especially if it is dependent upon public funds. Is it therefore entirely improbable that the needs and desires of the community, assuming the community can distinguish between what it wants and what it needs, might be able to dictate to the museum's administration what works of art should be acquired, which exhibitions held, how much sophistication tolerated in the museum's educational programs? Museums were created to raise the standard of public artistic experience, in which task they should no more dictate than be dictated to. It seems to me that the greatest museums, and those most successful in their educational programs, least derive their character from the needs and desires of the community which they serve.

One might facetiously turn the question around, less in the hope of reaching the correct answer than of placing the problem in a different perspective. What if we were to say that perhaps the community exists to serve the needs and desires of the museum? Surely the museum needs the community to test the viability of its activities. The problem was more sensitively stated by the late director of the Brooklyn Museum, Philip N. Youtz, when he wrote that "the role of the museum is to bring to students and adults who live in a complex civilization where most adventures are second-hand, a fresh visual knowledge of the great art of their own and of past cultures."

Having granted that education is a proper function of a museum if kept in its proper place, there are still questions to ask. Who comes to a museum? Are those who do most in need of knowing more about that with which they already have some acquaintance, or are there beyond the museum's walls literally numberless individuals for whom every effort must be made to entice them inside? Attitudes to museums vary, and in a free country the rights of the majority, who may number all those who do not want to go to a museum, should be respected. Curiously these rights are ignored

most of all by the educators themselves whose ecumenical mission will not let them allow one small child to struggle free. The messianic demand that since the museum belongs to all, all should participate in its activities, has as little justification as the devices used to attract the support of the maturely uninterested in the hope that they may help to relieve the museum's financial necessities. But once our extraordinary exertions to prove the museum's response to "the needs and desires of the community" have coaxed the unwilling, indifferent and innocent into joining the inquisitive and enthusiastic inside the museum, a series of contradictory situations develop within the educational program which require tact and intelligence to unravel.

THE HISTORICAL PARADOX:
CONTRADICTION BETWEEN OBJECT AND WORD

To what extent can the work of art stand alone, without additional verbal interpretation? The answer depends upon each person's previous experience, formal education, innate sensitivity, or casual curiosity.

Offhand one might think that the more extensive an individual's education, the better he should be able to apprehend the artistic qualities of a work of art as well as comprehend its historical significance and associations. Such, however, is not the case. The verbally-oriented character of American education has created a generation of museum visitors who are, so to speak, form-blind. They see what they are looking at only if it is a *tour de force* of craftsmanship and anecdotal subject matter, the more pleasurable when recognized with the least difficulty. One would like to think that the immense development of instruction in the history of art since the beginning of the century would have shaped an audience with a more sensitive as well as sensible approach, but the reverse seems to be the truth. The huge increase in museum attendance has not been matched by a proportional increase in the familiarity with the historical or formal constituents of the artifact.

WORDS, WORDS, WORDS:
THE LECTURE AND THE GALLERY TALK

Although most museums, by their physical prominence, rank as major tourist attractions, I am willing to concede that many

transient visitors, having entered more out of curiosity than in pursuit of aesthetic experience, yield to visual involvement with the exhibited objects once they are inside; and with a little help, their attention can be directed to the objects' artistic importance. Such help usually takes the form of a gallery talk through which the visitor may acquire the rudiments of historical perspective and a sense of what he might look *for* rather than merely look *at*. Though the most superficial and probably least enduring form of museum education, such talks are usually more gratefully received than given. More formal lectures also come in for considerable criticism. The slide lecture in a darkened room can lull the audience into too passive a mood for active intellectual and emotional confrontation of an actual work of art. The entire concept of formal lectures is questionable, for the student progressively becomes less receptive and consequently fails to become engaged with the subject. Yet the tradition of lecturer and captive audience has its merits. In all museums, large or small, there are areas of artistic production which are not represented, and cannot otherwise be brought to the attention of its public. Similarly, there are certain subjects, such as the relation of the decorative arts to their architectural environment, and architecture itself, which can achieve only token representation in a visual museum. And finally, those of us who have lectured at museums know that the effort is not entirely wasted. The gratitude of the few lost sheep that are saved from the flock can be measured in their enlarged intellectual and emotional experience.

The gallery talk poses problems of another nature. Aside from the fatigue of standing at attention, if the numbers attending the talk amount to more than a very few, the majority will have little opportunity to correlate the docent's remarks with a close examination of the object under discussion. The more gifted the docent, the larger his audience, and the smaller the net returns. The presence of docent and group also creates a noise pollution where quiet contemplation is the only condition under which a work of art can be satisfactorily apprehended.

THE INTERPRETATION OF THE PAST IN THE PRESENT

The contradiction between the object and the word, between education and innocence, between historical knowledge and artistic

experience poses the most difficult of educational problems in the interpretation of the past to a public lacking historical knowledge and even indifferent to it. Every teacher knows how difficult it is to make the past seem "relevant" to today's young people; yet until well along in the nineteenth century education was directed primarily to informing students of the meaning of the past in the Shakespearean sense as prologue to the present. French and American Revolutionary leaders saw themselves as incarnations of the heroes they had admired in Plutarch. At a crucial moment in the fortunes of our country when the British army threatened New York, John Adams compared his plight with the dangers which had threatened the Roman Republic. Have we today anywhere in the Western world a statesman who through his public acts and utterances justifies his actions in relation to the proudest aspirations of the ancients? How far our consciousness of the past as meaningful to the present has receded from our concerns can be ascertained by reading any college catalogue: most courses deal with history after 1800 and with what is optimistically described as political science.

The problems which the historical innocence of his audience pose for the museum educator cannot be avoided, except in museums founded specifically for the presentation of contemporary art, since by far the largest number of objects in most museums were created in the far away and long ago, and not one of them can be seen and studied in relation to the environment for which it was intended. To take a specific situation: A museum educator finds himself obliged to interpret an important new acquisition to a motley audience at his museum. The acquisition is a first-rate example of allegorical painting from the School of Fontainebleau by a Primaticcio-influenced anonymous French master. Where does the educator begin? Even for older people the acceptance or recognition of Mannerism may be puzzling because this complex development of European art in the mid-sixteenth century has only been studied since about 1925. How does one clarify for an uninformed audience of pluralistic ethnic origins the complicated interchange of artistic ideas between France and Florence in the early sixteenth century? What, for instance, was available to François I (and who was *he*, by the way?) which determined the character of the palace of Fontainebleau, of its interior decorations, and in their subject matter the contemporary philosophical and literary ideas of a court

society? Yet these are all elements which shaped the form and content of this painting.

I have, of course, stacked the cards heavily against the hypothetical docent, in order to stress the recalcitrant habit of certain works of art to decline to reveal their historical origins to the first comer at first glance. In the Fontainebleau painting, even an examination limited to its formal structure alone may prove bewildering to the audience, given the intricate ambiguities of the Mannerists' reaction, in comparison to the easier apprehension of the geometrical purity of the high Renaissance against which they reacted.

THE "RELEVANCE" OF MODERN ART

The accelerating recession of the past does not make easier the interpretation of the art of the present, especially in its more extreme conceptual manifestations. When a tradition has been interrupted, how can one comprehend the anti-traditional? In Conceptual Art, where there is little to hold on to, physically or visually, the educator must deal with invisible ideational situations, with the wraith of an activity which ended in the artist's mind where it began, and whose message, if any, may be cryptic or disagreeable, often as protest against society. This may arouse an audience's hostility quite as much as the most abtruse manifestations of earlier modern art.

As the past becomes increasingly disregarded as a source for understanding the present, the art of the present becomes exasperatingly remote from artistic apprehension. Moreover, whereas the art of the past (roughly until 1945) was created to be seen in situations dominated by the give-and-take of individual experience —the church, the palace, the home—most recent serious art is so large in size, so overwhelming in scope that it can only have been intended for the museum in the first place. If the nineteenth century saw the creation of museums only for art, the twentieth has witnessed the creation of art only for museums. Even in the work of one so aware of tradition as the English sculptor Henry Moore, we find that the older he grew, the more his sculptures grew in size and weight, and can only fitly be seen in large public spaces or the vastest of museum galleries. This impressive trend toward monumentality involves difficulties for the educator in the loss of intimate communion between object and viewer. The contemplation of

sculpture designed for public places absorbs the individuality of the spectator into a group, a crowd, a mob.

During the unruly late 1960s, museums were verbally and physically attacked by radical groups accusing them of having failed to recognize or attempt to correct the imbalance of our social and political conditions. "Relevant" and "irrelevant" were the capital words. I would like to suggest that neither word has any "relevance" to the definition of a museum's function. The "irrelevance" of its collections and programs may indeed be its most psychologically useful function for the public. What can a roomful of fine eighteenth century French furniture or English silver mean to the mythical "average" American museum visitor? Where it *does* mean something, it has introduced an element of life-enhancing difference into some humdrum existence. To inner-city dwellers or rural farming communities, what would be "relevant"? Things they have seen and known and used every day of their lives? The answer should be a feeble "yes" or a resounding "no."

The total structure of a work of art requires the indivisible conjunction of form and meaning. As the contemporary sculptor, Theodore Roszak, remarked, without meaning there can be no form, indeed no excuse for it, while without form, the meaning remains incommunicable. Andrew Wyeth's retreat into the tradition of a lost pastoral America is as self-defeating as many contemporary artists' repudiation of the concept of the work of art as an ordered structure of form and feeling as old as the human race's ability to make things by hand. To renounce the past or the present is no answer, not even in the short run. When Baudelaire complained that the old tradition had been lost and the new not yet found, he may have pleaded as a romantic but not as a reactionary. The new tradition continues, as the old had done, to elucidate, not to ridicule, the human condition. If to the difficulties of defining the form and content of the art of the present, we add the immense and pluralistic nature of contemporary culture where what is valid in the galleries of Madison Avenue may have little "relevance" in other parts of the country, we can appreciate the difficulty of interpreting ourselves to ourselves.

THE MUSEUM AND THE SCHOOLS

One cannot emphasize enough that a work of art is both a

physical object and an event in time, to be aesthetically appre-
hended and intellectually comprehended by generations geographi-
cally as well as temporally remote from its origin. As an event in
time, in the sense that it could only have come into existence at a
given moment, it carries within it numerous complexly related
ideational aspects implying the intellectual, spiritual, social, politi-
cal, philosophical, and scientific experience and speculation unique
to the time of its creation: as a painting by Rembrandt could only
have been executed in seventeenth century Protestant Holland; a
Claes Oldenburg could only have been put together in twentieth
century New York. A work of art is thus not only a thing of beauty
which will endure, if not forever at least as long as men cherish it,
but also probably the most sensitive instrument we possess for
understanding the past and clarifying the present. These two
aspects suggest the two situations in which its double identity can
best be studied: as a physical object, in the museum; as an historical
event, in the school.

For example, as a historical event, the vast palace of Versailles
expresses the power of its absolute monarch, Louis XIV. But it does
not just *illustrate* the idea. Its form *is* the idea. In this manner, works
of art can serve as exceptionally powerful antidotes for the primacy
of the word in contemporary education. As events in time, they
should have a place in every school curriculum, not just in art
courses. Hence if the museum is to fulfill that part of its educational
function which deals with the historical aspects of art, much closer
cooperation between museums and schools must become the rule
rather than the exception. There must be more extensive and
intensive exchanges of ideas and information between the two
institutions, adapted to the infinite varieties of educational situa-
tions in the schools and to the often finite capacity of museums to
provide original works of art in every area which might be needed.
But unless there is a radical change in the attitude of school
administrators, the impulse for cooperation and coordination will
have to come from the museums for which it will prove a heavy
burden indeed.

At what age children should be brought from the school to a
museum depends upon the facilities available at their museum, and
the educational imagination of the teachers. Younger children's
imagination can be captured by working with the very essentials of
art, with color, light, perspective, space, three-dimensional form,

etc. If the museum has the space, time, and funds to provide workshops for participatory adventures, children can even explore for themselves and discover how the basic principles perform in action; for there is much to be learned about different materials and textures by handling them, or about sculptural forms by grasping three-dimensional shapes. One must caution, however, that the museum may not be the ideal place for such experiments. Most museum directors and curators recoil from the thought of encouraging students to touch works of art, however secondary their quality, when for the rest of their museum-going lives they will have to be sternly warned against touching anything whatsoever. For works of art are frail and utterly defenseless.

At or beyond the fourth grade, when historical studies expand the curriculum, the work of art as an historical event can find a place, but probably more effectively in the school than in the museum. For example, should a museum be so fortunate as to own a fine early Copley, the students could be shown with slides the place of Copley in the history of American art and the reason for the characteristic qualities of his self-taught technique. After that, leave it to the students themselves to discover the Copley in their own museum.

This division of responsibility between museum and school for the difference between the work of art as an object and an event may be costly, difficult, and frequently frustrating. The distinction between the "*res* itself," as Wallace Stevens called it, and talking about it, requires immense amounts of time on the part of the museum staff which will be wasted without the cooperation of the teachers and the goodwill of principals and superintendents who often are inclined to begrudge the hours it takes a class to travel to a museum, to say nothing of the cost. The museum visit may be more easily arranged and more effective for primary than for secondary schools. In the former the children are taught by a single teacher who can arrange the schedule to accommodate the museum visit. This is more difficult in the high schools where time is rigidly apportioned among the subjects of instruction. Moreover, boys and girls of high school age are usually more reluctant to accept the emotional commitment which is essential to the aesthetic experience. Their embarrassment may hide behind boredom, restlessness, or even petty vandalism.

The solution to teenage lethargy may lie in a closer correlation of the high school curriculum with museum artifacts contemporary

with the subjects studied. It is easy to suggest that examples of Greek and Roman art should be shown in courses of classical civilization. But why not show students of geography and natural sciences how changing concepts of cosmological speculation are not only reflected in, but actually determinants of, artistic structures throughout history? Can one really believe that the gravity, density, and absolute rightness of each object for the place it fills in a great Chardin still life could have been depicted that way before Isaac Newton's discoveries? The possibilities for such correlation between idea and object are dazzling and inexhaustible, but their fulfillment will require not only much closer cooperation between school and museum, but also more sophisticated educational experience on both the museum educator's and the school teacher's part. Until then, the elaborate gadgetry of modern educational technology will be wasted.

TEMPORARY EXHIBITIONS: RELATION TO PERMANENT COLLECTIONS

No one can deny that the temporary exhibition is an important part of a museum's program. It encourages not only new visitors to come but also those who may feel that they know their museum almost too well, because a temporary exhibition can lead them to discover new meanings in the permanent collections. But important exhibitions have become increasingly difficult to arrange because of inflationary costs and the reluctance of many owners to expose their treasures to the hazards of extended travel. If costly exhibitions should become an impossibility, would the solution lie in that favorite ploy of museum educators, the exhibition where in place of actual works of art a didactic exercise in stylistic expertise, historical environments, or the like, is contrived by means of photographs, models, and other substitutes for the real thing? *Harlem on My Mind* at the Metropolitan Museum in 1969 was just such a contrivance, regardless of its very real merits. This would seem to be the shape of the future if we are to take at face value the statement by a participant in an ICOM conference who declared that a museum would do better to mount an exhibition on *Dutch Life in the Seventeenth Century* rather than one on *The Art of Rembrandt*. The difference between the two kinds is unbridgeable. Rembrandt's art, with all its complicated interrelations, tells us more, and more directly, than all the illustrative material the most industrious

researcher could assemble. Rembrandt's works are real and communicate a reality that was lived by him and his contemporaries. In the other exhibit, even actual works of art would be reduced to the sociological function of proving the reality of something else, of historical events which are lost and gone except when they can be visually recalled, and what better recalls the past in acute visual terms, the work of art or its simulacrum? Is it not the duty of a museum to provide for its visitors the most fundamental aesthetic experiences within its power, rather than exercises in historical retrospection? In a large museum there may be room for both types; many small museums cannot afford frequent exhibitions of original materials. But the distinction remains, and the public deserves to understand the difference. (Scarcely had these paragraphs been written than the Sunday edition of the New York *Times* for August 18, 1974, carried a review of the Cranach exhibition in Basel by the newspaper's art editor, John Russell, headed "The Museum Show of the 70s Will Have Less Art and More Context." It is later than we think!)

In a temporary exhibition on topical subjects the emphasis necessarily falls upon verbal exposition to support the photographs and objects of historical interest. Such exposition is always distracting and inevitably diminishes the artistic integrity of such works of art as may be included. Whether this is to be counted as a gain or a loss depends ultimately on the priority assigned such an exhibition within the overall program of the museum. If an exhibit's primary aim is to explain the characteristics of middle-class Protestant society, would there not be more to be learned from a genuine example of even a minor Dutch painting than from a series of reproductions? Would Vermeer's *Woman Weighing Pearls*, could one command it, not explain a whole outlook on life and simultaneously let the spectator share in one of the supreme aesthetic adventures in European art? In short, the physical existence of the work of art is the primary fact about it. Its historical origin may account for its formal and expressive content; yet the artist's genius and the work's quality can only be apprehended, not explained. The subject matter of Picasso's *Guernica* could only have been conceived after the Fascist bombing of that Basque village, but the picture could only have been painted after the invention of Cubism. We miss the point of *Guernica* if we see it primarily as a comment on Fascist brutality, rather than as an object.

In trying to be all things to all kinds of people, a museum may be tempted, sometimes by its educational staff, to seek novelty at the expense of artistic integrity in the praiseworthy effort to induce people of all ages to *see* what they are looking *at*. The larger the museum, the more intensive will be the means available to lure the customer through the door. Four recent exhibitions at the Metropolitan Museum, the most conspicuous of our general art museums, have touched the extremes of popular appeal on one hand and scholarly reserve on the other, between trying to titillate the less commendable instincts of American interest in the arts, and letting objects of stupendous artistic authority speak for themselves.

In 1967 Mr. Hoving's first major exhibition as director of the Metropolitan, planned by him before he assumed that office, did in no way discredit his reputation as a remarkable showman. All it discredited was the intelligence of the public which was urged to contemplate a potpourri of objects, drawn from cultures throughout the world and time, which had nothing in common except that they had once been owned by members of royal families. The installation of *In The Presence Of Kings*, as it was called, was spectacular if one cares for objects dramatically spotlighted in cavernous halls. But there was no artistic connection between one object and another, no feeling for the position of an object within its own historical style sequence, but instead an accumulation of luxurious curiosities whose only common bond was that they supposedly demonstrated that kings had "taste." The exhibition had little aesthetic coherence, and its educational pretensions could not be taken seriously.

The exhibition of *Harlem on My Mind*, so unfavorably received, was possibly the most brilliant exercise in museological journalism since Edward Steichen's *Family of Man* began its international travels at the Museum of Modern Art in 1955. Both were primarily photographic, Steichen's entirely so; but in *Harlem on My Mind* the integration of audio-visual components with the photographs was a serious attempt to make the sights of a place and period intelligible also in its sounds (oddly enough, the lessons learned from *Harlem on My Mind* were more skillfully integrated with the costumes exhibition of 1973, *Inventive Clothes: 1909–1939*, where the muted dance music of the 1920s and 30s set the proper period note and even helped us to understand the functional structure underlying the style of the gowns). But of course *Harlem on My Mind* did not contain

much art. It was essentially a sociological essay. The present writer may be in a minority of one in his admiration for that exhibition, but he grants that it was shown in the wrong museum. It belonged, by rights, at the Museum of the City of New York.

But works of art can illuminate history without losing their intrinsic qualities as art. One of the most persuasive, and certainly the most sensitively installed of the four large exhibitions at the Metropolitan during its Centennial Year was the *Nineteenth Century America* exhibition (1970). With no extravagant dramatic effects but a touch of humor now and again, and employing only authentic objects, the curators revealed the range and character of American decorative arts as they had never been seen before. If there were oddities, like the armchair made of elk horns, they were at least artistically and historically valid as demonstrations of American taste in a certain place at a certain time. But there were also surprises; to name only one: the quality of late nineteenth century cut lead glass, a sub-species of glass-making long relegated to second-rate antique shops until the Metropolitan's curators began to assemble outstanding examples in the years just before their exhibition. All in all, this proved to be one of the most coherent, intelligent, informative, and aesthetically gratifying educational exhibitions (those adjectives and adverbs have been chosen intentionally) that the Metropolitan had offered the public in many years. Here was indeed an example of explaining ourselves to ourselves.

The exhibition of French tapestries, in the spring of 1974, represented a more traditional, and now almost prohibitively expensive type of international loan exhibition of masterworks. Interestingly enough, the educational adjuncts were both minimal and peripheral. This was no exhibition of "Medieval Life as Seen in French Tapestries," but an exhibition of the art and technology of tapestry-weaving in the later Middle Ages and Renaissance. The works were there for, and as, themselves. The current issue of the museum's monthly *Bulletin* contained a brief but informative explanation of how tapestries were woven, and an iconographical analysis of the two sets of Unicorn tapestries. The larger scholarly catalogue, prepared in Paris, could be read at home. And for those who wanted to see how tapestries were made there was a small room, unobtrusively situated in the center of the exhibition, where demonstrations were given at stated hours, and where photographic

documentation was available when the weaver was not. To be able to see both sets of Unicorn tapestries at once, one from Cluny and the other from the Cloisters, proved the chance of a lifetime. When it came to the difficult problem of installation, the taste and knowledge of the curators seems to have determined the arrangement and sequence of the exhibits. Their success was measured by the crowds which filled the galleries, and learned by looking.

A temporary exhibition can have a beneficial effect upon the permanent collections when their rearrangement is required by the demands of the temporary installation. At the Metropolitan in 1970–71, when the painting galleries were needed for a large contemporary exhibition, the permanent collection was removed to the north galleries and, as a temporary expedient to show as many pictures as possible in a small area, hung in the manner of older European museums, one painting above the other or in tasteful groupings whose arrangement was determined more by decorative considerations, or the size and shape of frames, than by the works themselves. The effect was educational. The greatest paintings seemed to lose their inherent character in proportion to their contribution to the decorative display. How little may our ancestors actually have been able to see under similar conditions? It confirmed our contemporary habit of treating each work as an entity, the full revelation of which is, after all, a curator's chief responsibility.

Beside this instructive lesson for the professional, the rearrangement of a permanent collection can benefit a wider public by calling attention to relationships between forms and ideas which may only have become visible to the curators or director through so simple an occasion as trying to fit a new acquisition into an established installation. There are surprises which await those who think they know their pictures well when they suddenly see unexpected felicities.

One need not, however, indulge in a frenzy of rearrangement, such as overtook the Metropolitan before and during its Centennial celebrations, so that nothing is left in its familiar place and the habitual visitor may be disoriented or frustrated by trying to find his favorites. Who would want the *Victory of Samothrace* anywhere but on the great staircase in the Louvre? Large and commanding works of art can serve as useful points of reference. Like old friends, they welcome the return of the unsophisticated and the scholarly alike.

If we agree on the proposition that any seriously conceived and interestingly installed exhibition (*Dürer's Wood Engravings*, for example) cannot but be an educational experience, and that an exhibition based upon a didactic theme (*Life in Nuremberg in Dürer's Day* might be a tempting exercise for an education department) may not be a satisfactory artistic experience, then we must be on guard against the misuse of the permanent collection for expository rather than artistic reasons.

Granted that a college or university museum enjoys a greater degree of freedom in developing its program, since its primary function is as an educational instrument. Yet in many communities the college or university or school gallery may be the community's only art museum which therefore has an obligation not only to its student body but also to the community. If the museum enjoys a national, even international reputation in the scholarly world (as in New Haven, Conn.; Northampton, Mass.; Andover, Mass.; Oberlin, Ohio), has it the right to treat important elements in its permanent collection mainly as instructional devices?

I am thinking here of the present installation of American art in the Yale University Art Gallery. Conceived by a brillant educator and authority on the subject, and executed by an exceptionally gifted young architect, the installation has, since its opening in June 1973, attracted rapturous attention from students, reviewers in the scholarly as well as popular press, and the public. The basic principles governing the installation were plausible: to show how objects of decorative art were made, how they were used, how style changed with changing times. As many who have visited New Haven know, the visual impact is overwhelming, especially the clusters of tables on bases of different heights, the walls hung with chairs, the superimposed early nineteenth century sofas, or the revolving shelves of silver which permit the visitor to select a row of teapots, creamers, or what he wishes, by pushing a button until the right shelf rises or descends to view. No pains were spared to teach the visitor what he needed to know about the technological and stylistic development of American decorative arts from 1630 to 1830. Some teaching demonstrations are unforgettable, such as the chair slightly pulled apart so that one can see, at a glance, how maximum strength was secured with minimum joinery.

But—and this is a big *but*—in this installation, designed to counteract the concept of the period room with its static wax

cabinet feeling for the past, several important values have been disregarded. A wall of chairs can be a thing of beauty in itself, not to mention the information to be gained from being able to study their construction more closely; but chairs were meant to be sat on, and were designed to be seen from different angles than high on a wall. This question of reasonable viewing positions affects many aspects of the decorative arts. Worse still, the Yale collection of American paintings, mainly portraits from the mid-seventeenth to the early nineteenth century, has been treated as a series of documentary illustrations of the decorative arts. It may be interesting to know that a chair and table in Copley's superb *Mr. and Mrs. Isaac Smith* can be shown to have existed in more than Copley's imagination by a juxtaposition of the painting with an actual chair and table of the period; but for one who admires Copley this side of idolatry, it is saddening to see his brilliant qualities dimmed by the demotion of the Smiths to the position of educational points of reference. I deduce from the present situation at Yale that a work of art is a very delicate object whose artistic integrity can only be apprehended when treated with tender loving care. Who can do this best, the curator who knows it as a work of art, the educator interested in the function it originally fulfilled, or the designer who sees it as a character in a contemporary drama of light and color?

THE PLACE OF THE EDUCATOR IN THE AMERICAN MUSEUM

Granting that among the most important functions of a museum is its educational service to the community, we need not question the educator's important role on the museum staff, or assign him a position which he considers inferior to those awarded the curators. Yet despite increasing demands for their services, the educators in many museums are still second-class citizens and denied access to those areas of authority, activity, and responsibility which they feel are rightly theirs.

Their frustrations were expressed, in no soft-spoken terms, at a Conference of Art Museum Educators held at The Cleveland Museum of Art in November 1971 under the sponsorship of the Association of Art Museum Directors. It originated in a feeling on the part of certain directors that museum educators were not "in touch with one another." Much more came of the conference than is implied in words suggesting a brotherly get-together. Profound

dissatisfaction with their status accounts for the character of the proceedings of the conference which were published as *Education in the Art Museum* by the Association of Art Museum Directors in 1972. The statistical tables included in the report make sad reading. It is apparent that, at least in 1971, the members of a museum's educational staff were almost forgotten men and women despite the fact that many were doing a first-class job in their role as shock troops who cope with the first encounters of the public at the museum, at all age levels. Based on their education, experience, and the importance of their work in relation to the total program of their museums, I can think of no logical reason why they should not be compensated, dollar for dollar, on a scale comparable with the salaries of curators possessing similar qualifications, similar work schedules, and similar responsibilities toward the total program.

Yet even if we agree that the educators are entitled to receive more for what they have already given, one may still wonder whether they have not asked for more than they need, or whether their demands exceed their responsibilities as well as their prerogatives. For instance, among the eight principles defined by the various committees into which the conference was divided, the first, that "art museums are institutions with original works of art" was followed immediately by the second, that "art museums are educational institutions frequently with formal departments charged with specific educational responsibilities." The second half of this statement is indubitably true; the phrasing of the first half could be questioned: education is one, but not the exclusive, function of an art museum.

The third principle touched upon the relation between education and public support: "Sources of funding for the future are dependent on museums fulfilling their educational function. This appears particularly true of government funding." This seems to place too strong an emphasis on the educational concerns of government agencies. It is not inconceivable that the national interest requires federal, state, or municipal support for art museums which perform minimal educational functions or none at all. Museums are national cultural assets which do not require docentry to justify their continued existence. The fifth principle seems intended to expand the responsibilities of the educational staff in other directions than those normally comprehended within a museum's program: "Art museums have educational functions

not based solely on their collections or on their physical plant." The remaining principles were less controversial, dealing with the integration of the educational staff with the total museum staff, the need for establishing standards of evaluation, and an offer to assist museum directors "in meeting manifest needs of present-day communities."

The steering committee offered recommendations for implementing the principles voted by the committees. Only the first recommendation could create serious problems for the continuing operation of museums as we have known them in the past. It stated that the "Education Staff of art museums should participate in the formation of priorities and policies of their museum." If this sounds harmless, its implications are drastic, and were so spelled out by the committee charged with reporting on "The Contribution of Education to Policy-Making" which went far beyond the confines of education. Among this committee's recommendations were the following two:

> the Education Officer expects to contribute to all decisions, including the setting of priorities, in the following areas in addition to those normally considered educational:
>
> (a) acquisitions, including priorities as to amounts budgeted from operating funds and the needs of certain areas of the collection;
>
> (b) exhibitons and installation including allocation and direction of funds for permanent collection, temporary and circulating exhibitions.

Under *Exhibitions*, the committee recommended that:

> Educators must participate from the beginning in the planning of permanent and temporary exhibitions, and contribute their judgement regarding choice and juxtaposition of objects, labelling, manner of presentation, and the security and circulation factors affecting group teaching. Final decision on these items should rest with an exhibition director, be he curator, educator, or other staff member.

(Observe that the museum director finds his position, if he has any left, reduced to that of "other staff member.")

I have omitted matters which can be considered the proper concern of the education officer. But what are we to make of the statement that he expects "to be involved in training and indoctrination of employees in all departments of the museum" (the departments of budget, repairs, maintenance?) and to have "a voice in ascertaining the availability of staff members to museum visitors" (to tell curators when to report for their public duties?).

Since the members of the committee who signed this report included some of the most respected senior as well as junior members of educational departments, as well as two museum directors, it is difficult to ignore what sounds like a bid to take over the administration as well as the policies of a museum, despite a few gestures toward the ultimate authority of the museum director.

Where lies the ultimate authority of a museum? Customarily with the trustees who employ the museum director. (The participants at the conference seem not to have read *Professional Practices*, an earlier publication by the Association of Art Museum Directors, in which the responsibility of the director to his trustees is clearly defined.) Who then determines the program of temporary exhibitions, and the development of the permanent collection? Usually the director and the curatorial staff because they have the first responsibility for discovering possible acquisitions. What principles determine the subject for a temporary exhibition originating within the museum, or the acquisition of this object rather than that? Whose is the final decision? The trustees', the director's, the curators' or the education department's? If it is to be the last named, what will be the standards determining the character of an exhibition, or of an acquisition? Will they be based on a consensus as to aesthetic experience or the educational information which the exhibition may provide, or the enduring artistic quality of the object? Is this suggestion of a museum where every priority is to be determined by the standards of the educational staff only a nightmare or the wave of the future?

It is common sense that even if educators have been treated as second-class citizens, to right past wrongs one need not turn over to them the direction of the museum of the future. A permanent collection assembled by educators could be a disaster if each object were chosen for its pertinence to an educational program rather than for its intrinsic merit. And why should educators assume to have a voice in setting priorities between "certain areas of the collection"? Collections grow, almost like organic creatures, of their own momentum. The interest and importance of American museums are their specialties, particularly among the smaller ones. One goes to Hartford to see Baroque art and eighteenth century ceramics, to the Frick to see a wealthy collector's taste, to the Clark Art Institute if one shares Mr. and Mrs. Clark's enthusiasm for Renoir. Such specialized collections pose problems for a well-

rounded education program, but they give each institution a character of its own. Even the large museums have their specialties. One goes to the National Gallery in Washington primarily for paintings; the collections of decorative arts at the Metropolitan are so fine that one might make a case for their superiority over the paintings. In Boston the collections of Egyptian, Indian, and Far Eastern art, and in Cleveland of Medieval and Far Eastern art give those institutions their particular personalities. What the education-ists propose is a leveling of every museum, with funds carefully allocated to neglected areas, or areas of relevance to the commu-nity, and always with an eye on government funding because the museum is less an institution for the collection, conservation, and presentation of works of art than for "educational functions not based solely" on the collection itself.

A hint of those extra-museum functions is contained in the report of the committee to prepare *A Credo for Museum Education*. The first paragraph states that "A museum is an educational institution for the public and therefore obliged to serve the broadest portion of society within its capabilities." If we grant that, we must accept the consequences that "the museum *must initially* involve itself with the community and take *positive* steps to combat social injustices within the scope of its programs, exhibitions and hiring policies, while maintaining high standards." (Italics mine.) One cannot help feeling that for the educator, social justice has a higher museum priority than historical truth or aesthetic quality. One cannot turn this position around and state that the museum should support social injustice, but one might wonder whether it would not be better for it to leave the solution of socio-political problems to those who know more about them. Having said this much, one is accused of considering the museum as an ivory tower. What is wrong with an ivory tower? Should it not be a thing of beauty, to protect and preserve beautiful things? Indeed, the view from an ivory tower may disclose more of the true landscape of our lives than that from an educator's office.

The Place of Scholarship in the American Museum

Throughout the educators' reports from the Cleveland confer-ence there runs a thread of rivalry against "the curator" who seems

to be the whipping boy responsible for every roadblock the educators have had to surmount or circumvent. There is no denying that the position of curator, conservator, caretaker—call him what you will—has historical primacy on the museum hierarchy. Long before there were directors, the person in charge of the collection was responsible not only for its care but also for its classification. As the process of classification became more complex, the caretaker became the curator and then the scholar responsible for all the expository support, from an accurate label to various kinds of publication, and finally to the *catalogue raisonné*.

The *catalogue raisonné* is a curator's crowning achievement. With it he offers the world all the available information which is pertinent to an understanding of the objects in his care. On the basis of his labors, scholars and students pursue their researches, confident that the knowledge available to them is the best to be had.

This certainly fulfills an important aspect of the museum's function as an educational institution. The more the pity, then, that the educators should flaunt such a one-sided view of the curator's task. Do they not know that his services in meeting the public, from the examination of objects brought for inspection to the delivery of lectures, are part of his daily job? Do they not know that the expertise a curator must have to find objects recommendable for acquisition is more searching than the learning an educator needs to cope with school children? Let the salary scale reflect that the educator's job is very demanding; but let him not blame the curator that it is. Why not recognize that not all people are capable of all things, that the curator and educator may be specialists in their respective fields, but that they are united in a common cause?

The scholarly achievements of American museums are, to say the least, spotty. The Metropolitan Museum had been in existence for almost seventy years before a series of *catalogues raisonnés*, not yet completed, began appearing for its paintings. The Museum of Fine Arts in Boston has no catalogue of its paintings; the checklist issued by the Art Institute of Chicago contains no detailed information about condition, provenance, previous publications, etc., which a scholar needs. The Clark Art Institute in Williamstown has a scholarly catalogue of its drawings, but only a small handlist of its paintings, and nothing on the extensive silver collection except a series of slim brochures issued for public consumption. On the other hand, the catalogues of painting, sculpture, and the decorative arts

in course of publication by the Frick Collection have established a standard of scholarship and quality of book production which are irreproachable.

This wide variation is the result of a variety of causes. Funding is perhaps the most formidable obstacle to the production of a successful *catalogue raisonné*. In addition to the expenditure of curatorial time, which may take years of laborious research, printing costs have risen to a point where any publication imposes serious budgetary considerations. Matching grants from the Ford Foundation in the 1960s acted as a goad for many museums, among them the Yale University Art Gallery which has issued a first-rate catalogue of its American silver, but a less satisfactory one of its paintings. Even the Ford grants would not go so far in 1974 as they did ten years ago.

More sustained scholarly publication, in the form of reports on special projects or journals published annually or quarterly (the *Journal of the Walters Art Gallery*, or the *Metropolitan Museum Studies*, published from 1928 to 1937 and revived as the *Metropolitan Museum Journal* in 1968) have established standards of scholarship equal to that of the best universities. Curatorial scholarship also has certain advantages over the more academic variety. Curators are usually not publishing for promotion without which the academic scholar perishes, and they address themselves more succinctly to the point at issue, which is usually the complex of problems created by an item in their care.

The relation between academic and museum scholarship is both ambiguous and anomalous. It requires clarification if good scholars are to be attracted to museums as soon as possible. Because the curator usually has less time for uninterrupted research and receives lower pay, shorter vacations and fewer sabbaticals than his colleagues in the academic world, his position carries less prestige than a teaching appointment at a college or university. As a result, several generations of graduate students have scorned museum careers for the security (few museums offer tenure) and comparative freedom of academic life. In this light, the curator works harder, longer, at a greater variety of tasks including administrative responsibility, than does the academic scholar. I wonder if the curator, instead of locking the door of his ivory tower, is not a more selfless servant of the public, than others in the museum or the academic world.

Usually the curator also encounters the public through his contributions to the museum's monthly bulletin, where such exist. Those published by the Metropolitan are the handsomest in format, and contain articles on subjects of interest to the public in which no compromise is made between scholarship and popular appeal. On a smaller scale, the bulletins of the Museum of Fine Arts in Boston and the Cleveland Museum have published articles which are in no way inferior in the search and presentation of accurate information. The curator, like the professor, is above all concerned with truth and with disseminating the truth about the objects in his care. When he does his job well, he is entitled to more academic respect than he presently receives.

Another category of publication in which museum scholarship reaches a wider public is through exhibition catalogues. When these are more than a checklist they become permanent contributions to the literature of the subject. To the Museum of Modern Art under Alfred Barr's direction goes the credit for having created the first serious catalogues dealing with the modern movement, many having become standard works of reference for twentieth century art.

The degree to which a museum can be considered a center of scholarship depends on a combination of favorable factors. In the first place there must be a collection of objects which deserve close scrutiny. Secondly there must be curators of sufficient scholarly attainment to undertake the work, and they must be given time to do it, including travel time for research if need be; then there must be sufficient funds for proper publication. Unless all these factors are present, scholarship will lag behind the demand. The National Endowments for the Arts and for the Humanities have recognized the difficulty in meeting such demands, and have offered imaginative programs of assistance, especially in providing funds for scholars to visit smaller museums to study and publish collections which otherwise would long remain unknown.

The museums of America are one of the most remarkable achievements of a free society. In less than two centuries they have been organized and filled with treasures from the whole wide world. With academic institutions they share the exciting burden of curatorially preserving and educationally interpreting the cultural history of the human race. In their increasing concern with contemporary art they are engaged in the difficult task of resolving

and explaining the tension in modern society which contemporary art expresses. And, by and large, within their limited and shrinking budgets, they perform these tasks with imagination supported by sound scholarship. The activities of the American art museum, undertaken in however many ways, are among the most significant ingredients of the spiritual health of our pluralistic society.

Daniel Catton Rich

5
Management, Power, and Integrity

The charters of American art museums founded in the second half of the nineteenth century show an amalgam of elements taken over from the university and from corporate business. Typical are the Acts of Incorporation of the Museum of Fine Arts in Boston enacted by the State of Massachusetts in 1870. Twelve leading citizens, including such names as Eliot, Endicott, and Parker are the founding trustees, augmented by three trustees appointed annually by Harvard; three others annually named by the Boston Athenaeum and three more annually chosen by the Massachusetts Institute of Technology. The body corporate has, in addition, the mayor of Boston, the president of the Public Library, the superintendent of Boston's public schools, the secretary of the Board of Education, and the trustee of the Lowell Institute, the last five *ex officio*.

The purpose of erecting a museum is stated as "the preservation and exhibition of works of art [and the] making, maintaining and exhibiting collections of such works, and [of] affording instruction in the fine arts." The board of trustees is to elect other trustees, the number not to exceed thirty.

DANIEL CATTON RICH *was director of the Art Institute of Chicago, 1945–1958, and then of the Worcester (Massachusetts) Art Museum until 1970. A co-founder of* Film-Art, Inc., *and a past president of* Poetry Magazine, *he has been a trustee of the American Academy in Rome. Long an active member of many national and international art committees, Mr. Rich is chairman of the Art and Museum Committee of the Guggenheim Museum. He is the author of books on Seurat, Rousseau, Degas and O'Keeffe in addition to countless articles.*

Structure

Here, in essence, is a plan of management that was to be followed by most American museums for the next hundred years. Trustees in Boston represented the civic and financial leaders. They had become aware that an art museum could be—or must be—a part of any civilized community. Educated and traveled, they realized that "the Athens of the West" was incomplete without an institution where artists, designers, and the public could see and be instructed by works of art.

At the same time, as hard-headed businessmen, they set up a governing board with complete power. They made themselves a self-perpetuating body which had control of all policies and operations of the institution. They conducted the business of the museum as though it were the business of a corporation.

The inclusion of the *ex officio* members was not mere window dressing. After the Civil War, leading Americans greatly expanded the democratic ideal of education for the many. The Boston charter is low on political trustees—only the mayor was invited. Other trustees in this category represented the chief educational institutions. This was useful in seeking a charter for a non-profit museum, as was the stated purpose of affording instruction in the fine arts, an obligation carried out fully as the School of the Museum of Fine Arts still exists.

Later Developments

One must remember that in the early days of even large city museums there was a very small staff, sometimes not even a director. The Art Institute of Chicago, founded in 1879, began with a secretary who not only kept the minutes of trustee meetings but carried out detailed instructions from the board. The care and exhibition of the collections in Chicago were vested in one young lady who had the imposing title of "Curator" painted on her door. Acquisitions in the Art Institute were the province of the trustees who not only accepted collections, bestowed prizes in annual exhibits, but invaded Europe to bring back old masters. Fortunately in Chicago, these businessmen collectors had rather extraordinary

taste, capturing Rembrandts and El Grecos while some trustees in less fortunate cities were gloating over their Rosa Bonheurs and Meissoniers. In many museums, large and small, the board was led by men who had a fierce pride in this civic undertaking and served faithfully and gave generously. It was understood that their own collections would eventually land in the museum.

The first directors of our museums were usually connoisseurs or men of good taste, often from the same social background as the trustees themselves. Art history was in its infancy and was to wait for some thirty years before being imported in bulk from Europe. Occasionally an artist headed a museum, and there were frequent cases of artists as trustees. The director in this period was often hired for his connections. Many of these early directors stayed in office for decades, their longevity equalled only by the longevity of orchestra directors. Policies were made by the board and delegated to the director who carried them out with what staff he could command. He was, in every way, the "hired hand" of the trustees, while fraternizing with them at dinner parties.

GROWING COMPLEXITIES

The museums meanwhile were growing enormously in their collections. It was a period of the great trek to America of works of art of all varieties. Europe and the Orient yielded up treasures for dollars, art inevitably landing where money is. It became necessary to make order out of this wealth of disparate material, and departments were organized: painting and sculpture, prints and drawings, textiles, Oriental art, Greek and Roman, Egyptian, and that catch-all of diverse objects, decorative arts, which could include anything from a carved Gothic altarpiece to a pressed-glass Sandwich cup plate. After the Centennial exhibition of 1876 in Philadelphia, Americana began to find its way into the museum as collectors discovered that a Windsor chair was not only pretty but patriotic.

To head these new divisions it was necessary to appoint sub-heads under the director. Specialists were needed not only to buy important authentic examples to fill gaps left by donations but to study and ultimately to publish the ever-growing mass of material, much of which—for exigencies of space—had sunk to basement storages.

A NEW TYPE OF DIRECTOR

In the 1920s a new type of director emerged to head the expanding museum. More professional than his predecessors, he might have come up from curatorial ranks or have been lured away from another museum. The profile desired by the trustees was that of a paragon. He must (supposedly) be an art expert in many fields (though as a curator he probably would have specialized in one); he must have marked ability as an administrator, dealing with both his own staff, often made up of "difficult" personalities, and the wider public which was constantly making new demands. He should be able to pry works of art out of reluctant collectors, play the social game (along with a suitable wife) and above all, as museums found their funds dwindling, raise money. Equally at home in Rotary or the Union League Club, he was expected to win financial support for his institution, which found itself in sharp competition with colleges, hospitals, symphony orchestras, and opera. Trustees were to be pacified and women's committees (in the Boston museum it was more elegantly named "The Ladies Committee") were to be soothed. He should also write well and speak eloquently. With all this he had no security; the board could fire him at any time on short notice. Supervising building additions, dealing with labor unions, and lobbying for government funds were added responsibilities.

Changing Patterns of Trustees

The complexion of the board was likewise changing. The old pattern was a group of self-perpetuating members. Often sons and grandsons of founders were elected to carry on an hereditary tradition. Today there are three types of art museums: those that are entirely private, depending on large endowments; those partly financed by public funds; and those that are underwritten completely by federal, state or city government. Ordinarily, the privately funded museum changed more slowly in trustee selection while the museum which got some support from the city or state was under pressures to modernize its board.

To the small, exclusive group of citizens were now added token members from minorities—women, blacks, and Jews. At the same

time, the board was greatly enlarged. Forty or fifty members could now constitute the governing group, though most policy decisions would fall to a small executive committee.

Among the new arrivals were collectors named with the hope their possessions would ultimately end in the museum. Some of them gave generously or left significant bequests. Others were more apt to use the knowledge of the director and his staff to help build their own private collections, then, when prices of art soared, as they have in the last fifteen years, to sell at the top of the market. As one collector frankly stated, "I bought my Gauguin for a hundred thousand dollars. When I was offered a million, I couldn't resist." Such trustee-collectors seemed more interested in capital gains than in the museum.

The board still exercised almost complete control. Its policies were delegated to a director and were filtered through him to the staff. There was practically no reverse process in which the staff offered ideas and suggestions to the board, though a director at his discretion now and then informed trustees of staff requests. Through powerful committees such as a committee of acquisitions or a committee to pass on gifts and purchases in each department, trustees had the final word on what should be accepted or bought. In many museums, the exhibition program was also subject to their approval.

Popularization

Meanwhile the museum was growing more popular. Where earlier visitors had been artists, art specialists, teachers, and predominantly women, all the public *en masse* was now not only invited to enter, but cajoled and urged to do so. As deficits began to appear in annual reports, attendance figures grew important. A large attendance could prove to a city council or a foundation that more funds were needed. At the same time national magazines devoted pages in color to art; art was being taught in the schools, in junior museums, and museum classes while many college students took at least one course in art history. Amateur painters increased. Galleries selling art appeared and multiplied.

In the past curators were often content to exhibit their treasures in a staid or even scientific manner—more in the tradition of a

natural history museum. Now new aesthetic installations attracted notice, and museum lighting, which had often seemed a dim, semi-religious illumination, was greatly stepped up.

A program of splendid loan exhibitions was instituted: masterpieces from European museums, paintings, sculpture and tapestries, historic screens from Japan, hanging scrolls from China, primitive carvings from Africa, etc. Frequently changed and dramatically presented, such exhibitions delighted the public. Where the original purpose was to educate, the contemporary purpose seemed more to entertain.

The museum entered new fields. The success of the Museum of Modern Art (founded in 1929) stimulated institutions to daring. Heretofore, recent painting and sculpture had, as a rule, been chillingly accepted and moderately shown. But more of the public demanded showings of what was going on. The avant-garde became not only acceptable but popular. Photographs were collected as art, films were shown as art, concerts were held in the galleries, Muzak was piped in. One could sit down in a reconstructed Romanesque chapel and absorb canned Gregorian chants.

Greater public attendance was the result of increased publicity. At one time the museum would send a brief report to the press upon acquisition of a great painting and now and then a stodgy newsletter. Realizing competition from other organizations, it began to employ a skilled publicity counsel who used every advertising technique to swell attendance figures. Museum bookstores and gift shops were set up in prominent places while lunch rooms and snack bars not only comforted the visitor assailed by "museum fatigue" but prolonged—as one serious study showed— the length of his visit. It was due to all these new attractions and new ways of getting information to a wider public that in the 1960s museums could proudly announce that annual attendance at their combined institutions topped that of attendance at sports events.

Conflicts between Directors and Trustees

During the last fifteen or twenty years there occurred a general worsening of relations between directors and trustees. Few directors felt as Homer St. Gaudens, a former head of Carnegie Institute, wryly expressed it, "I do just what the board wants me to

do. If they asked me to buy a baby carriage, I'd go out and buy one." Much of the dissension centered on trustees' approval or disapproval of acquisitions. Both the director and staff felt their professional competence was challenged when the board turned down a recommendation they had strongly advised, often after months of search, study, and consultation. Equally, trustees might vote to accept works of art which the staff believed below museum standards. To the staff the board often appeared capricious or prejudiced or unreceptive.

A famous Cézanne portrait of his wife was presented a few years ago to a trustee committee. The chairman astonished the director by remarking, "I never did care for Mme Cézanne." Many conflicts arose over modern art. A generation ago, experimental works were often rejected as outlandish or "crazy." Later, when contemporary art grew popular if not chic, it became difficult for a director to secure acceptance for an important old master. Trustees often urged the museum to acquire works by the very artists they were collecting, thus helping to bolster their own taste.

The more the director felt his professionalism challenged, the more the board members resented his role. They complained that they were nothing but rubber stamps, that things were being forced down their throats. Trustees are notoriously sensitive to public opinion, particularly in the press, and when local newspapers made fun of an exhibition of contemporary art, they often blamed the director if he had selected the showing or if he had recommended the jury who judged it.

In such a climate of distrust, there was a quickening turnover in museum directorship. Directors were hired and fired with increasing speed. The Museum of Modern Art had three directors in five years, one of them surviving only nine months. Such a situation was not only demoralizing to the staff but viewed with suspicion by young art scholars who might otherwise have been interested in a museum career. These well-trained men and women gravitated, instead, to the universities, where conditions were more stable as far as management went and where in addition to teaching they could continue research in a less troubled atmosphere.

It became hard to find top personnel so that trustees were forced to pay higher salaries to directors. Though still below comparable wage scales in universities, these salaries were often out of proportion to what curators and assistants received. In a leading museum

a curator who was recognized as the best authority in her field worked for seventeen years without a rise.

Both trustees and administration recognized that a crisis was approaching. Various new patterns were tried. In 1962, the Association of Art Museum Directors recommended the director be made a trustee, hoping, one imagines, that if elevated to the board, he would increase authority with his peers. The director of the Metropolitan Museum of Art and the director of the Art Institute of Chicago were both elected trustees as were several other museum heads. The disadvantages of such a move were soon apparent. The staff felt cut off from the director who hitherto had served as a link between them and the board. Now he had joined the Establishment and was no longer able to represent them with the same freedom. A more subtle difficulty faced the trustee-director. He was asked to vote on policy matters where he might rather have remained silent. A vote against a majority put him in an awkward position and if he went along against his better judgment, he felt he had compromised himself.

If the director turned out to be a poor administrator, why not replace him with a businessman, who—in the trustees' world— knew how to organize and run a corporation? This arrangement was tried in several museums, the director being demoted to a position of curator-in-chief. Or why not divide the directorship and have one head for art and another for business and administration? The difficulty with this latter plan was that it put the two directors in competition, leaving final decisions to the president of the board. Both the Art Institute of Chicago and the Solomon R. Guggenheim Museum attempted such double-headed management but later abandoned it. The Art Institute now has reorganized its structure, having a chairman, a president, and four vice-presidents. Only at the vice-presidential level is an art background recognized. The chairman is a businessman and the president a former college dean with no experience in art.

In some few cases trustees themselves became directors. The Corcoran Museum in Washington, D.C., named one of its board to head the institution as did Pasadena. At times trustees slipped behind the director's back and ordered curators to hang certain pictures or change frames to suit their fancies. A well-publicized case of such trustee meddling occurred a few years back at the Baltimore Museum of Art. Not all trustees were so arbitrary. The

Guggenheim Museum restricts decision on accessions to professional members of its board. But in general, particularly in the smaller and newer museums, trustees jealously guarded the power of passing on acquisitions as they guarded the power of the purse.

PROFESSIONALISM GAINS

To read the minutes of the Association of Art Museum Directors during the last fifteen years is to follow growing dissatisfaction with the management of our institutions. Year after year, resolutions were passed, attempting to strengthen the director's position and to make the board more responsive to professional decisions. Finally in 1971, the Association, after two years of study, issued a significant report, *Professional Practices in Art Museums.* This handbook predicates a contract between two groups: a governing body and a professional staff who have confidence in each other and are united in their commitment to carry out the institution's responsibilities for the greater benefit of the public.

Recognizing that "acumen and procedural awareness" are necessary for successful administration, the report stresses "taste, knowledge and experience of a highly specialized nature."

The director's power is considerably enlarged. It is his professional responsibility to make proposals for implementation of the board's policies and to originate suggestions to the board. The governing body must reassure him that he is the one person answerable to it and all staff members must conform to policies delegated to him.

No object shall come up for acquisition without the director's formal presentation; nothing shall be purchased without the board's full knowledge of the director's opinion and that of the curator concerned.

Eyeing recent dismissals of museum heads, the director is furnished protection with a written contract which spells out salary, fringe benefits, retirement, expense accounts, travel time for research, sabbaticals, living quarters, length of appointment, and method of termination. This contract must be confirmed by the entire board and only the entire board can terminate his duties. In the latter case, he is usually to be given a year's notice or a year's salary in lieu of notice. The board is made responsible for the museum's finances and carries entire responsibility for fund-raising.

It is likewise accountable for the various assets of the museum, the collections, the plant, and financial holdings.

By the time this study was published, and a previous report by the American Association of Museums called "The Museum Trustee Handbook" had been distributed, some of the misunderstandings between boards and directors were beginning to abate. There were several programs and seminars in which representatives of administration and members of the board participated while a group of younger trustees began to interest themselves in more harmonious relationships within organizations. Bit by bit boards started to delegate—often reluctantly—some of their power to the director and staff.

Just as there appeared to be a more sensible balance, the art museum was shaken by a series of seismic shocks, some came from outside and some, unexpectedly from within.

Artists and Museums—a Confrontation

For at least a hundred years many artists have held museums in low repute. The cry of Cézanne, in the 1860s when a young revolutionary, was "Burn down the Louvre." Artists saw art institutions as elitist, dedicated to the safe art of the past and ignoring what contemporary painters and sculptors were producing. It was this ignoring that rankled. A young painter once complained to Sherwood Anderson, "It's not that they aren't *with* us. It's because they don't know we exist."

The life of most American artists has been one of deprivation and struggle. Only a few have been able to live by selling their art; others have taken all kinds of jobs to support themselves, some of them teaching but many reduced to menial occupations while continuing to toil at their art. Historically they identified themselves with minorities and radicals. They arrayed themselves against the "system" and a powerful part of the system in their minds was the art museum.

In 1969 a group of dissident artists and art theorists formed a revolutionary group, named the Art Workers' Coalition. For them the museum symbolized capitalist society with all its evils of the Vietnam War, recent assassinations, and the shootings at Kent State. Their particular target was the Museum of Modern Art,

where they made extraordinary demands. They insisted that the museum sell a million dollars of art from its collection and give the money to the poor of "all races in this country." They demanded that the board of trustees accept members from "the public" with no regard to background or race so they could be involved in control. The Museum of Modern Art was to be closed until the end of the Vietnam War. They demanded the immediate resignation of all the Rockefellers from the board, since their investments were obtained by *matériel* supplied to the war effort. They issued manifestoes, picketed the museum noisily, and finally spilled containers of blood in museum galleries.

Espousing the cause of black artists and women artists, they insisted that there be black art in all museums. The Museum of Modern Art was to set up a Martin Luther King Study Center headed by a black. Museums were to decentralize, creating a series of small galleries in ghettos so that the "culturally deprived" could enjoy some of the advantages of the rich.

Women artists and supporters in Women's Liberation demanded quotas in collections and exhibitions: a high proportion of works by women should be purchased and an increasing percentage of paintings and sculptures by women should be featured in museum annuals. Both black and women artists angrily insisted that art museums should make up for past sins; they should buy and exhibit more art by blacks and women to justify neglect of former years.

Some museums quickly arranged exhibitions by black artists. The Whitney Museum, in 1971, put on such a showing but in the words of Stephen Weil, the museum's former administrator,

> found itself caught among various factions, one of which thought the exhibition should not be given at all, another of which thought the exhibition should be postponed until a black curator was put in charge, and a third of which wanted the exhibit to proceed as scheduled. In the end, a boycott organized by the second group was partially successful and a number of artists withdrew just prior to the exhibition's opening.

In 1970 the same museum was attacked by a group of militant women artists who

> launched a campaign demanding that the sculptors represented in the Whitney Annual be fifty percent women. They were quickly joined by a militant black group, demanding that half of those women be black and the other held that half the men represented in the show be black as well.

The Metropolitan Museum of Art held the first showing of black culture in 1969. Organized by visiting curators, it failed to accomplish its aim: to pacify the black community. At once it was pilloried by competing groups of blacks, the introduction to the catalogue (written by a black woman) attacked the Jews, and the uproar was so great the catalogue had to be withdrawn. The show was picketed by dissatisfied black artists who wanted their paintings and sculpture shown rather than blown-up photographs and recordings of Harlem jazz. At its opening someone scratched an "H" with a ballpoint pen on ten paintings ("H" for Hoving, the director of the Metropolitan, an enthusiastic sponsor of the exhibit) including one Rembrandt. Museums in New York grew alarmed.

The Coalition began a series of "sit-ins" and strewing of anti-war pamphlets in museums. They demanded desks in museum lobbies where they could distribute literature stating their grievances, and give out handbills attacking the Pentagon. Such "Happenings" grew more frantic and for one entire day all New York museums closed their doors, concerned that works of art might be damaged.

There is something ironic in this use of the museum as a podium for revolutionary tactics. A few generations ago it was so aloof from the mass public as to make demonstrations of this kind unthinkable. The museums then went out to the "people" and now the "people" turned back on them with a vengeance.

It is doubtful how much was accomplished by giving in to such pressures. There have been an increasing number of museum exhibitions by blacks, usually chosen by black curators and stoutly defended by black critics, and often attacked by the white press for mediocre quality. The public has been assured by some critics that only blacks can comprehend the beauties inherent in black art.

Women artists have fared a little better. There has been a discreet increase in the amount of work shown by them with special exhibitions in Brooklyn and elsewhere pointing to their indubitable contributions.

Other pressures developed from the increasing number of volunteers invited by the museum to contribute time and "ideas" to the program. Volunteers were organized into official boards, consisting not only of now-accepted women's committees, but young men's boards, members' councils, associates for suburban communities, advisory committees on public relations, public school art societies, and other variations. It was hoped that such adjuncts would raise

money to help shrinking incomes. Some of them enthusiastically organized balls and benefits, resembling those traditionally associated with charity fund-raising. The charm of the museum benefit was that it took place within the museum where art not only formed a glamorous background but precious objects could be taken from storage or even from exhibition cases to use as additional decor.

The results were sometimes unfortunate. One day a visitor to a leading New England museum had come a hundred miles to enjoy its collection. He found the place in an uproar of preparation for a benefit. He supposed the theme to be some reference to street life, for wooden sawhorses, stop-and-go lights, No Parking signs, trash cans and fire hydrants filled the galleries, obscuring paintings and cheapening the attractive installation. Some rooms had been closed and turned into pantries; in others, caterers were setting up hotplates perilously close to historic tapestries. He wondered how much staff time had been involved in this display and how many hours of cleaning up would be necessary after the fête was over. The few thousand dollars the benefit produced seemed hardly worth it. He was not at all sure, either, whether such funds would be freely turned over to the museum for operation—where it was most needed. Volunteer boards often have pet projects they foist on the museum and wish to use money they have raised. After all, there is nothing exciting about funds for maintenance. As a former president of the Art Institute of Chicago remarked, "Nobody ever gave a ton of coal in memory of his mother."

Another use of the museum is to turn over its galleries to a typical auction, arranged by some volunteer organization. Art auctions of appropriate material contributed by patrons or obtained from dealers at a discount seem legitimate, but one may question the type of auction where committees solicit local merchants for anything that will sell. Handbags and lawnmowers, toasters, wedding dresses, and canoes are proudly set up in the museum where somehow the imprimatur of the institution glorifies everyday use.

Many volunteers defend their actions by pointing out that the museum now has come alive and that they are "involving" the community in art activities. Instead of "art oriented," the institution is now "people oriented" and a hum and buzz in the galleries means that this once elitist organization is becoming "relevant."

They forget that the purpose of a museum is to collect, preserve, and exhibit "objects"—not "people."

Staff Problems and Unionization

In the past, most staff salaries have been low, not to be compared to a university scale. There has been no revealing of comparative salaries within the staff. Usually an understanding with a newly employed curator or assistant depended on how inexpensively the museum could hire him. No policy for promotions or in some cases, even for retirement, have been stated by management. In addition junior members, especially in large institutions, felt cut off from having any voice regarding general policies or even in specific recommendations for purchase or programs.

Frustrated by such conditions, a group of younger staff members in 1970 at the Museum of Modern Art formed a Professional and Administrative Staff Association and signed with a union, the Distributive Workers of America which set up a museum division, chartering it as Local I. The museum agreed to an election which PASTA (a short and convenient title for the lengthier name) won, entitling it to represent almost all clerical and professional employees up to the level of assistant and associate curators. In August 1971 it struck the museum two weeks in a vain attempt to stave off staff layoffs. It won, however, a boost in salaries; the minimum hiring rate was raised from $4,770 a year to $5,750 with a 7.5 percent pay increase for the staff.

From the first, members of PASTA had sought representation on the board of the Museum of Modern Art and on its key trustee and upper-level curatorial committees. It increased these demands in 1973 by insisting that full curators and operational heads second in command be added as union members.

The trustees refused and again PASTA struck, this time enduring a long, bitter walkout of eleven weeks with jeering pickets and floods of mimeographed information handed out to the public. Finally, the strike was settled and again the minimum hiring wage was raised, but by a mere two hundred and fifty dollars. The union did win a right to inspect agenda of trustees' and committee meetings in advance and to appear before the board to state opinions.

Aside from these concessions and a contract clause guaranteeing job security, PASTA seems to have gained little from its lengthy strike.

The Museum of Modern Art is not the only institution in the country to have a staff union in addition to the more usual unions of maintenance men and guards. The Minneapolis Institute of Arts has a hundred of its professional and administrative staff enrolled in an independent union with seemingly harmonious relations, while at the San Francisco Museum of Art some twenty staff members belong to the Office and Professional Employees International Union with similarly happy results.

The lessons of unionization have not been lost on museum management. Directors are now listening to staff committees and coordinating committees, and certain institutions have even organized a series of special advisory staff groups as at the Metropolitan. This movement has been denounced by the Museum Workers Association (developed during the Museum of Modern Art strike) as "company unions." When seventeen employees fired by the Metropolitan took their complaints to the National Labor Relations Board, stating the museum had dismissed them for union activities and dominated four staff organizations, the Labor Board ruled that three of the seventeen should be reinstated, but allowed the four "company unions" to continue, prohibiting them, however, from engaging in collective bargaining. At a union election held on October 17, 1974, for 268 Metropolitan Museum of Art professionals and nonprofessionals by the National Labor Relations Board, results went against the union 174 to 92.

Disposal of Works of Art

Another and far more serious threat to museum autonomy arose in connection with the deaccessioning and sale of paintings from the Metropolitan Museum of Art. The museum had purchased a portrait by Velásquez for the record sum of $5,400,000 and to help defray its cost, sold a Douanier Rousseau and a Van Gogh for prices which the art world felt too low, particularly as the dealer involved was reported to have resold them at enormous profits. The Metropolitan also traded a group of paintings for a sculpture by David Smith and a canvas by Richard Diebenkorn.

The Rousseau and the traded pictures came from a bequest of the late Adelaide De Groot, who had expressed a wish (not binding according to museum lawyers) that any paintings the Metropolitan declined be given to other museums.

The New York *Times* conducted a long, investigative attack on the museum, articles appearing almost daily which questioned not only the wisdom of the transaction but accused the institution of bad faith in the De Groot matter. At first the director, Thomas P. F. Hoving, retorted that while the public might be interested in the process of deaccessioning, "the Charter of The Metropolitan Museum of Art states that every work of art is entirely owned by the trustees. There is no restriction on the museum."

Alerted by this debate the New York State Attorney General, Louis J. Lefkowitz, entered the scene. "My office," he stated, "has been given by law the high duty of representing the public for whose benefit you hold your charitable and educational assets." To this he added concern "about whether the works of art that the museum is disposing of . . . were held subject to restriction against such disposition and if there were no restrictions, whether the sales were provident, prudent and reasonable."

Here was a new concept, fraught with danger for art museums. The financial health, even the survival of such institutions, rests on tax exemption and tax deductible contributions. The Metropolitan, moreover, receives money from the city to construct its buildings and help underwrite its enormous annual maintenance.

Next the Metropolitan issued a "white paper," *Report on Art Transactions, 1971–1973,* listing in detail all works deaccessioned during this period and citing "disposal" (an unpleasant term, redolent of sanitation activity) of such objects as had been sold, traded or auctioned off. This was past history. The Attorney General's office and the museum worked out "Procedures for Deaccessioning and Disposal of Works of Art," a complicated process in which the main restrictions for "disposal" consist of notifying the Attorney General in advance (fifteen days before, if the work is valued over $5,000 and forty-five days before, if the work has been on exhibit during the last ten years and valued at more than $25,000). Methods of disposal are limited to exchanges with other museums or public auction.

Other even more restrictive legislation was proposed in the City Council and the State Legislature. A bill sponsored by Carter

Burden would also make it mandatory for the institution to notify the administrator of parks, recreation and cultural affairs and the finance committee of the Council of the City of New York of any work of art acquired or to be acquired costing more than $100,000. In Albany, Assemblyman Franz S. Leichter introduced a bill which would make it necessary for an institution to notify the Commissioner of Education ninety days in advance of *any* disposal or acquisition, under threat of revocation of the museum's charter by the Regents of the state.

On October 19, 1973, the Attorney General held a conference of museum representatives (not only art museums but natural history and historical institutions) to discuss the deaccessioning contract. A number of museum directors testified, almost all of whom felt that they should not be put in straitjackets because the Metropolitan may have unwisely sold or traded works without proper caution.

The new principle of "public interest" in art museums largely financed by private funds added another disturbing pressure under which our institutions have to function. For years museums had sought a perhaps impossible goal: government financing without government interference. At times grants made from the various state art councils seemed to ignore the basic need for maintenance and operation. Special projects, innovative techniques, surveys, especially as related to minorities, were more readily approved. This was a subtle type of restriction which, fortunately, is being replaced as we see in the announcement by the New York State Council on the Arts, where some $5,600,000 has been allocated to New York City institutions, the majority of it to offset burgeoning deficits in operation and programs.

Who Owns the Museums?

The question of who owns the museums would have been impossible a generation ago. Yet in 1972 at Warsaw there was a serious museum conference on this very subject. An address was given by Thomas M. Messer, director of the Solomon R. Guggenheim Museum, who sees power, once tightly held by trustees, being diffused. Directors did not receive the major part of this diffusion; it passed into various instrumentalities and groups. Bit by bit, government is stepping in to challenge disposition and even

accession of works of art. Organized labor is invading the staff, which goes on strike if it does not get its due. Public groups demand longer hours of opening and new services. Disadvantaged citizens protest and publicize their grievances. The museum, torn and battered by dissension from outside and within, seemed, in 1974, to be uncertain as to its proper, ultimate role.

The need, as Hilton Kramer (The New York *Times* June 9, 1974) put it:

> is nothing less than the creation of cultural institutions that can satisfy the pressure of democratic appetite—with everything this implies about radically different levels of taste, education, background and opportunity—without sacrificing the high values of disinterested discrimination and historical preservation that are the museum's sacred trust. Almost unnoticed, and certainly without any single power contriving its fate, the museum has more and more become one of the crucial battlegrounds upon which the problems of democratic culture are being decided.

Integrity in the Museum

The situation described by Kramer makes it all the more necessary for museums to function with complete integrity. If Watergate has had no other effect it has alerted the public to unethical as well as unlawful activities. The unlawful, as far as museums go, is easier to avoid than border-line practices which help to shake community faith.

The art museum needs a clear, articulated policy, hammered out by consultation between trustees and staff. It has been suggested that such a policy be written down, that it be based upon past experience of the museum as well as containing decisions on today's problems, and that it be widely circulated among members, public, and press. Changes which occur should likewise be publicized so that everyone is aware of where the museum stands. Policy is the final responsibility of the trustees, but its implementation falls to the staff who should understand often complicated details. This will help avoid hasty or expedient decisions.

Leadership in the museum must be furnished by the director. The Association of American Museum Directors includes a Committee on Ethics which has produced a code of professional conduct. The director must avoid buying or selling works of art for personal profit, must not recommend for purchase any work in which he has

any financial interest, must accept no commissions or gifts from buyer or seller, and is not permitted to give paid certificates on authenticity, authorship, or monetary value of a work of art.

"In all his activities," the code continues, "it is assumed that he [the director] will act with the highest moral principles; that he will meticulously avoid any and all activities which would in any way compromise him or the institution which he directs."

The director is further prohibited from personally collecting works of art if such collecting is "in conflict with the interest of the museum he directs." In one or two past cases, directors *did* buy works in competition with their museums, in one institution even usurping objects curators had found for acquisition. Here one may note practices in other countries. In Germany no museum head may collect at all; in the British Museum curators are not allowed to acquire objects in their own field while at the Victoria and Albert Museum a more liberal—and perhaps intelligent—practice is followed: staff members may purchase works for themselves but if they wish to sell must submit them to the trustees at the prices acquired.

Most American directors follow a method of offering work they might acquire to the museum first. If trustees do not wish to buy it for the collection—and here the director needs to exercise a nicety of ethics in presentation—he may purchase it for himself. There is an advantage in personal collection by museum experts. To have hanging on their own walls works of art they admire (and can afford) is a lesson in practical connoisseurship.

One of the most serious problems, and one that has been if anything overpublicized, is the matter of deaccessioning and subsequent sale of works of art from museums. The attack on the Metropolitan, already referred to, has had the useful result of making institutions far more careful in their methods of releasing art for sale or exchange. There is a new awareness that every protection must be given to deaccessioning as much, if not more, indeed, as to acquiring objects. The Attorney General in his public hearing, proposed that museums trade among themselves, but representatives at that conference were not enthusiastic. They pointed out that works discarded were often minor examples other museums would not want. They felt that restricting sales to auction often realized less than in private trading. The Museum of Modern Art illustrated the latter point, by insisting that some of its greatest

treasures had been acquired by skillful, unpublicized exchange in the art market.

If deaccessioning is no longer the inflammatory "news" that it once was, a serious and still unresolved situation faces museums. Many antiquities now in our collections have been smuggled from or bribed out of their places of origin. Growing nationalism in these countries and despair of archaeologists have made the public cognizant that museums have not been without fault in acquiring ancient and primitive arts. The former complacent policy was to buy anything in the open market, legally passed by U. S. Customs. Occasionally a foreign government could prove that a work in an American museum had been stolen. In that case the institution usually returned it and made the dealer refund the purchase price. Archaeologists found the growing demand for Pre-Columbian, Egyptian, Etruscan, early Chinese art, etc., was destroying many ancient sites. Grave robbers were digging in tombs by night; middlemen were trucking fragments of Greek sculpture or Indian bronzes across national borders. There was a vast and profitable business—worldwide in extent and involving millions of dollars—in which the museums were critically involved.

The traffic became so flagrant and so many important links in man's history were being lost that UNESCO in 1970 adopted a "Convention on the Means of Prohibiting and Preventing the Illicit Import, Export and Transfer of Cultural Property." The thrust of the Convention is to stop illegal export of and import of archaeological and ethnographic cultural property and in the case of objects stolen or smuggled out of an exporting country to seize and return them to their original nation. The question of recompense to the individual or institution purchasing such works is a complicated one, not satisfactorily resolved in Senate Bill §2677. Signed by the U. S. Senate in 1972 the Convention has not yet been formally adopted by the United States or indeed by any other importing nation. Proposed legislation by our government has become controversial, for it seems to complicate the matter by authorizing the President and Departments of State and Treasury to assume roles which are unnecessarily complex and may be detrimental to honest importation. Recently our government has signed treaties with several Latin American countries in which U. S. Customs will carefully check importations. Objects misrepresented may be returned to the nation of origin and the importer prosecuted.

Meanwhile, before the Convention has received implementing legislation necessary, some museums have still been purchasing archaeological works in the open and undisclosed market, in spite of resolutions passed by the Association of Art Museum Directors, upholding UNESCO's restrictions. They have not insisted on documents proving legitimate export nor have they delved into an object's provenance and history.

The Metropolitan's purchase of a splendid Greek vase by Euphronios at a price ten times as high as any Greek ceramic had hitherto brought, touched off a storm of protest, first from the Italian government which believed it to have been recently excavated on Italian soil by grave robbers and smuggled out of the country, and second from archaeologists who pointed out this exhorbitant price encouraged more unlawful digging. The Italians have yet to prove their case, which seems to be collapsing, and the Metropolitan has stoutly defended its own history of the vase and its extraordinary price.

At least two archaeological museums in America have adopted strict policies regarding purchase of works, underlining methods and penalties of the Convention, and urging American museums not only to avoid illicitly exported material but to refuse any gift without a clean bill of health. It is doubtful if art museums will accept the latter condition, as the UNESCO Convention does not apply retroactively.

The National Gallery of Art in Washington and the Metropolitan Museum of Art have adopted a pragmatic policy. When a desired object is found for sale and the dealer cannot produce documentation establishing a reasonable provenance, the museum writes to the Antiquity Service of the probable country (or countries) of origin, asking for information on this specific work of art. If no reply is received within forty-five days, the museum may proceed as it wishes.

Such an inquiry would have saved the Museum of Fine Arts in Boston from a recent scandal, centering round the acquisition of a small portrait attributed to Raphael. The painting was found in Italy and not only was smuggled out of the country in a manner suggesting a grade-B movie, but was undeclared at U. S. Customs upon entry. The result was a formal protest by the Italian government and mandatory return of the panel. Perhaps this overwhelming desire to buy a "masterpiece" arose from tremendous

competition among museums. The National Gallery had acquired the rare *Portrait of Ginevra de' Benci* by Leonardo da Vinci, at a reputed price of between $5,000,000 and $6,000,000. When Thomas Hoving, Director of the Metropolitan, heard the news, he confessed that "he couldn't sleep all night." He countered with the acquisition of the Velásquez *Portrait of Juan de Pareja* for $5,544,000. Boston's museum—which was celebrating its Centennial the same year as the Metropolitan—had to produce its own miracle. Hence the Raphael. The sordid and unfortunate denouement followed.

During the course of the New York Attorney General's conference, a question was asked: "Should the U. S. adopt restrictions on exports of works to other countries?" It is true that many important paintings and sculpture by American contemporaries have found their way into West German public and private collections. Starting with canvases by the Abstract Expressionists in the 1950s and continuing with Pop, Optical, Minimal, and Photo-Realist examples, Europe, for the first time in our history, has admired and purchased art by living Americans. The Japanese have been buying up French Impressionists as well as quantities of minor earlier paintings in the United States.

The consensus was against restricting export of any works of art. Free circulation of contemporary art was regarded as a valuable activity in an international world and the small number of first-rate paintings that have found their way abroad is not considered serious. Compiling a list of our national treasures or setting up severe restrictions would, it was felt, only make the present exporting countries retaliate.

More important than theories of export is one condition touching the central integrity of a museum. Rapidly rising prices of art and our government's policy of tax-deductible giving has been abused by museums from time to time. Formerly it was felt that the valuation a donor put down on his income tax return was of no concern to trustees or director; it was between him and the Treasury Department. Since 1966 the Association of Art Museum Directors has taken a firm stand against excessive valuations, urging museums to refuse works where the monetary value is based on misrepresentation.

Many issues become clear if the museum is to operate under honest principles. But as Thomas M. Messer has noted, there are a number of "gray" areas more difficult to define. For example there

is the question of accepting gifts from artists. Should an institution take such offers, knowing that artists use their inclusion in museum collections for publicity and consequently higher prices? Should private collections be welcomed for exhibition when such loans enormously enhance the monetary value of the works shown? Two cases involved a part of Walter Chrysler, Jr.'s large collection lent to several museums and then sold, and an exhibit of Allen Funt's paintings by Alma Tadema which, upon conclusion of the display at the Metropolitan, were sent to an auction where their prices seemed much improved after their museum exposure.

Not directly connected with ethics are considerations of museum principles unanimously passed at Association meetings and subsequently ignored by some directors. Traditionally the chief purposes of a museum have been to collect, preserve, and exhibit. It is disquieting, therefore, to have suggestions within the profession, that great museum collections be split up and sent to sections of a city where disadvantaged citizens live. Why not branch museums just as there are branch libraries? The parallel is inexact. Museums deal in unique objects while libraries deal in duplicates. Copies of Shakespeare's plays can be ordered for any number of branches. Social critics of the left regard the Metropolitan as a vast art trust to be broken up by some cultural Sherman Act, unwilling, as they are, to admit that the very strength of a museum lies in its cohesiveness. The Museum of Modern Art is not "irrelevant" simply because it presents the greatest survey of twentieth century art to be found anywhere, though one of its directors, John Hightower, remarked that while the collection should not be sold it represented a fantastic visual resource and should definitely be dispersed.

Even directors who subscribe to some long fought-over principles in theory may, when it comes to practice, completely deny them. For years directors and staffs have opposed segregation of collections often insisted upon by the donor. The donor does not wish to see his group of objects, gathered with care and foresight, "split up" and melded into other galleries where they appropriately belong by school and period. The result can be a pantheon not of art but of collectors, their names inscribed in large letters, presiding over separate kingdoms. The Association of Art Museums strongly advises in its handbook that "gifts and bequests be of a clear and unrestricted nature and no work should be accepted with an attribution or circumstances of exhibition guaranteed in perpetu-

ity." The director of the Metropolitan Museum of Art was one of the committee writing the report, but this did not prevent Mr. Hoving from accepting, exuberantly, the important Lehman Collection which must be kennelled in a newly built pavilion, and kept apart from other collections. The Metropolitan might have known better; its curators have struggled manfully in the past to fit the Altman and Bache donations into a general survey, exercising the ingenuity of a jigsaw puzzle. Such unilateral decisions affect the whole profession; it becomes more difficult for other museums to stick to a declared principle when abrogated by a great museum like the Metropolitan Museum of Art.

In general a museum's integrity is displayed not by its "image," carefully cultivated by a public relations staff, but from the attitude in which the institution takes on the many complex—and often conflicting—problems that beset it. Here probity and consistency are paramount. A museum that veers and dodges like a battleship trying to escape a *kamikaze* attack, quickly loses public confidence, laying itself open to investigation and greater control by regulating agencies.

For the Future: Alternative One

If the art museum continues on its present course, one can see trouble—if not disaster—ahead. The arbitrary power of self-perpetuating boards, with their reluctance to allow participation in policy from the staff, and particularly, vast, expanding museum plants are only two straws in the wind. In America we have a tendency to make everything too big; many museums would subscribe to Browning's terse phrase: "Mere size is something."

We can already see the results of buildings which are too large, under present economic conditions, to operate fully. In 1974 the Philadelphia Museum of Art, an Acropolis on a hill in a park, lacked funds for guards so that many galleries were closed off during certain hours. The Brooklyn Museum had a similar problem; there were times when the public was turned away from various collections by locked doors. Yet the Metropolitan Museum of Art was on a vast building scheme, absorbing a late Egyptian temple, the Lehman pavilion, and a new $11,900,000 project for its American collection. The Art Institute of Chicago was vastly

enlarging its present space and was out to raise a fund of $46,400,000. All this frenetic expansion came at a time when most museums were deeply in debt; during a three-year period at the Museum of Modern Art, some $3,000,000 of its endowment of $16,000,000 went down the drain to meet current expenses.

In some ways American museums have been unfortunate in their model: the Louvre. Made up from a series of former palaces, it served as an inspiration for many of our museum buildings. Nonhuman in scale, huge galleries awed and impressed the visitor rather than welcoming him as a person in search of transcendent values in art. The building of the National Gallery of Art in Washington, old-fashioned even before it was completed in 1937, was once defended by a former director, John Walker, who felt that many Americans who had never experienced the grandeur of European palaces should be allowed to walk in marble halls.

Not only classical or Renaissance palaces but new modern structures have helped increase costs just at the moment when all operational expenses are soaring and funds shrinking. The Pasadena Museum of Art is a recent example. Erected in 1969 at a sum of almost $5,000,000, it was going bankrupt when rescued by the millionaire collector, Norton Simon, who took it over, agreeing to pay its back building debt of $850,000 and its running deficit of some $30,000 a month. He practically appoints the board and appropriates 75 percent of the space to install part of his huge personal collection. As an acquaintance remarked, "Norton Simon has given collecting a new dimension. First, it was works of art, and now museums, themselves." Everywhere cultural institutions are in difficulty. A sign of the times is the recent disbanding of the Dallas Symphony after seventy-four years and the end of the Washington (D.C.) Ballet. News from Italy that the great Brera Museum in Milan is closed and that many other Italian museums in the summer of 1974—in the very midst of the tourist season—shut their doors, unable to hire substitute guards, is not reassuring.

Adding to costs are many new services demanded by the public. Not only a downtown gallery (if the museum is on a city's outskirts) but an increasing number of classes for amateurs: painting, pottery, photography, etc. Volunteer boards can think up a project a minute, all of which increases the museum budget. These include "out reach" programs "socially oriented," with such missionary

endeavors straining funds and taking up an inordinate amount of staff time.

Who will pay for these deficits? Undoubtedly the federal government, through the National Endowments for the Arts and Humanities, and state art councils will contribute significant amounts in good times under sympathetic administrations. But let a depression set in and government funding will dry up overnight. Increases in city appropriations depend on a rising tax rate and are difficult to obtain. The art museum is competing, constantly, with the performing arts (a ridiculous term, suggestive of trained seals or educated dogs) many of which have powerful friends and lobbyists. The public that pays the bills feels it has a right to dictate. One can see the situation worsening.

Undoubtedly a number of museums within the next decade or two will run out of funds. They will possess millions of dollars in collections, but not money enough to show or protect them. There will be stepped-up campaigns of public relations; "communication" will be the catchword of the period, without a clear idea of what the museum can or should communicate.

Eventually many institutions will be bailed out by the government, who will no longer grant them funds but take over the museums, entirely. Bureaucracy, with all its attendant redundancy and waste will result, and art museums may return to their former quiet. Rigidly administered through civil servants, they will have lost their glamour and once more function chiefly as storehouses of the past.

Alternative Two

There is another possibility: museums do not have to go bankrupt in money and ideas, if they will take a long hard look at reality. Today there is a flurry of rewriting by-laws and reexamining more superficial aspects of the problem such as efficient business practices and new techniques for raising funds. The art museum can survive best if it will go back to its basic purpose and redesign its structure and meaning.

TRUSTEES

Boards of trustees should stop electing their own successors; members should serve not more than six years, retire and wait

another six years before eligible for reelection. They should abandon passing on works of art where few trustees have the competence of a professional staff. This power should be delegated to the director and senior curators.

The veil of secrecy under which the board operates should be removed as far as is practical. Deliberations ought to be part of public record, and the annual report should publish in its lists of acquisitions the price of every work bought or the valuation of every gift. (It would be well for the public—hypnotized by huge sums paid by a few museums for a few masterpieces—to realize that museums acquire a $200 print as well as a $500,000 painting.)

There seems no reason why a member of the museum staff (unionized or not) should not become a voting trustee. Experience with student trustees in universities has been far from revolutionary. On the whole they have had little to contribute, often being bored by policies which they fought hard to influence. The staff member on the board, would, one believes, add more weight, for he is constantly involved in carrying out decisions made by trustees.

STAFF

The director should always be a professionally trained art authority and not subject to uninformed decisions on art by a businessman president or board chairman. Any administrator or business manager must come under the director's jurisdiction. Secrecy should no longer surround staff salaries. A close look at university practices would be useful with regard to titles, promotions, and wages paid. A newly appointed assistant should know how long he must serve before being eligible for an assistant curatorship, what length of time he must wait before becoming a full curator. Salaries should be clearly stated. Such candor will not only reduce tension between administration and professional staff but will help attract some of the brilliant young people who are seeking security in universities.

No one who has not been active in a museum knows the time and effort wasted by the director and senior curators under the system of trustee approval of acquisitions. Lobbying, meetings with chairmen and sympathetic members of departmental committees, the whole charade of diplomacy and "soft sell" often must be undertaken before a work is bought. Equally serious is the loss of major works

not approved by the board. With time saved, the staff will be able
to conduct more research on collections and publish the results of
their scholarship. In small museums it might be wise—since no
director can be an expert in every field and few specialists exist on
their staff—to consult an outside authority when a major work is
under consideration.

COLLECTIONS

Large urban collections may be well advised to eliminate certain
burgeoning departments. This does not mean splitting up signifi-
cant major collections into smaller units and scattering them round
the city but shedding some late additions to museum fare. The
Metropolitan Museum of Art, once called the Grand Central
Station of the Arts, might lend (if by deed of gift it cannot present)
almost its entire Rockefeller Collection of Primitive Art to the
Museum of Natural History. (An exception could be made of the
Pre-Columbian material, which is equal in quality to other great
sculptures of the past.) Museums of natural history have come a
long way in presenting objects with taste since the day, forty years
back, when a visitor to the Field Museum in Chicago asked to see
its "art." "We have no art in *this* museum," was the cold rejoinder.
After René d'Harnoncourt installed American Indian and Oceanic
artifacts to show their aesthetic values, scientific museums began to
wake up and employ modern presentation. In large institutions
decorative arts also could be severely cut back. The great examples
of minor arts, the occasional brilliant enamel or work in wood,
ivory, metal, or pottery ought to be exhibited with as much respect
as a major painting. Americana could be released to historical
museums where much of it rightly belongs, while other examples of
furniture, ceramics, etc., including those sad survivals from great
mansions, period rooms, could be set up in a special museum of
historic decoration.

The Art Institute of Chicago embraces an art school and a
theatre. It is not impossible to detach both from the museum and
reattach them to a university or university branch in Chicago. This
would accomplish two objectives: do away with the great expansion
of space contemplated (with attendant expenses of maintenance),
and improve the art offerings of other educational institutions in the
area.

When the Museum of Modern Art was founded in 1929, its prescient director, Alfred Barr, demonstrated that photography, film, and even architecture (really uncollectable) were part of a single, modern movement. Today its photography department might be transferred to a specialized Museum of the Photograph and its film collection merged with others into an American version of the Cinémateque Française.

Such shedding of great quantities of objects would not only reduce costs of maintenance and staff but would make large institutions easier for the public to enjoy.

The Metropolitan Museum of Art during its centennial year of 1970 boasted of over five million visitors but potential damage to works of art must be considered in applauding this statistic. In Boston's museum the conservator reported that since galleries were not air conditioned the very atmosphere, contaminated by great crowds, was deleterious. The Museum of Modern Art complains of dirt, dust, and fluff from its huge attendance. A famous psychoanalyst was once asked, "Why do people go to museums?" He replied, "From a feeling of cultural guilt." Though the Metropolitan insists that a recent survey shows that the majority of visitors like the place the longer they stay, one has only to observe the thousands of tired families, dragging themselves through its vast halls, trying to see "everything in a day" to realize that much of the material on view should be installed in study collections for student and specialist. "Cultural guilt" could be replaced by quiet enjoyment were there less to see.

PROGRAM

It is essential that the museum drop a number of services which are today adding to skyrocketing costs and are often peripheral to the main thrust of an institution. The whole field of children's visits and classes should be exhaustively restudied. The art museum, as a former director of the Metropolitan, Francis Taylor, wrote in a prophetic little book, *Babel's Tower* (1945) was tending to become a parish house, trying to be all things to all people. The huge "three-star spectaculars" in the form of loan exhibitions are fortunately coming to an end due to immense insurance valuations. Otherwise, wear and tear on masterpieces might have used up some of the world's great art in a single generation. Already museums

with reduced budgets are beginning to make intelligent use of their possessions, arranging them in special showings. The recent exhibit in the Museum of Fine Arts in Boston, "Degas, the Reluctant Impressionist" is a case in point. Most of the works came from their own collection, heightened by a few significant loans.

There should be more imagination in educational use of objects. Perhaps the old historical survey of gallery after gallery telling the "progress" of art through schools and periods might be replaced now and then by stimulating juxtapositions to show new relations between works of art. Departments of public education should have a complete reevaluation. Originally the museum educator was a starry-eyed lady who would have agreed with Anatole France that the art experience "was the wandering of the soul among masterpieces." Gradually museums hired docents who, better trained, took groups round the galleries and at their best set up a lively give-and-take with the audience before the work of art. Unfortunately even these have often been replaced by the Acoustiguide, a mechanical lecture. Visitors wear tape recorders and earphones reminiscent of astronauts. They walk like robots; stop dead before a painting, then quickly move on to another "high-point," ignoring anything between. They have been programmed as successfully as some of the reduced humans in *A Clockwork Orange*. It is possible to impart considerable information through the Acoustiguide. It is impossible to deliver an art experience through such means as there is no back and forth discussion.

COOPERATION AMONG MUSEUMS

Museums are being forced into cooperation but there should be considerably more. In New York, for example, there is no reason why the Museum of Modern Art, Whitney Museum of American Art, the Metropolitan Museum of Art, and Solomon R. Guggenheim Museum of Art should all buy sculptures of the same period by David Smith. Loans back and forth are easy and the dangers less than in packing, shipping, and handling to outside museums. When the Metropolitan was considering the purchase of the expensive Velásquez, it attempted to get two other museums to bid with it, the picture to be on view in each institution a certain number of years. Unsuccessful, it mortgaged its funds, bringing on the whole necessity to sell excellent works to help foot the bill. Mr. Hoving has

made a successful international arrangement with the Louvre. Both museums will share in buying certain works of art and share periods of exhibition. Perhaps unproductive competition among museums is on the wane.

WHAT IS A MUSEUM?

Almost every day we are told that museums are in a state of confusion regarding their role. "Museums on Trial," "Museums at the Crossroads," "The Crises in the Museum,"—such articles frequently appear in magazines or Sunday supplements. Art journals are full of a quest for the museum's identity. But if the institution is to survive, it should return to first principles of an art museum which remain collecting, preserving, exhibiting, and above all educating. Collecting in the future is bound to slow down, preservation with modern methods to increase, exhibiting to become more selective, and education, the last of these to be taken seriously, greatly to expand. Its emphasis will be less on audio-visual apparatus than fresh and innovative thinking on how the art experience can become aesthetically and psychologically satisfying. To adapt a McLuhanism, "The museum *is* the message."

Acknowledgments

Many of the above facts and opinions were drawn from following publications:

Art Forum, *December 1973, pp. 41–48.*

S. Burnham, The Art Crowd, *New York, 1973.*

G. Glueck, *"Simon Control of Museum Stirs Coast,"* The New York Times, *February 5, 1974, p. 32.*

G. Glueck, *"Strike Hardens Attitudes at Modern,"* The New York Times, *February 5, 1974, p. 28.*

A. Grant, *"How Good is Moma's Pasta,"* Museum News, *June, 1974, pp. 43–44.*

J. L. Hess, The Grand Acquisitors, *Boston, 1974.*

R. Hughes, *"The Museum on Trial,"* The New York Times Magazine, *September 9, 1973, pp. 34, 102, 103, 104.*

J. H. Lamotte, *"In Memoriam: Deprofessionalization at the Institute,"* The New Art Examiner (*Chicago*), *June, 1974, pp. 1, 10.*

W. McQuade, *"Management Problems Enter the Picture at Art Museums,"* Fortune, *July, 1974, pp. 100–103.*

T. M. Messer, *"Le musée du coeur des contradictions américaines,"* XXᵉ Siécle, December, *1973, p. 77 (brief English summary p. 196).*

A. H. Raskin, *"Behind the MOMA Strike,"* Art News, *January, 1974, pp. 36–71.*

S. E. Weil, *"The Multiple Crises in Our Museums,"* a paper delivered at the 48th Annual Meeting, Western Association of Art Museums, Los Angeles, October 27, 1971 (mimeograph copy).

V. Zolberg, *"Building for Cultural Clout,"* The New Art Examiner (Chicago) June, *1974, pp. 1–2.*

In addition I wish to express my appreciation to those directors of museums who kindly gave time for interviews and especially to Elizabeth Shaw of the Museum of Modern Art for invaluable information.

Walter D. Bannard

6

The Art Museum
and the Living Artist

The Nature and Function of Art, Artists, and Museums

A work of art is a coherent physical entity put before a special apperception called taste. An object becomes art when it is declared and accepted as art and exposed for apprehension of its properties instead of its usefulness in relation to other things. Certain types of objects fall naturally into the class because a culture recognizes them as art; thus we have painting and sculpture. And there are types of objects which evolve from usefulness into art, or become seen and then exercised as art, such as photography and film, or utilitarian objects allowed as art, such as some furniture and some artifacts of primitive cultures. Of course, it is possible for an object to fall away from art; a sculpture used as a doorstop is a doorstop. But taste, though finally harsh, is initially accommodating. Anything can come before it. In our culture more and more does, including much that is artistically trivial. This challenges taste and helps preserve things which might be lost to taste in the future.

Aesthetic judgment is like practical judgment in one way and quite unlike it in another. Practical judgment values an object in proportion to its usefulness in some phase of life, and can estimate

WALTER DARBY BANNARD *lives and paints in Princeton, New Jersey. His one-man shows as well as group shows have been held widely in the United States and abroad since 1965, and his works are in public collections in more than a score of galleries and museums. The subject of many articles by art critics, Mr. Bannard himself writes and lectures extensively and is an editor of Artforum.*

163

that value from the attributes of the object. Aesthetic apprehension includes judgment as it searches for greater aesthetic pleasure. The pleasure, and the value it has, is the "usefulness" judged. No specifiable attribute can induce this pleasure or bring this value. Only aesthetic attendance can; the experience renders judgment and judgment renders the experience. Aesthetic pleasure is all, and only, experience. It is estranged from words and divorced from effect. It is intense, swift, lively, unpredictable, unalloyed, indescribable and real, and it has value. I cannot afford proof of this value in words because it does not rest on principles. It is not easily had, but once in hand it comes across as a fine joy, without rancor or expense, without the subtle vengeance of common sensuality.

Of course there is also the measure of history, the importance our culture gives objects which are useless except as vehicles of something felt but indefinable. If art lacks high human value, then we have been persistent fools, and art is a systematic delusion, a hollow monument. Many of us know this is not true, because we can consult our feelings and report them. We can say art holds something for us nothing else can. But there are those for whom art remains opaque, foreign, phony, the passion of the privileged few. In one way they are right. Art is for a privileged few, but those few have earned their privilege and deny it to no one. Those of us who make art our life are not the keepers of the jewels or the guardians of the shrine. We are here to preserve the highest standards and make them available in the face of criticism and misunderstanding. Lowering these standards is a disservice to art, to ourselves, and to everyone. We must maintain them to give to those who can appreciate, and offer to those who cannot or will not. We know that art has the functional permanence of a natural organism, and the same physical fragility. Great art does not compromise. As Oscar Wilde said, "Art should never try to be popular. The public should try to make itself artistic."

A fine work of art is a species of invention, and all profound invention is individual. It comes up from a deep and solitary well. Feelings and ideas are not shared until they are expressed; profound feelings, fresh ideas, if commonly found, would not be profound or fresh. Genius is genius by its rarity. Today the older working forms of art-making have eroded in favor of conception or innovation; coming to inspiration, to the full use of genius, is a long process, demanding persistence and patience made more poignant

by the loneliness of the trade. The serious artist, ambitious for his art, is prepared by nature and driven by vocation to consult and trust only his own feelings, and to be skeptical of intrusion. He is a self-contained manufacturing unit who will only alter his product from internal need, who expects to endure rejection of that product after it is made, and suspects, even despises, the various "systems"— particularly gallery and museum—which bring his product to the public. These traits, in turn, have fostered the unfortunate dogma of the artist-as-exile: if you're honest you're poor, if you are rich and famous you've sold out. To the artist material success is a hypocrite's nightmare, even if well-deserved and slow in coming. He feels obliged to conform to the stereotypes of present-day bohemia. And now the attitude is celebrated by art purposely designed not to enter the "system," as if aping the outworn neuroses of the art world will yield the depth of past art.

But this wave of romantic hysteria is a last flurry, a dying gasp. Art is coming back into our life as central and important. Improved industrial and social conditions satisfy our needs and move further from our interest, just as religion did when the real harshness of life was alleviated. Art will surpass technology. It is not stationary; it grows and is improved by cultivation. It gives the ultimate pleasure and the most efficient one. And as it moves to the center of our culture, artists and museums must pave the way.

Museums have grown and changed since World War II. Life is getting better and easier, and people turn to the arts for self-fulfillment. Public interest and interest in the public take an ever increasing share of the art museums' time. Ironically, museums are threatened as much as helped by their new popularity. Their willingness to accommodate the public fuels further demands and requests. The special exhibit, improved exhibition techniques, increased education facilities, and travelling shows are at once the glory and despair of the art museum. Private funding, once their life blood, is no longer equal to the task. The earnest scramble for public money has begun, and with it bureaucracy spreads its paralyzing roots, for example through the accreditation procedures of the Association of American Museums.

Museums must defend what they are, not try to be what they are not. The museum is like the artist in some ways: isolated by devotion to high standards, dependent on its own conscience, suspicious of intrusion from the outside, and awkward in its own

defense. But it is also a public body. An artist may be expected to be a buffoon, which is unfortunate but need not interfere with his work. But the museum is expected to be all things to all people. It cannot be. The purpose of the art museum is to bring the best art to the public in the most efficient manner—and by that I do not necessarily mean the most economical. Everything must be measured against this principle. Just as the artist must put away the false image of the lonely bohemian, so the museum must learn the lessons of survival and the perils of popularity. It must not be done at the expense of integrity, real integrity, integrity of high standards, of freedom, and conscience working together.

The Artist and the Museum

I have some personal experience in museum work, and I am sympathetic with museum problems. But I see the art museum from the outside, as an artist, and it is the viewpoint that I must propound. What follows is neither comprehensive nor balanced. The subject is general because there is no such thing as "the artist" or "the museum." Therefore instances of types of activity, problems, and suggestions will not be true or applicable in all cases.

THE ART MUSEUM AND RECENT ART—WORKING ATTITUDES

Museums, and the collections which preceded them, preserved objects which had outlasted or had been taken out of the environment in which they had a place. The attitude that a museum object was both old and exotic was institutionalized in internal structure, a system of separate but equal departments, each having as its curatorial concern a specific "field" within which were a number of objects of a type. The "field" is fairly stable; change is in terms of scholarship and discovery, which creates a slowly growing body of knowledge, like an enormous midden which curators can crawl about, magnifying glass in hand.

The notion of quality, therefore, is sometimes non-aesthetic. An ancient sculpture can have "importance" that is more exemplary than artistic, more to do with qualities than quality. A good curator can tell us when and where the piece was made, but he may be less sure if it is as good, as art, as a piece from the same culture a hundred years earlier. New art brings forth objects for which there

is no sign of "importance." Connoisseurship comes in slowly, like wine-tasting after fermentation. Museums know that in the great body of new art are some works which are good enough to merit their attention, but they have no guidelines, no way to separate the good from the bad. All too often museums substitute policy for connoisseurship.

WAIT AND SEE

The museum waits for things to shake out before buying or showing new art, seeking safety in passivity. But a passive stance is not workable. The following examples are composites of real situations.

1. A large art museum is negotiating to buy a piece of sculpture from a private collector. The sculpture was made nine years before, and the collector bought it then for $5,000. The present value and asking price is $85,000. The curator of contemporary art tried several times to get this purchase through the acquisitions committee but was turned down. Now they have decided to buy it because it appears to be an "important step" in the history of modern sculpture.

What has happened? The museum has failed to serve the public efficiently and well. The sculpture has been withheld from public view for nine years. Now it will cost the museum more money, money that could have been used for other purchases, and the museum has lost the accrued value.

2. A museum buys at auction a painting by the "outstanding" member of a certain school of modern painting, a type of art the museum at first had rightly disregarded as not very good. Then the price was low, but now, at auction, it brings $130,000. Unaccountably, the artist's work has risen sharply in value. Critical opinion, almost without dissent, regards the artist as a modern master. The museum is "forced" to reverse its judgment.

Again, the museum has failed the public. It has wasted money and betrayed its own good judgment. It has been led by the market, by galleries and collectors, by failed critics. In all periods, certain types of new art are driven into an oversold condition. This naturally happens at the point of greatest critical acclaim, which naturally is the point of greatest desirability. This persists for a while and then settles out, eroded by the wisdom of time. The

museum has a bad investment and a mediocre work of art, which will be hung alongside, and as equal to, much finer works. Connoisseurship has failed, but the public does not know it.

3. The museum has a very conservative policy of exhibition and acquisition. It is the only art museum in a fairly large metropolitan area. Its big show of the year is a retrospective of a great French Impressionist, which gets rave reviews. There are no shows of recent art; there had been a loan show of early Abstract Expressionist paintings a few years before, but nothing similar since. There is no juried show of local artists. Museum policy reflects the attitude that exhibiting "unproved" art sanctifies it, and that the museum should properly avoid anything that smacks of the marketplace.

The result? The museum's "conservative" policy fails the public. "Showboat" exhibits like that of the Impressionists are loved by all but gain no ground. New art will be old, expensive art when it is finally bought. The interested public must go to the few galleries in the city or read art magazines to see the rich ferment of new art. Local artists have no way to get first-hand impressions of new art, or the art of a generation past, and nowhere to show, so they move to New York. The museum maintains high standards, but at what expense! Rather than exercise their taste they abandon it, and excuse themselves with righteous non-reasons, such as "influencing the market," which is not their business. And they lose the most vital part of their constituency.

A wait-and-see policy is a bad policy.

AVANT-GARDISM: CELEBRATE THE NEW; BUY ACROSS THE BOARD

Each period of modern art has had its easy answer, and that answer is usually framed in terms of accessibility. In the late nineteenth century it was the Beauty of the Classics, in the early twentieth it was the sensuousness of latter-day Impressionism. Ours is the "tough" pose of newness, following the Dada strain of the late teens and twenties of this century. These attitudes imply that quality can be identified with a particular material or process. Such attitudes have come to be called *academic.*

The history of modern art, for about the last hundred years, shows that art which has lasted came in company with formal innovation, that at the root of quality was newness. When the depiction of real objects in an illusion of real space was swept away

by abstraction, the artist had to start from scratch, to invent his own pictorial structure. Contemporary inspiration is conception, invention. This spirit, with the historical "guarantee" that quality comes with newness, plus the ubiquitous yearning for the shortcut, equals avant-gardism: deliberate newness for its own sake.

Ironically, avant-gardism is thoroughly academic, like all other easy answers in art. The credo is negative: turn away from "out-moded" forms, not only from the traditional forms and materials of art-making but also from the assumption that art has human value, and that some art has more than other art. Duchamp's impulse to undermine high art by mocking it has spread and calcified, as these things will. And it has allied with a spurious democratism which condemns value distinction. This puts the art museum on the defensive, because its very task is discrimination. It must defend its traditional function or go along with avant-gardism, as either part or all of its exhibition and acquisition program.

However, there is a way to accommodate avant-gardism, and other "isms," without compromising the integrity of the museum. Because of the many types of art now being made, the museum can have a continuing series of small shows which would purposely reflect current trends. Each could have a small monograph about the characteristics of the art and its dynamic place in current art-making, not as defense or apology, but as description. Taste and judgment would be put aside in favor of simple reporting, and that would be made plain. Such shows would be a service to the art public, the artist, and the art historian, all of whom would be encouraged to "taste and compare," and decide what they like. The museum would, in effect, say "this is what is going on. What do you think of it?"

Or the shows could be homogeneous, putting different kinds of new art together, perhaps on a rotating basis, or putting new art up against older art. This would give up the scholarship employed defining the unifying characteristics of a style, but it would afford comparison, which is at the root of connoisseurship.

Shows of this kind would have an added dividend: they would take pressure off. Off the public, encouraged to criticize, weigh, and choose, not look in awe. And off the museum, which need not agonize over what may enter its sacred precinct. There may be complications and difficulties. Good curators are ambitious and

may not like spending time and money on shows which will not bring them before the public eye. And no matter how relaxed the selection process, artists and their agents will carry on about "who got in" and "who was left out." The Whitney Annuals were always very interesting to me as an artist, and very influential. But they seem to have crumbled from a combination of curatorial incompetence and disinterest and the inevitable critical outcry when each Annual was not a heaven-sent and end-all spectacular, instead of the middle-level buffet they were and should have been. I think every museum with sufficient resources should have a continuous "Whitney Annual." In this way all current styles could be brought into the museum and shown to the public without promotion or favoritism, without compromise, without commitment of the "authority" of the art museum.

Showing everything can be a public service, but buying everything cannot. There is a theory that buying large quantities of new art when it is cheap will catch a few big fish for little money. This is wasteful, inefficient, and as much a violation of the public trust as the opposed attitude of wait-and-see conservatism.

1. The method assumes that bad art will be bought. The rationalization is that a "study" collection will be built for scholars of the future. I am very much in favor of showing bad art, and minor art, under certain conditions. I think art schools should give courses on bad art. But an art museum is not a museum of the history of style. Public money should not be wasted buying, keeping, and exhibiting inferior art. Even bad art tends to last, physically. It can make its way outside the museum.

2. At best, it is an inefficient way to collect. Of course it is wise to buy good art before it goes up in value. But most of the art made at any particular time is inferior, so the proportion of bad art bought this way will be very high. Bad art is only bought cheap if the museum has an active policy of selling when they realize, ahead of the market, that certain work is inferior. But few museums have this policy. And if they buy indiscriminately, they will sell the same way.

3. The method will not get the best of an artist's work. If careful and wise selection is not the general procedure, it will not be the specific procedure.

4. Any experienced collector, of art or anything else, knows that it is better to get the top item rather than several lesser items for the

same amount. The masterpiece has greater human value than any number of lesser works and its market value rises at a steeper rate. The money used to buy inferior art should be applied to good art, even if more expensive.

Buying across the board, picking up anything that is new, is not good policy.

THE ART MUSEUM AND RECENT ART—THE ONLY SOLUTION

There is no easy way to do well the buying and showing new art. In art-making, in museum work, in any human activity, success comes through competence. There is no substitute for quality in art and there is no substitute for a good curator and director. Substituting policy for competence will institutionalize failure. Just because good curators and directors are hard to find is no reason not to look.

It has been my experience that failure at the curatorial level goes back to the director and board. They look for the wrong character-istics in a curator of contemporary art. There is a fear of extremes, even the extreme of quality. This is understandable; a good eye, foresight, and imagination in new art brings down criticism, often savage and irrational. I have seen this many times. Trustees are successful, conservative persons of high standing in their commu-nity. They do not like controversy. So museum policy must create conditions favorable to enlightened showing and acquisition of new art. I have the following suggestions.

1. The curator of new art should be picked by one person, not a committee or any other kind of group, and not necessarily by the director. The selector should be a person with a known record of good judgment about people, and he should be sympathetic to new art. He must recognize genuine, uncomplicated ambition and the ability to see art well, which are the basic qualities this curator must have.

2. The department of recent art should not be set up like other departments in the museum. The curator should be given a budget and a period of time to do exactly as he pleases. Exhibitions and acquisitions would be his responsibility and he would be held accountable for them. There should be no acquisitions committee for new art.

3. Kant wrote ". . . seek the testimony of the few; and number

not voices, but weigh them." There are persons who have a record of seeing the quality of good new art before others. They should be asked to sit on an advisory committee for new art used entirely at the discretion of the curator. They should be chosen solely for their proved ability to spot quality, even if they have conflicting interests. The curator must sort out the information and make his own judgment about the self-interest of any member of the committee.

4. A study could be made of those in the museum business who seem to have been consistently "right" over the years; and an analysis could be made of the dynamics of their talent. A number of persons come to mind, not always in connection with new art. For example, the director of a small museum with limited funds who buys superlative examples of "out of fashion" art at depressed prices. We all know that a great Pollock could be had in the early 1950s for $6,000, but we have forgotten that a pretty good Monet did not bring much more. As far as I know, no systematic study has been made of the cycling ratio of quality to cost, and of the persons who have done well and badly in the market.

5. The ability to pick the best new art can become a recognized specialty to be nourished, like any other talent. Museum schools, for example, can have intense courses of comparative study of quality to train museum professionals. The course would be purely aesthetic and would assume thorough grounding in art history. Only real art would be used; no reproductions, no books. Such schools would be in large art-producing cities like New York, where plenty of good and bad art can be seen easily. Discussion, disagreement, and debate would be the order of the day. The thesis would not be written, but would consist of the judgment of a specific body of new art. The most concentrated art "education" I ever had was judging the Davidson National Print and Drawing Competition, for which I had to select, in four days, some 170 works from 3,709 submitted. It was physically and emotionally grueling, but my taste was challenged, and altered, as never before in such a short time. I do not know how this experience could be brought into a museum school course, but it is worth trying. A school like this would quickly have an international reputation and be a great good for museums and the museum public.

THE ART MUSEUM AND THE ART COMMUNITY

As an artist, as a member of the art public, I have a natural interest in the art museum. Most of my suggestions are made in the

interest of high standards and efficiency, which I take to be the two essentials of museum operation, and the means by which the museum can do the most for me. Museums usually aim for high standards, but these standards may be undermined by certain insidious attitudes within the art community and by the new popularity of museums. Efficiency, however, has never been the strong point of the art museum. There is wastefulness, duplication, and a high ratio of expense and effort to performance. I have seen this first hand, and I have seen the opposite: a museum severely handicapped but forced to produce, and forced to revert to very direct and basic methods. A museum is like a business with a product to sell and a public for that product. Their responsibility is to the whole public. Artists are a special part of that public, but only part. Any special compensation for artists must also directly help the museum. The museum is the highest agency for the artist's work and the artist is the art museum's basic resource. If the museum can stimulate and improve art-making in its community, all will benefit.

EXHIBITION AND THE ART COMMUNITY

Here are a few things museums can do.

1. Get the best new art out where it can be seen. This is important in the larger art-making centers of the country. Art is fed by art. That is why there are centers of art-making: Paris in the nineteenth century, New York now. To the evolving artist, the good artist, half of making art is seeing art, of judging, appraising, evaluating, ingesting, using. When I was learning my trade, in the late 1950s, nothing was more important than seeing art promiscuously and talking about it endlessly. The most important shows were mixed group shows in museums. I could not care less that the critics of the time had bad things to say about these shows; I was there, attending each picture in turn with the anxious hunger of an ambitious young painter. I looked for what the picture had for me, what I could take to add to my inventory of painted form. There is no sterner criticism. It would be hard to overestimate the value these shows had for us.

I only wish there had been much more. We had to turn to galleries and art magazines for varied fare. Even today in New York, the art-making capital of the world, there is no single

permanent exhibit that really shows the incredible richness of American painting of the last thirty years. There are samplings, but they are so limited, so fragmentary. This is very unfortunate for artists. Galleries usually show recent art; museums have bought too cautiously; and most of the work of a previous generation is in estates, private collections, or the storage rooms of large galleries. Great recent artists are known to thousands of people through one or two pictures perpetually reproduced. We are driven back to books and magazines, to the "museum without walls." We are grateful for this resource, but it is not the real thing. The art is there. There must be some way for museums to show more of it, more regularly.

2. Homogenize permanent and special exhibits to encourage comparison judgment, seeing. Why must exhibits be arranged by who did it and when done? Provenance is not aesthetically important. If a museum has a good collection, "new" exhibits could be made just by judicious rearrangement. This could be done fairly easily. It would help both the artist, who would see in different juxtapositions, and the average museumgoer, fatigued by repetition.

3. Have local open juried shows. This is important where there is much art-making and few galleries. If done right, it helps everyone. I have seen local shows dropped or not begun because the procedures were self-defeating or unlikely difficulties were anticipated. A study of such shows would bring to light the best techniques.

The May Show at The Cleveland Museum of Art is a well-planned, durable local show, 55 years old in 1974. That year, over 2,000 works of art were entered from thirteen counties in northeastern Ohio, a small enough area for the practical delivery of relatively large and fragile works of art. Three hundred and seventy works were accepted. Jurying is done by museum staff members; the catalog is the museum's May bulletin. Costs were about $3,000, most of it for part-time help and mailing. Many volunteers also help. Attendance is usually up about 50 percent during the period of the show. There is a lot of publicity. Sales usually are more than $30,000 and the museum gets 10 percent. Sales are increased by a well-attended "Patron's Preview"; you get an invitation if you bought a work from the show the previous year. The May Show stimulates interest in new art on the part of the public, artists, and the museum staff. Businesses and government agencies buy more

and more for offices, and museum special exhibitions of recent art influence artists in the area, affecting much of the work submitted to the show. It is obviously a good thing for everyone, and should be done by any museum with sufficient resources.

If a regional art museum fears that there is no talent in their area, I refer again to the Davidson National Competition. The 3,709 entries came from everywhere; good art coming out of places I did not even know were inhabited. The great increase in communications in the last generation has helped produce a great increase of art-making. Apparently only a few of those artists have any hope of regular exhibition. It is a resource which should be tapped.

OLD PROBLEMS, NEW DEMANDS

Recently many demands have been made on museums by artists' groups. I find many of these demands unworkable and restrictive because they do not consider the nature of artists, museums, and the museum public. Though intended to help artists, their implementation could do the opposite.

The Art Workers' Coalition, a New York group, presented the Museum of Modern Art with a list of demands in 1969. It was a good codification of ideas in the air then as now. I have drawn from that list, adding from other sources, to make a general view of the kind of proposals which have come from artists' groups in regard to the relationship between artists and museums.

1. Museums should exhibit certain special kinds of work, the work of certain types of artist, and engage in certain activities, specifically:

A. Create separate sections of the museum, and exhibit programs or quotas for disadvantaged groups such as blacks, women, artists without galleries.

This would be against the first principle of museums, as stated above: to bring the public the best possible art in the most efficient way. *Any* quota corrodes that principle and is undemocratic. The museum's obligation is to an unrestricted public, not to any special group, and it must maintain its responsibility to its charge.

Furthermore, it will not work. Quota systems do not take account of human nature. Pride will out. The good minority artist, knowing that his or her work will stand up to the best, wants that work chosen for its quality. Whatever their sympathies, they will not want their work shown in a qualitatively indiscriminate way.

Permanent exhibits on a quota basis would become aesthetic "slums," a prison to escape from. Anyone accepting inclusion of work knowing that the selection is influenced by factors apart from the work will be compromised. The public, knowing the selection process, will expect the work to be mediocre. The artist will be degraded, the museum will lower its standards, and the public will be cheated.

B. *Create conditions for the exhibition of technologically complex work: hire staff technicians, buy equipment for special effects, go out of the museum to carry out complex environmental art for which the museum building is not suited.*

Again: public service and efficiency. Painting and sculpture are "democratic" because relatively many works can be shown simply and cheaply, and the public is given a variety of choice. This is a fact, not a justification of the media. The museum must weigh its decision. Is the electronic or environmental work good enough or interesting enough to spend extra time and money; is the museum obliged to provide the artist with a "studio" and pay for his materials; and is there any public benefit from an environmental work which few people can see? It will be found that exhibition or creation of these works involves a high ratio of cost to performance. It also would discriminate against those who work in more easily handled media.

2. *Artists should retain some rights to their work after it is sold.*

A. *An artist should have the right to refuse to allow his work to be put in any show he does not want it in, and he should collect a fee when a work is shown.*

When a work is sold to a museum, the museum assumes ownership and legally has the right to do whatever it wants with the work, consistent with the terms of its charter. Any restriction on the use of the work will hinder the museum from discharging its public function efficiently. Restrictions of showing and the payment of fees would add to the burden of cost and paperwork and would diminish effectiveness. If museums made money, a "residual" right could be negotiated by the artist's agent. This would make sense, as it does in the television industry. It could happen. But presently it would benefit no one, not even the artist. Museums would be even more hesitant to buy and show.

B. *Artists should get a percentage of subsequent sales.*

This is an interesting idea, but it is fraught with technical

problems, and really is not the museum's business unless it sells art. An artist might share in the *profits* yielded in subsequent sales. But then he should reimburse the seller if the work is sold at a loss. Given the intricacies of disclosure, mutual agreement on timing, and methods of sale, the paperwork and the inevitable quarreling, I see only the lawyers coming out ahead.

 C. *Museums should not sell the work of living artists.*

Museums make mistakes. It is not in the public interest for a museum to keep and store a work of poor quality for its collection. It should be sold. It will be objected that such a sale can hurt the reputation of the artist, but the artist already has had the advantage of the sale to the museum, and the museum would probably handle the sale discreetly. The museum must put the public interest first.

 D. *Museums should inform artists of all legal rights they may retain in a purchased work: reproduction rights, copyrights, etc.*

It is up to the artist to get this information, not the museum. Copyright law in fine arts is interesting and complex, and a clear statement of artist's rights and how they can be applied would be welcome. It would be a most interesting article in one of the art magazines. Again there is not much money involved, so the question is academic. But this may change.

WHAT ARTISTS CAN DO FOR THEMSELVES

 Their position in the art world makes museums seem responsible for things outside their area of competence. They are seen as "local government." This they cannot be. In many ways artists and museums are natural antagonists who must work together, like labor and industry. Artists have a tough time and others make more money from their work than they do. But the museum cannot solve this. And no amount of complaining about the evils of the "system" will help. If artists are to improve their lot, they must take the classic path of social reform: organize. And organize sensibly, practically.

 Artists' unions are springing up in many parts of the country, and some of them are refreshingly down-to-earth. The Boston Visual Artist's Union, organized in 1970, is a good example. It is really a guild, rather than a union, because it is organized for the natural benefits which accrue to a group rather than to make demands on

another sector. The membership—artists and craftsmen from all over New England—is more than 1,000 and growing rapidly. Their newsletter has a circulation of about 1,500. They obtained a very fine rent-free gallery and office space in downtown Boston where they have shows, meetings, panel discussions, and other activities. Practical things count most: discounts on art supplies, health insurance, a lawyer to advise artists, a committee to influence legislation, a "job bank," a slide registry of members' work. There is a bit of "anti-system" rhetoric about the group, but they stress the everyday matters an organization can handle better than individuals. Given the nature of artists, as described above, this is quite an accomplishment. If this movement developed with the same spirit, we would have a *national* artists' union, vital and pragmatic, powerful enough, for example, to influence federal legislation, and a national arts lobby, including museums and all interested persons, a profound force for the public good. There are already too many smaller groups, fragmented and competitive. We need a national "union" to render one voice out of many.

ARTISTS AND MUSEUMS: INTERRELATIONSHIPS

Social change and changes in art since the late 1960s have given rise to the idea that the artist should engage directly in museum activity. Proposals to this effect have been articulated but the idea has never been thought out. The rationale seems to be that artists are affected by museums and therefore should have a say in what museums do and how they do it. This is liberal and sounds good and hangs out the picture of the poor disadvantaged artist versus the rich elitist museum. But a little thought brings up other viewpoints. For example, that an artist's participation in the museum would be a self-serving conflict of interest, like hiring a drug manufacturer to work for the food and drug administration.

THE ARTIST IN THE MUSEUM ORGANIZATION

Our principle of standards and efficiency says that the artist, *as such,* has little to offer the museum by working within the museum organization. There is one exception, to be mentioned later.

The artist in museum administration—The psychology of the artist is not fitted to work well within an organization. Actually, I think it is

too bad that so many of artistic temperament do work for museums. The art museum is the public agent for the arts, not an "artistic" organism. Those responsible for museums must be good organizers, tactful politicians, and shrewd fund raisers. They could learn from businessmen, lessons taken from the remorseless marketplace, where bad management is repaid by insolvency. The Harris report "Americans and the Arts" gives clear evidence that museums misjudge, misunderstand, and mishandle their huge constituency. It states, for example, that 93,000,000 Americans would be willing to add five dollars to their income tax if it went to support the arts. And museums are crying for money! We must organize, we must become more realistic. Hiring artists will not help.

The artist as trustee—I can think of three reasons to put an artist on the board: one, because he could give money or art or something else the museum wants; two, as a token gesture to the art community; and three, because he has a special feel for art which could be instructive to the rest of the board, guide them into an aesthetic viewpoint, which trustees usually lack, and help bring the board closer to the objects, and the spirit of the objects, which are the reasons for the museum's existence. But the first reason has little to do with the artist as an artist, the second is cynical and merely appeasing, and the third presupposes a person who would be valuable to the board, artist or not. The reason for taking on a trustee is that he will be a good trustee. Everything else is secondary.

The artist on an advisory committee for exhibition or acquisition—I know I put myself out on a limb when I say this: artists are notoriously bad critics. Art history is studded with examples. It is hard for an artist to be objective. This is understandable. Objectivity, balance, fairness—these are qualities which must be worked on and sustained, like physical condition. As I evolved my own painting over the years, I was attracted to and used many "ideas" I saw in other artists' work; much of that work was not first-rate, but that did not matter—it had something I liked. When I write about art I must force a distancing, another way of seeing. The best judges of art have been persons who love it, are sensitive to it, and are "once-removed": writers, collectors, dealers. Artists are too "deep into" art. And there are the natural jealousies and allegiances. And

too, there is the matter of conflict of interest. All in all, it is not a good idea.

The artist as explicator—It has been my experience that artists do have something special to give by teaching and by talking about art. This is more true of successful artists. They are not more articulate than others, but they have forced their feelings into materials, put their work out against the work of their colleagues, and can refer back to what they have learned. Not every artist will be a good teacher or lecturer, of course, but the chances are good. And the successful artist will have the initial respect of students and audiences.

Museums are not tied to that great anesthetic monster, the education establishment. They can set up art education as they please and hire whom they please. And they have real art right at hand. It is a wonderful, open opportunity. Here is the place for intelligent innovation. Young artists could be given rigorous training in their craft, which includes the dynamic understanding of art as well as how to stretch a canvas. Most art schools are either frozen academies or chaotic playgrounds. Museums could do it well, and artists could be a valuable part of this. I would like to see it happen.

THE ARTIST PARTICIPATING AND PERFORMING

Integration, democratization, teamwork, participation, availability—these catchwords are in the air. They sound good as long as they stay abstract, and if you have not lived long enough to see how transitory and unreal liberal intellectual group attitudes are. I recall the 1950s, the "silent generation," when we all agonized over conformity and Reisman's "other directedness," and cursed the magazines that promoted "togetherness." Now it is group rights, everybody-the-same, join the team, and down with difficulty and the lonely "elite." And so it goes.

The art world, which has its full share of mindlessness, goes right along. "Work for what you get" is not a thought for the times. Not only is art to be made available to everyone, as it should be, but translated, diluted, popularized, made easy. Museums, which have met popular demands for pleasure and enlightenment, are caught in the middle, "mausoleums" for "dead art" which must hasten to

implement the "vital, living" art of the present, and, it is threatened, of the future. Artists now want to use the museum as a studio, a stage. They make art that moves, makes noise, can be played with, entered, or walked on, that uses video and film, that contains themselves and "breaks down the barriers" between the work and the observer. Questions of value (is it any good?) are shunted aside; distinctions are made in terms of innovation and availability, and are expressed in clichés.

Art museums, whose good intentions do not always coincide with good judgment, are trying to accommodate these works and these attitudes. The International Committee for Museums of Modern Art of ICOM (The International Council of Museums), meeting in Poland in September, 1972, drafted a set of proposals "to be submitted to the museum profession." They are wonderfully vague and painfully worded, and I repeat them here not for their specificity or literacy (that will be obvious) but because they are the first "official" expression of the artist-should-be-in-the-museum idea.

> In view of the double orientation of modern art museums, on the one hand conservation and preservation of collections and on the other such forum characteristics as experimental and innovation activities, the promotion of information, as well as an exchange of views between the artist and public, it seems indicated that the simultaneous functioning of the two above named components within the framework of a single institution is highly desirable.
>
> Accordingly, modern art museum personnel should make every effort to enlist the artist in a common partnership, because the artist alters the character of a modern art museum and its public role by enlarging and redefining art itself through his work and ideas.
>
> The creative and animating presence of the artist is essential in a modern art museum. Through his work within the museum, which in this manner has become a studio and laboratory, the artist would be able to move from his present marginal position in society toward one of central and public significance. As for the public it would discover the seriousness of the artist's concern and would gain a deeper understanding of his thoughts and his art.
>
> The modern art museum as custodian of the artist's work and as interpreter of his ideas is obliged to consider his intentions as far as possible. At the same time the museum is bound to consider the work of art in its fundamental universal context. [ICOM, v. 25, no. 3, 1972, p. 190.]

These proposals are not internally justified. When it comes down to *why* all this should be done, the text lapses into soft, reassuring indefiniteness: "It seems indicated" that it is "highly desirable,"

"enlarging art itself," "deeper understanding of . . . his art," and the last phrase above, which defies translation from English into English. Nowhere is it made clear what the museum and its public can expect to gain. The "seriousness of the artist's concern"? A lot of bad artists are very serious. If the "artist alters the character of the modern art museum," will we all come out better for it? If the "presence" of the artist was truly "creative and animating," this would be fine, but what if his personality is rotten and his art is no good? Many good artists are not very nice people. What if he gripes and complains and gets in the way, and makes himself generally insufferable? What if he does not stick to agreements and embarrasses the museum? Artists do things like that. The museum can go out and get a nice, clean cooperative artist. But that is no way to select art. And how many artists pile in the museum at once? You have got to have them all, if you are going to be fair and democratic. Will they all line up and talk at the public, like a mumbling, ragtag zoo? Will there *be* any public?

Then, as always, there is the question of quality. All current rhetoric notwithstanding, quality, the "goodness of good art," in Clement Greenberg's phrase, is the sole quarry of the museum. It has been my experience that informational and participatory art simply is not very good, and therefore not useful to the museum. There are physical reasons for this, but they are complex and I cannot develop them here. It is up to each art museum to decide what to do. But it must consider what it is gaining if traditional standards are relaxed in favor of vague ideals.

Quality speaks out in another way, from another direction. I have noticed, time and time again, how very interesting direct participation and the "studio" presence of the artist can be when strict standards of fine arts quality are not an issue. I think in particular of certain exhibits and demonstrations put on by the Museum of American Folk Art and the Museum of Contemporary Crafts in New York in which the aesthetic element is there but subordinate to other kinds of interest: tactility, craft, history, "how-to." Forcing minor art to be high art robs it of its interest, because the aesthetic approach is exclusive. It is all right to see interesting things about any art, and it is all right to enjoy the amusement park atmosphere of informational and participatory art. But it is *not* right for a museum of fine arts, whose policy is to

collect, conserve, exhibit, and interpret contemporary fine art and to give us the special joy of fine art, to divert funds thus intended into the exhibit of minor art.

Museums are the victims of their own success and progress; the more they give the more is wanted. They also suffer because the newer multi-media types of art-making evolved within the gallery-museum context. The mutual antagonism between "newer" and "older" forms of art-making, between "formalists" and "anti-formalists," has come about only because both were born and raised in the same household, and the newer forms have not found their natural arena. All forms of art-making can live peacefully together. Painters can paint, sculptors sculpt, conceptualists conceptualize, and earth artists pile their dirt. But the art museum cannot be a universal patron and must not try to be one. It can only do what it has been set up to do in the best way possible, and exclude what is outside its ken. Museums are not obliged to see that "avant-gardist" interdisciplinary forms of art are supported just because they exist. If the stuff is any good, it will find its audience and patronage, and, as is already happening, its museums. To each his own.

In Conclusion

If the above remarks seem conservative, it is because I see the art museum as a conservative institution, literally conserving, protecting us from the loss or depletion of fine art, exposing it to us in the most prudent and effective way. Recently I was on a panel with Harold Rosenberg. He said that museums should not "mess around with art history," that with-it, up-to-date shows were interfering, "gambling" with art history. I would have trendy shows under certain conditions, as described above, but I agree with him. Museums are not here to participate in artistic innovation but to select and present the finest fruits of that innovation. Museums need the kind of innovation that will increase operational efficiency; innovation in exhibition, organization, fund raising, innovation for the museum itself and its constituency. The museum and the living artist, so poignantly interdependent, must keep a wary distance. This means strain and altercation, but that is the natural order of things, a check and balance. We are in the middle of a great

creative period. Artists and museums are at the center, becoming more and more important to our civilization. Each has its function; each must defend and perform these functions fiercely, intelligently, and separately.

Robert Coles

7

The Art Museum and
the Pressures of Society

When I was a resident in child psychiatry at the Children's
Hospital in Boston, I came to know Boston's various museums
exceptionally well, and perhaps, from a somewhat peculiar vantage
point. My mother and father had always taken my brother and me
to the Museum of Fine Arts, the Isabella Gardner Museum, the
Museum of Science; but now I was a daily visitor, and with me
were children who, often enough, had never before been inside "this
kind of a place," as one Boston youth of thirteen—black, and born
in rural Alabama—kept calling Mrs. Gardner's "palace." That
particular patient of mine had been called a "learning problem" by
the Boston school department, but it was the 1950s then—so, today
he would be considered "culturally disadvantaged" or "culturally
deprived." He had gone to a two-room country school in a town
fifty miles north of Mobile, where *black* teachers, proud of their own
position in society, had told him and others like him, all the time,
that they were "dumb" or "uncivilized," or "unable to see." I was
especially struck by that last description, because I had found the
young man rather quick-willed and perceptive, if also difficult to
talk with, moody, and rebellious. Once he elaborated: "She'd say
that a lot of us niggers, we're only good for working out in the field

ROBERT COLES, M.D., *is Research Psychiatrist at the Harvard University Health
Services and a lecturer in General Education there. He has been a member of the
editorial board of* The American Scholar *and contributing editor to* The New
Republic *and* American Poetry Review. *His* Children of Crisis *won a Pulitzer
Prize in 1973.*

for the bossman, and we don't belong in school, because we're
unable to see—we're blind, she'd tell us, so it's a waste for her to
point out anything to us."

At ten he had arrived in Boston, and by eleven he was a vexing
problem to his teachers, who eventually decided that he needed
"help." At the time (the Eisenhower period) we were not supposed
to have a "racial problem" in America, and my own profession was
not by and large inclined to look beyond a child's early experiences
with his mother and father for explanations of "sociopathic
behavior," which was one of the phrases attached to his record
when he first appeared at the hospital. Certainly I was not going to
challenge any prevailing orthodoxies at that particular moment in
my life. I simply kept asking him, visit after visit, conventional
psychiatric questions—about his mother and his father, how they
got along with him, and he with them, and on and on. Not that he
felt constrained to respond; he began to convince me, because of his
stony silence, that he was not only "unable to see," but hard of
hearing, as well. I found myself talking louder and louder, and
perhaps more insistently, a measure of my frustration as I tried
unsuccessfully to engage in some minimal conversation with him.
Finally, after about two months of such efforts, he told me that we
were through—just when I thought we were, perhaps, making
silent, unacknowledged progress: at least getting used to each other.

I was a little desperate for myself (what would my psychoanalyst-
supervisors say?) and for him too (what would the school and court
authorities say, the latter involved because of a spate of minor but
foreboding delinquencies, which ranged from playing hookey to
small-time grocery store theft?). I asked him whether there was not
some way, any way, we could try to stick it out together and try to
understand what each of us was trying to say. Well, he was not
going to be taken in by my polite, somewhat evasive and plaintive
language: "I'll go for a walk if you want." That was all
right—though I have to add that in the 1950s, such a step was
rather out of bounds in any number of psychiatric quarters: "acting
out" it was called, "acting out" by both therapist and patient. And
I could only agree; that is to say, I felt at the time a failure for not
being able to keep the patient and myself in a constant, vigorous
conversation, held in the rather small and barren cubicle given
hospital residents for out-patient "examinations." But even "acting

out" seemed preferable to the loss of a young patient. So we started our trips.

As we walked away from the hospital, the young man began talking—not much, but more than I had ever before heard. He would point out cars to me, the ones he liked, and remark upon their virtues: color, design, equipment. In a few minutes (such is Boston's Fenway district) we were within sight of both the Museum of Fine Arts and the Gardner Museum. He had never seen either, and he asked me what they were. I told him. He said nothing. Or rather, he changed the subject: where could we get a coke, or root beer—he loved the latter. I did not really know; we had been walking in the wrong direction for that. As we came within sight of the Gardner Museum, he asked me if they had anything to drink in there, and I said water only, and he said that he was thirsty enough to settle for that, and so we marched in. He was stunned by what he saw: a large and beautiful garden in full bloom in the middle of a cold, snowy Boston winter. I shall never forget his immediate and only question: "How come they let us in here?" I tried to explain that anyone could come in on most days, from late morning to late afternoon. He looked around and said nothing, but there was a scornful look on his face which unsettled me for reasons I was then unable to figure out. I recall looking around myself—and seeing only a handful of people, and wondering whether my companion did not feel as if he were an intruder, especially when a man in a uniform followed us around as if he had reason to keep a close eye on us. Perhaps that youth, who was doing so poorly in junior high school, had quicker sociological reflexes than I did.

We never talked about the Gardner Museum very much thereafter. We would go by it—I took walks with him on each visit and thereby we got to know each other—but he declined many invitations I issued to return. Once I asked him why: "It's a house; I don't think they like a lot of people in there." I asked him who "they" were. He did not know; or if he had a thought or two about the subject, he was not going to say anything, at least do so directly. Instead he diverted my attention to the Boston Museum of Fine Arts: "Why don't we try that place?" We did, and he liked what he saw—long corridors, large rooms, and as he put it, "plenty of place to run or hide." Hardly a suitable aesthetic response; but I was surprised by the obvious pleasure he felt—and by his request that we return there the next time. I told him we could go there as often

as he wished, and he seemed pleased. He again had one question for me: "Will they mind if we come back?"

By then I had at least learned not to ask him whom he had in mind when he referred to "they." I simply told him no, "they" would not—and he seemed to believe me. Perhaps he felt, just a touch unconsciously, that I was one of "them"—a solid citizen, a white, middle-class professional man who, as a matter of fact (I only now realize) had told him earlier that my parents had often taken me to the two Fenway museums as a child.

I have since then become much interested in the ways children express their ideas and feelings in the drawings and paintings they do. In the three volumes of *Children of Crisis* I have so far completed, and in the two volumes of the series I am now working on, children's art figures prominently. Often I am asked how I happened to develop that interest; and often when I give the answer, I am met with a degree of incredulity. But the fact is that the first black child I treated came to love talking about some of the paintings he saw in the Boston Museum of Fine Arts, and eventually loved doing some drawing of his own. And that way he could talk not only about what he saw or himself created, but what those "pictures," as he called them, prompted him to remember about his own life. My experience with him caused me to ask other children, often as shy as he, about talking in a small hospital room about their fears and hopes, whether they might want to talk, and perhaps, visit a nearby museum. One child, of Irish working-class background, had always done well in "art," but like the black youth had no idea what a museum was—at age eleven. He loved Mrs. Gardner's former home—he always, and correctly, called it Fenway Court—and he delighted in imagining himself lord and master of the place: "If I was the boss here, I don't know if I'd let people in every day; maybe just on week-ends." I pointed out to him that under such a rule, he and I would not get a chance to visit. He had a quick reply: "You could always go to the other museum; that would still be open to everyone all week."

His own life had been a hard one. His father had been paralyzed in an industrial accident. His mother had once had a serious case of tuberculosis, and was never thereafter very strong. There were six children, and two cousins, taken in because both their parents drank much too much. His own father was no stranger to beer, was short-tempered and could become quite nasty. When he brought

home from school his truly remarkable sketches or paintings, his father scoffed, his mother seemed indifferent. No wonder he had become progressively sadder and less confident of himself; and no wonder he fairly glowed with delight when he saw that there was a long tradition to keep him company and give him sanction: artists and what they had managed to create, and an audience of people, both old and young, who kept coming to look, to be moved and taught. If in loneliness and despair he sometimes exercised his imagination rather strenuously, it was not because he was losing "contact with reality" or becoming prey to his "fantasies": but rather, he was telling me (and not incidentally, himself, because patients can listen to themselves when they speak to their doctors) how little a whole side of his mind and heart had been encouraged —and how delighted he was to be given the chance to stand there in Fenway Court, his eyes intent upon flowers or a painting or sculpture, or walk along those corridors of the Boston Museum, so near to landscapes, portraits, still lifes which he could openly and without fear admire.

Now what do those two youths, today quite grown up and themselves parents, have to tell us about the subject under inquiry in this essay? Of course, they would be the last ones to insist that they have anything to say on the subject. In each case they were the first in a neighborhood to visit any of Boston's museums; and neither of them was exactly applauded for doing so. Nor have they been completely won over, so that they are, as adults, active visitors. I have kept up with them over the years, and know what they feel—and feel able to say, the two not always synonymous. About a year ago, as the second of the two I have drawn from carried on at length about Boston and its various institutions, a touch of nostalgia prompted this:

I used to like those trips to the museum. You got a taste of what it's like to be rich—own a lot of nice pictures, and live in a big house. My walls, here—they're not good enough even for wallpaper. Look at them—peeling and peeling. I'll bet the landlord goes to the museum with his kids. I'll be honest; every once in a while I say to myself: take the kids over there, and get them started, so maybe they'll want to become real good at school, and try for college. But I never have the time. I'm holding down two jobs already, and we're drowning in bills, and I'm lucky if I get enough time to sleep. How am I supposed to find the energy to cross the city of Boston and walk down those

*halls with my children? I have to admit, I tried about a year ago. I had a
Sunday off—I get one a month—and I told the wife that I wanted to take the
oldest boy to a museum. "To what?" she said. I said a museum—you know,
downtown, where he can look at the pictures. My wife thought it was a great
idea, except for all I was supposed to do to help her out in the house—and
both her parents and mine were expecting visits. But I went; and I swore to
myself, coming home, that I'd never again waste my time that way. You
should have seen the place—hippies, full of hippies. I asked myself on the
way home: was that the place I used to go to, with the doctor? No—that was
my answer.*

He did not want to pursue the matter. I tried to answer what I
regarded as an unfair accusation, but found him all too anxious to
change the subject. On a subsequent visit I brought the subject up
again—by telling him not only what I had seen on a trip to the
museum, but what kind of people were there, too: mostly middle-
aged, and quite respectable in appearance, I thought. He was not
inclined to argue with me directly, but he insisted on having his
say:

*It's not for me—for us. You can't persuade me. I admit it: when I was a kid,
I liked going there. But that was something special; if I hadn't been in all the
trouble I was, I never would have got near the place. I was thinking when I
took my boy there: this place, it's for people with money, or people who are
going to get money later on—the college kids. I saw them marching some
colored children through, telling them to look here and there and everywhere.
It was as if they were saying: see all you've been missing; here it is! I know,
it's probably good for them, to go and look at pictures and listen to music.
[There had been a concert going on while he was there.] But then they have
to leave and go back home; and it's not easy, when you land in your backyard,
to remind yourself that life is no picnic along a river, the way it shows some
of those people having in the paintings, pleasant picnics. Maybe for some it's
a picnic, but not for the colored, and not for us around here, either.*

So much for the relationship between French Impressionist artists
and a young American working man. What of the "colored
children" he saw in the museum? As he reminded me, they were
not seen very much years ago in such places. Do they at last feel
welcome there, now that efforts have been made to rectify things?
Was his ironic, if not scornful observation, therefore, utterly out of
order? Here is another black child talking—this one ten years old,

born in a Boston ghetto, and not a "patient" of mine, but a boy I happened to get to know because he was being bussed to an all-white suburban part of greater Boston:

I've been to the Aquarium. I've been to the Children's Museum. The white people, if they're rich, they like to give their possessions to museums. You read their names on the walls, or under the pictures. I came home once, and I took a picture I'd drawn, and I wrote under it: "Gift of Johnnie Holmes," and hung it up in my brother's room. You know what? He thought I'd gone and lost my mind, that's what. I told him he ought to go visit a few museums himself; but he's only six, and he hasn't got started yet. I spent a week out in the suburbs last year. I was with some nice people; they want to help the blacks, they kept telling me. It was a busy time; every day they took me someplace. Twice we went into the city, and I wondered where we'd end up. It was the Museum of Fine Arts one time, and then the Aquarium. I'd been to both places before. The schools, they want to make sure you get your culture. They keep on talking about "culture." I asked one kid, he's white and his father is a lawyer, what all this culture business is, and he said it beat him, so that was good: there was somebody else who was there to scratch his head and say he didn't care what the guides said. They lead you past the pictures and they tell you how this guy painted one way, but another guy, he had a different angle, when he was doing his painting.

When I came home I thought it would be a good idea to take my younger brothers and my little sister to the art museum, so they could get a look. But they didn't want to go. My brother Mike asked me what a museum was. I said it was a place where they keep a lot of pictures. He wasn't sure if it was a building or what. He said he'd rather watch TV. I told him he could do both, go to the museum, then come back and turn the set on; but no, he wouldn't. I'd been telling him about painters, how they can look at something the rest of us won't even notice. He said we should go get some of those painters and have them cover our walls; they'd look better.

He means to be even more ironic than the reader may guess. A neighbor's infant died a year before of lead poisoning: the walls of an old, broken-down building had turned out to be, quite literally, poisonous. Not that the black child was not worried about appearances as well as the medical reality of lead poisoning. He knows all too well the difference between an ugly ghetto tenement and the almost spell-binding beauty of Fenway Court or parts of the Boston museum. If he is scornful or sarcastic at moments, he is also poignantly aware of his lot and that of others:

*I guess if I'm lucky I might end up living someplace else, but I doubt it.
There's a man across the street, he's a* doctor! *He's tried to move out of here,
and he can't do it. They moved to a suburb and they got calls, telling them
their house would burn down. So they got scared and moved back here. He's
the one who told me to take the younger kids to the science museum. We had a
good time there, but they all wanted to come home real fast; and like I told
you, they weren't ready to try another museum. Don't ask me why. Maybe
they don't see why they should; maybe it's for other people, not for us. In
school they tell us to go visit every place. They took us to a newspaper, and
you walked inside a globe, that's right, and there were the oceans and the
countries around you* [the "Maparium" at the Christian Science
Monitor Building]. *They give you a lecture there. They tell you about all
the continents, and how the globe was built, out of special glass. They know
about every strange country; but I'll bet they've never come near where we live.
There's not much use for us to leave here or for other people to come here and
look us over.*

Was he giving me a not so subtle bit of advice? I think so; I think
he would include me as one of those white strangers who are
continually trying to "understand" and "study" him and others like
him—and to his mind, we are engaged in a futile exercise. Once he
responded this way to a television advertisement that urged people
to go visit Boston's museums:

*The lady on TV said that you should go to them, no matter where you live.
She said the place was for everyone to visit. My daddy laughed, and so did I.
My daddy said I was the first one in the family to go to a place like that, and
he could see why it's a good idea. But after you come back, it's still the same
here; that's what he told us never to forget. If you stay in high school, maybe
you can get yourself a job—*maybe. *If you visit the museum, you come back
and you have to forget about the nice place, and the pictures. If you don't,
you're in trouble. Try not to think about how some people have it good; that's
what my grandmother used to say. She worked for a rich lady. She would
come home and describe her house—the old furniture, you know, and a lot of
pictures, and she'd have fresh flowers brought there every day and put on a
huge dining room table. My grandmother would dust, and sometimes help
cook, though there was another lady whose job it was to cook.*

*The people had fifteen rooms in their house, and there was only them.
They'd had a daughter, and she got killed in a horse-riding contest,
something like that. They would spend more money in a day, my grandmother
was sure, than we'd spend in a year or two. They were always going to*

museums, and they were important to the museums. They ran them, my grandmother said, along with some friends of theirs. They owned three houses besides. They told my grandmother that she should take all of us to look at the pictures in one museum, and they were going to give us a membership, and we could go to hear music, too. My grandmother told them that it's alright, and very fine, but she didn't think we'd be able to go to such a place, because it was hard. Well, they didn't press her too hard. They told her she should ask them, if there was ever any place she wanted to visit. So, when she told us that, and we'd just lost the electricity here, and my father had no job, my mother told her to tell them that we needed a better place to live, and the landlord gave us practically no heat here, and with the rats and all, it would be better if we lived in the museum for a while. That way, we'd be warm in winter, and like they tell you in school, we'd all be getting a good education, looking at the pictures.

Once I went with my grandmother to their house on a Saturday; they were going to have a party, and I helped polish the silver. They have a museum; the house they live in is one. Each room has pictures, and the cook, she knows all about the furniture and the pictures and everything. The cook told us that they are rich people and I believe her. She said you could take one of the paintings and sell it, and you'd be rich; and the same with the silver and some of the furniture. The way I see it, if someone steals a little of their property, and if he's poor, then it's not bad. But when I told my grandmother that, she told me to hush up, or she'd put soap on my tongue. I asked my mother if she agreed with me or grandma, and she said grandma. But it's no use pretending, my mother admitted, that it's a fair world, when people can cash in pictures and have a million dollars, and my dad can't find a job, and if he doesn't hide, the welfare lady will cut us off, and then we'll be thrown out.

It turns out that his grandmother once brought home a print, the gift of her employer. It is the only picture on any wall in the apartment, and it has been kept remarkably intact by the whole family: Renoir's *Le Bal à Bougival*, the original of which is at the Boston Museum of Fine Arts. The grandmother was somewhat apologetic when she brought the print home: would everyone like it—especially when they learned that the "missus," as her employer is called, chose to give such a present—instead of, say, cash. But her fears proved groundless. The children and their parents (the mother is the eldest daughter of the grandmother) need no prompting to comment on the picture. Here are the mother's words:

I saw you looking at them, dancing. I stop every day, once or twice, and look at the two of them, and somehow I feel better. Don't ask me why. I'll be tired and I'll be sitting on a chair with my head down nearly to the floor, and suddenly I'll look up and they'll still be there, holding each other and looking happy, and so I feel a little happy myself. I don't do any dancing myself; no time or money for that. My husband locks himself in the closet when the welfare lady comes, never mind dance with me, or he slips out before she's able to catch him. She warns us that she's coming "unannounced." It's too bad, because he'd like to work, and he's tried to get a job. I wish that welfare lady and her supervisor would have this picture in their office; maybe then they would be in a better mood. My girl, the oldest, asks me if they're in love, in the picture. I tell her I don't know, but probably.

You need to stop every once in a while. You can't just be driving yourself. I tell my children please to quiet down and let me pray. I have to talk with Jesus, and ask Him to give me strength. Then I'll begin to feel stronger; so I look at the picture, and I tell myself that maybe that woman, she had a lot of trouble in her life. But she still could go dancing. And the man, he could have been all upset about something. You wouldn't know it, though, by the way he is there; and the artist, he could have been poor, like some artists are, but he painted a happy picture. Of course, he must have made a lot of money, or his children did, because look how they've made this copy of his picture, and there probably are thousands and thousands of copies, just like it. I saw on television a man who wrote a book, and he said he'd made a lot of money, because thousands of copies of his book were sold. I thought of the painter whose picture we have; and I told my husband: I hope the artist got the money, and not some crook who took it away from him.

You can't be careful enough in this world. My mother comes back with stories of the white people, the rich ones, and I don't know if I should believe her or not. They aren't spending their time looking at pictures, I'll tell you! The man, he gets tips on the stock market. Then he buys stocks. Then he sells. He's a millionaire. His wife, she drinks a lot, and tells my mother about all the dirty linen, and then my mother comes home and tells me. I told my mother to tell her to go look at this picture she sent us, and maybe she'd feel better. One day, the missus was real upset, and she was drinking a lot of tomato juice, and it was only nine or ten in the morning, and she'd put some liquor in it. And she was talking and talking, and my mother got all upset, because the missus started crying and all; so, my mother got desperate and she did tell the missus to go look at the "dancing couple," we call the picture. Well, the lady wasn't sure what my mother was saying, but finally my

mother explained, and the missus, she suddenly began to laugh and laugh, after all that crying; and she didn't talk, just kept it up, her laughing.

My mother got scared, and she thought the poor missus was taking leave of herself, and she almost was going to call up the husband. But the missus finally stopped, and she told my mother that she and her husband, they had a lot of pictures, real paintings, not copies like ours, and they were high up in the museum, her husband was, and she took people through the place, and served tea or something; but neither she nor her husband stared at pictures the way my mother told her we did. That's what she said. And she said "it goes to show you." I asked my mother what "it goes to show," and she wasn't sure herself, but she said she thought the missus didn't understand how that "dancing couple" could lift my spirits the way it does, and my mother's spirits—and there she was, with more pictures than I have hands and feet, and you can throw in my husband's too, even if he's not supposed to be living here with us! When I told him what my mother had gone through, with her missus lady, he said "that's the truth," and he said if you own something, it doesn't mean it's going to bring you the happiness you want, and if you have a copy like we do, you can still put your mind to it, and your spirits can get a lift, no matter how bad things are for you. And don't you think that's what the painter would like to know—that he could affect you, something like that?

She asks her question rather shyly and uncertainly. Who is she to presume knowledge about the motives of a man whose very name she does not know? She is simply telling someone that for her a print can be an object of attentive concern—a comforting or reassuring sight, or more grandly, the source of a redemptive vision. Over-blown rhetoric from yet another comfortable if not guilty white liberal outsider, who has decided not to shun melodrama and exaggeration in order to make a point or two? Perhaps—but one can also dismiss with ever so much condescension the persisting effort that even the poor (again, the so-called "culturally deprived") make on behalf of themselves: to see, to try to comprehend, to gain some distance on themselves and their particular predicament. It is sad, in a way, that such individuals, so responsive to one of Renoir's paintings, cannot seem to get to know more of his work, and that of others whose drawings, lithographs, paintings or pieces of sculpture might, quite definitely, be inspiring to people who more than occasionally feel down and out, if not badly let down. I suggest, I hope, no clever palliative—a means of subduing legitimate social and political outrage. The point, rather, is coherence—something

we all need and struggle for, and something whose presence, one suspects, does not preclude a whole range of activism.

Here is the way it is put by the "man of the house," one of those terms a welfare worker has occasionally used in connection with this family which appreciates at least one nineteenth century French Impressionist master:

Maybe it's a silly picture for us to like. We'll never meet people like them, I know that. I don't know who those people are, except that they're white, and the lady, by her clothes, seems pretty well-off, I'd say. The guy, he's cool. Then you see those people sitting at the tables. They're relaxing, man—having a good time for themselves, a glass of beer. It's nice to be able to relax, and not feel yourself slipping into sadness. That's the trouble with having no money, and having no job—you have to relax, but when you do, you go down, down, down in your mind. It's no good. I drink the beer, and I know I don't have the right to be buying it, never mind drinking it. But there is something inside me that says I've got to—or else I'll be locked up in a hospital. I'll walk down the street and I'll see these store-owners, and the landlords coming in to collect their rent, and I'm ready to go buy a gun, I admit. But I don't, of course. If I went around with my finger on a trigger it wouldn't be long before I'd be dead or locked up in jail for life. I only wish the world would change. Sometimes I think of that picture we talked about—I think to myself: wouldn't it be nice if my wife and I could dance like that. Now I'll tell you: if you look at that picture real close, you'll see that those two are not only having a good time for themselves dancing, but they're feeling good. That's important; if you feel bad about the life you're living, you're in trouble. That's why I'll be walking down the street, and I'll see two people who look real happy, and I say to myself: if they're really happy, they deserve an artist to come over and paint them—you know, paint them walking down the street, with someone like me staring at them, something like that.

I'd go to a museum, yes, if I could see a lot of pictures like the one we have. I'm a little worried, though. There'd be too much to see. On television they can try to push so much on you, that you forget half of what you see. I watched the news last night, and there were so many reporters coming at you from so many different cities, that I gave up and turned the set off. You need to have time to rest your mind every once in a while. Maybe I could go to see a lot of pictures in the museum, like my boy did. Maybe I'd want to keep coming back: look at a picture on each visit. But there's no use going there. It's not the place for me; I know that.

One wants to stop him and ask him why. Why is a museum not the place for him? If not him, then whom? Are museums only places where the well-educated and the well-to-do go, or at the very least, feel comfortable in going? Is "art" the property of the bourgeoisie—not simply "art" as property purchased (and then bequeathed) but "art" as that encounter between a viewer who has set down in one or another way his or her vision of things and a viewer who is, so to speak, a seeker, or "on the hunt"? I put quotation marks around that last phrase because it, too, is drawn from a child I have come to know, this one white and of working class background. Here is what he could say, at twelve, about a range of issues very much connected to the concerns of this essay:

My father says don't be ashamed of being Italian, because in Italy a long time ago there were great painters. He has taken us twice to museums, and each time we went he pointed out the great Italian painters; he could tell by their names. There is a teacher who is at our school, and she isn't Italian, and she once told me and my friends that we weren't going to amount to anything, because we didn't read as fast as we should. My father said she might be prejudiced against us; she asked us if our parents ever get us to read. My father said that it's not her business to get snotty and uppity with us. He has two jobs, and he can hardly keep up with the bills, and he's lucky if he has a Sunday afternoon off, and when he comes home it's seven o'clock, and he's dead tired. Who does she think she is, dad said, and so did my mother. Then we went to the museum a few days later, and dad said that when the teacher's ancestors were living in huts or something, and not able to read or write, our ancestors were painting pictures and writing books, and all like that.

Some of the pictures, they were about the Bible; there was Jesus and his friends were near Him. Then there were angels, and shepherds with their animals. The museum was big, and we got lunch. Dad said we were too noisy, but when a lady stared at us, he got mad at her and said she thought she was a big deal, and she was just another person, like us, and the place was public, and the taxpayers kept it going, because the museum didn't have to pay taxes. On the way home he told us that we shouldn't feel ashamed of ourselves—never!—even if there's a teacher who thinks she's better, or that lady staring in the museum. Even the guards in the museum, they come around the corner and they stare at you. My father said he wanted to go up to one of them and tell him to get away, because we weren't going to steal anything, and the more he treated us as if we were there to cause trouble, the

more my dad wanted to go and punch him in the nose. But we left the room where he was stationed, and finally we got to another part of the museum, out of his reach. Then dad took us near and said we really shouldn't be angry at the guard, because he was just taking orders, and trying to keep the museum the way the people who own it want him to. When my sister asked who those people are, dad said he didn't know.

One can prod him. He has at that point been inclined to stop and go no further; but one can indeed prod: does he have any idea what those people are like whom his father has described as owners of sorts? No, he does not know exactly, but if he had to guess he would say this: "They're probably rich." Now, how has he come to that conclusion? For the social scientist interested in how (and when) children begin to learn not only the sexual "facts of life" but the social and political ones, the boy offers a remark or two worth, perhaps, ten or twenty volumes:

You have to be a rich man to own pictures like the ones we saw. Dad says some of them cost over a million. Can you believe it? If I had a million, I'd spend it on something else. But dad says some people have so much money, they don't know what to do with it, except buy expensive things, and then give a lot of them away. He showed us the names of people on the wall; they're the ones who own the museum, people like that. The teacher told us everyone owns the museums, most of them—the public—but that's not the way it is. If my dad complained about the guard, nothing would happen—or they might ask dad to leave right away. But if one of those rich people complained about the guard, he might get fired so fast that he wouldn't know what hit him. Dad said we mustn't touch any of the pictures; and we weren't touching them. We were running around the room, and the guard didn't like the noise we were making. My older brother, he said every time he's gone to a museum, there are a lot of rooms where no one is there, and it's dead silent, so you'd think they'd be glad to have people running through and laughing, but they're not. Maybe they should close the place up, the museum we visited, and only let in five or ten people every day, and they'd each have a body-guard with them.

His criticism is at points strident. His facts are, in certain regards, wrong. His various interpretations do not always hit the mark. For in truth many museums in recent years, including most certainly the Boston Museum of Fine Arts, have gone out of their way to attract children like him, and parents like his—to the point that it

would seem that there is little more they might do in that regard. Hours have been extended. Exhibits have been geared to the presumed interests of "a broader public," as one museum brochure I have seen puts it. Still, the boy is by no means a fool; he has sensed the obvious—that money and power have their effect inside as well as outside museum walls. Moreover, he has also realized that the issue is not money as a sum, but the whole matter of class and its various implications. For a rich man, choices have to do with one set of priorities; for a workingman there are quite other considerations—hence the inability of many of us who are fairly well-to-do to appreciate the utterly intangible, and maybe inexpressible, barriers which prevent many "ordinary" people from using their leisure time in a way some of "us" might consider valuable.

To some extent it is a matter of old traditions dying only slowly—the smug, removed, somewhat patronizing if not precious atmosphere that certain museums used to have—all too readily appreciated by school children, the *one* time in their lives they were taken there, or by any number of "plain citizens," who dared venture inside Museum X or Institute Y for a casual walk on a particular afternoon. But beyond all of that, one has to look at what poor and working-class people feel about more than a certain museum, or indeed, all museums; one has to understand how little time there is for any visits or trips, how little inclination there is for quiet, uninterrupted contemplation, when at every moment, virtually, the devil, in various forms, or Hell itself, seem all too near. And if that seems like a rather melodramatic or exaggerated version of what obtains in millions of homes, then I fear I have to fall back on the people I have worked with—whose urgent, everyday struggles to keep solvent, or worse, to stay the hand of hunger, do indeed generate alarm, fear, and yes, a kind of self-preoccupation (how do I get through this day, this week?) that, in sum, undoubtably discourage some of the interests others, less harassed, feel able to have.

My last informant for this essay is a bit more fortunate than others called upon here, but not by much. Because his brother teaches music in a high school, he is more disposed to the arts than some of his neighbors. He is an accountant, and on the rise. He lives in a quiet suburb, not one of the "fancy ones," as he puts it, but far enough "out" to be beyond the "street car suburb" range. Here is what he wants for his children—"the best," of course, spelled out:

It's been a long, hard road for me, and I'm just 34. I'm the first in my family to graduate from college. I hope my son and daughter both do. I used to think colleges are only for boys, unless you really have money. But these days, you get nowhere fast, especially with inflation, if you don't have a degree. And women have to be more independent. My wife likes to paint. She's an amateur. I encourage her, even if they cost plenty, the "art supplies" she's always putting down in our check book. My brother says the kids should take music lessons. He's right, but how much money is there? Not enough for everything; so, you have to choose. I'd like to take the kids to the Symphony. I'd like to go myself. I'd like to take my kids to the museum; I mean more than once every five years.

Once I stopped in at the Museum of Fine Arts myself, just on a lark. I was driving by, and I felt like breaking out of the rat-race for a half an hour. So, I pulled over—I almost got in an accident, because I did it so suddenly. And I walked in, and I just moved along, from picture to picture. It was like being in another world. I couldn't believe it. All the worries left me. I felt like I was becoming—well, you know, a philosopher. I got some distance on my life. I came home and told my wife that it was better than beer, better even than a good movie; because you could be alone with yourself, standing there. Then she reminded me of something: I'd gone there in the middle of the week, late in the morning, when just about everyone else was at work or at school. No wonder it was so nice and quiet. What if a mob of people was there, pushing at me, and stepping on my feet, and filling the air with their breathing and their noise?

I had to leave after an hour; I began to get nervous, and I knew I was way behind schedule, because of what I'd done. When I walked out of that place, I was looking to the right and the left: was anyone looking who might recognize me? Crazy! You see what it's like: you get in a rut, and that's it! By the afternoon I was asking myself why I'd bothered to take that hour off. To tell the truth, I was ashamed to tell my wife what I'd done. She might begin to think I was cracking up. Maybe I was worried that I was cracking up. But a guy like me, he can't afford to crack up—and I guess he can't afford, either, to take an hour off on a work day and look at pictures. Sometimes I wish I had another life; but then the phone rings, and you can't spend your time day-dreaming.

He is sure that writers and artists do just that; and whatever envy he feels toward them is buried deep, most of the time—though clearly there are "eruptions," one might call them, when he recognizes within himself various longings, frustrations, responses

which ordinarily are inadmissible. Perhaps he would be reluctant to refer to his "aesthetic" or "philosophical" side, but as one listens to him long enough, one does indeed begin to catch a glimmer of such a side to him—long since cut off and locked safely up, a perceived threat to the commercial values he has, for the most part, learned to accept without question. And so, he is not unlike some of the others I have called upon here, however "higher" his social and economic position. I suppose, if I were asked for generalizations about such people, and recommendations with respect to those museums who want to reach such men, women, and children, I would refer to the desperate straits an individual feels—when jobless, or on an assembly line, or confronted with bills that cannot be paid, or caught up in a hard, competitive struggle, no matter the financial reward. All of which means that leisure, as opposed to empty hours due to illness or due to sheer exhaustion and self-doubt, is by no means available to millions of Americans, perhaps to the overwhelming majority of them. Consequently, most museums are places frequented (with any degree of regularity, familiarity, and relaxation) by upper middle class educated people—no surprising conclusion, I suspect.

True, in recent years more and more busloads of ghetto children have appeared outside the doors of our urban museums, and to good effect—both for the children (and their parents, who, believe me, hear about those trips later on) and, I would think, the museums. I would be the last one to discourage further efforts to open wide museum doors, stretch the hours, reach a larger public than heretofore. Nor do I have any "solution" to a complicated problem that, to be blunt, touches upon more than matters of "taste" or "culture"—rather, the privileges and responsibilities of the so-called middle class. But I do believe, and I think with the support of the various individuals I have, so to speak, called in witness, that there is in many more of us than ever get to museums, or even have one Renoir print on our walls, a responsiveness to life's rhythms, mysteries, ironies, and ambiguities which is very much central to the nature of the artist's (or writer's) task. What a Renoir tried to clarify (for himself and others) about the world he watched is not unlike what a ghetto child or factory worker or white collar worker wants (maybe it is a matter of a secret craving) to clarify for himself—in Kierkegaard's words: "the meaning of life, or the nature of things—and an inquiry into either is often killed in the

academy, but may be carried on from day to day by any one of us, no matter who we are." So, perhaps we need satellite museums, mobile ones, more walls on various streets used by artists, and the presence of artistic salesmen of sorts—not in order to introduce new dimensions of philistinism in this country, or to undercut the legitimate and enduring value of the traditional museums, but to help give sanction to the thoughtful reveries of many millions of people, who may know nothing about "art" or "the humanities" or "museums," but who, in their own manner, struggle for coherence, vision, a sense of what obtains in the world, and very important, what ought to be or might be, as well as what is—the artist's quite traditional task.

Suggested References

The books and essays listed here are only a selection representing different viewpoints:

BAZIN, GERMAIN, *The Museum Age*, New York: McGraw-Hill, 1967.

CAUMAN, SAMUEL, *The Living Museum*, New York: New York University Press, 1958.

COOLIDGE, JOHN, *Some Problems of American Art Museums*, Boston: Club of Odd Volumes, 1953.

GILMAN, BENJAMIN, *Museum Ideals*, Boston, Cambridge, Museum of Fine Arts, 1918.

LOW, THEODORE, *The Educational Philosophy and Practice of Art Museums in the United States*, New York: Columbia University, 1948.

PACH, WALTER, *The Art Museum in America*, New York: Pantheon, 1938.

WITTLIN, ALMA, *Museums*, Cambridge: M.I.T. Press, 1970.

S. E. L.

Index

About The American Assembly

The American Assembly was established by Dwight D. Eisenhower at Columbia University in 1950. It holds nonpartisan meetings and publishes authoritative books to illuminate issues of United States policy.

An affiliate of Columbia, with offices in the Graduate School of Business, the Assembly is a national educational institution incorporated in the State of New York.

The Assembly seeks to provide information, stimulate discussion, and evoke independent conclusions in matters of vital public interest.

AMERICAN ASSEMBLY SESSIONS

At least two national programs are initiated each year. Authorities are retained to write background papers presenting essential data and defining the main issues in each subject.

About sixty men and women representing a broad range of experience, competence, and American leadership meet for several days to discuss the Assembly topic and consider alternatives for national policy.

All Assemblies follow the same procedure. The background papers are sent to participants in advance of the Assembly. The Assembly meets in small groups for four or five lengthy periods. All groups use the same agenda. At the close of these informal sessions, participants adopt in plenary session a final report of findings and recommendations.

Regional, state, and local Assemblies are held following the national session at Arden House. Assemblies have also been in England, Switzerland, Malaysia, Canada, the Caribbean, South America, Central America, the Philippines, and Japan. Over one hundred institutions have co-sponsored one or more Assemblies.

ARDEN HOUSE

Home of The American Assembly and scene of the national sessions is Arden House, which was given to Columbia University in 1950 by W. Averell Harriman. E. Roland Harriman joined his brother in contributing toward adaptation of the property for conference purposes. The buildings and surrounding land, known as the Harriman Campus of Columbia University, are fifty miles north of New York City.

Arden House is a distinguished conference center. It is self-supporting and operates throughout the year for use by organizations with educational objectives.

AMERICAN ASSEMBLY BOOKS

The background papers for each Assembly program are published in cloth and paperbound editions for use by individuals, libraries, businesses,

public agencies, nongovernmental organizations, educational institutions, discussion and service groups. In this way the deliberations of Assembly sessions are continued and extended.

The subjects of Assembly programs to date are:

1951——United States–Western Europe Relationships
1952——Inflation
1953——Economic Security for Americans
1954——The United States' Stake in the United Nations
 ——The Federal Government Service
1955——United States Agriculture
 ——The Forty-Eight States
1956——The Representation of the United States Abroad
 ——The United States and the Far East
1957——International Stability and Progress
 ——Atoms for Power
1958——The United States and Africa
 ——United States Monetary Policy
1959——Wages, Prices, Profits, and Productivity
 ——The United States and Latin America
1960——The Federal Government and Higher Education
 ——The Secretary of State
 ——Goals for Americans
1961——Arms Control: Issues for the Public
 ——Outer Space: Prospects for Man and Society
1962——Automation and Technological Change
 ——Cultural Affairs and Foreign Relations
1963——The Population Dilemma
 ——The United States and the Middle East
1964——The United States and Canada
 ——The Congress and America's Future
1965——The Courts, the Public, and the Law Explosion
 ——The United States and Japan
1966——State Legislatures in American Politics
 ——A World of Nuclear Powers?
 ——The United States and the Philippines
 ——Challenges to Collective Bargaining
1967——The United States and Eastern Europe
 ——Ombudsmen for American Government?
1968——Uses of the Seas
 ——Law in a Changing America
 ——Overcoming World Hunger
1969——Black Economic Development
 ——The States and the Urban Crisis
1970——The Health of Americans
 ——The United States and the Caribbean

Date Due

MAY 31 '97			